Digital Technologies
in Early Childhood Art

Also available from Bloomsbury

Early Childhood Studies, Ewan Ingleby
Early Childhood Theories and Contemporary Issues,
Mine Conkbayir and Christine Pascal
Education and Technology, 2nd Edition, Neil Selwyn
Literacy, Media, Technology, edited by Becky Parry,
Cathy Burnett and Guy Merchant

Digital Technologies in Early Childhood Art

Enabling Playful Experiences

Mona Sakr

Bloomsbury Academic
An imprint of Bloomsbury Publishing Plc

BLOOMSBURY
LONDON · OXFORD · NEW YORK · NEW DELHI · SYDNEY

Bloomsbury Academic
An imprint of Bloomsbury Publishing Plc

50 Bedford Square	1385 Broadway
London	New York
WC1B 3DP	NY 10018
UK	USA

www.bloomsbury.com

BLOOMSBURY and the Diana logo are trademarks of Bloomsbury Publishing Plc

First published 2017

© Mona Sakr, 2017

British Library Cataloguing-in-Publication Data
A catalogue record for this book is available from the British Library.

ISBN: HB: 978-1-4742-7188-2
ePDF: 978-1-4742-7189-9
ePub: 978-1-4742-7191-2

Library of Congress Cataloging-in-Publication Data
A catalog record for this book is available from the Library of Congress.

Typeset by Newgen Knowledge Works (P) Ltd., Chennai, India
Printed and bound in Great Britain

Contents

Figures

Tables

Acknowledgements

Parts of this book are based on my PhD research, which was conducted at Oxford Brookes University. My thesis, entitled 'Meaning and Medium in Young Children's Picture-Making', was funded by the Interdisciplinary Doctoral Training Programme, which was expertly managed by Professor Guida de Abreu. Without the practical support of this programme, I would not have been able to begin my career in research. My research was supported by two excellent supervisors to whom I am incredibly grateful: Professor Vince Connelly of the Psychology Department and Dr Mary Wild of the Education Department. Through careful and rigorous questioning and guidance, they helped me understand the sorts of questions I wanted to ask as a researcher and how I wanted to go about the processes involved in research.

In my time as a research officer for the MODE (Multimodal Methods for Digital Data and Environments) team at the Institute of Education, I was able to greatly advance my understanding of methods and analysis in the context of a social semiotic approach and how this could be applied to elucidate the practices involved in children's digital art-making. Through my conversations with Professor Carey Jewitt and Dr Sara Price, I developed important insights into my own research, which have influenced the ideas presented here.

I have written this book in the context of my work as a lecturer in the Education Department at Middlesex University. For their practical support of my research and constant encouragement, I am grateful to the head of department Dr Debbie Jack and my team leader Nicky Spawls. I love working at Middlesex and am lucky to be surrounded by colleagues and students who are an inspiration to me, particularly in their dedication to early childhood education. For challenging me to think in new ways, I would particularly like to thank my colleague and mentor Professor Jayne Osgood.

My research would be impossible without the kindness of the participants who agreed to be observed during their art-making. I owe a lot to all of the children whose art-making I have admired and explored, both the children in the school contexts where I conducted research and the young family members who have been ready to let me watch as they engage in digital art-making. My thanks also go to the adults who have allowed me to conduct these observations – the

parents and the teachers who have not only tolerated my presence but shown a deeply encouraging interest in the research I'm doing. I do hope that this book will be of interest to parents and practitioners.

I have been supported by Rachel Shillington and Maria Giovanna Brauzzi at Bloomsbury in the development of the book. I am grateful to them and to the anonymous reviewer of the manuscript who offered such a positive and clear reading of the book's contribution.

This book is dedicated to my daughter, Leyla Sawbridge, who was born during the final stages of its production.

Introduction: Digital Technologies in Early Childhood Art

What this book aims to do

Through art, children make sense of their experiences and the world around them. Drawing, painting, collage and modelling are open-ended and playful processes through which children engage in physical exploration, aesthetic decision-making, identity construction and social understanding. As digital technologies become increasingly prevalent in the lives of young children, there is a pressing need to understand how different digital technologies feed into important experiences in early childhood, including early childhood art. We need to consider how particular dimensions of the art-making process are changed and what can be done (by parents, teachers and designers) to maintain and even enhance the playfulness and creativity that children bring and show in the context of digital art-making. Stemming from a social semiotic perspective and drawing inspiration from posthuman and Deleuzian approaches to art-making, this book aims to highlight how children engage with different facets of art-making with digital technologies including remix and mash-up, collaborative creativity, affective flows, sensory stimulation, archival and authorship and intentionality and meaning. Through these themes, I aim to offer insights into how playfulness is visible and can be fostered in children's digital art-making. In addition, through observations and investigations of digital art-making, I hope to open up and further discussions that surround children's art-making more generally, regardless of the resources and media that are involved in it.

How we understand early childhood art

When we observe children engaged in art-making, we can focus on any of the many dimensions that are at work in the experience. Child art-making, just like

adult art-making, involves various facets – from the sociocultural to the highly personal, from the aesthetic to the physically pleasurable and from the experimental to the emotional. Indeed, there is so much going on in early childhood art that research in the field has tended to implement either highly narrow or frustratingly woolly theoretical interpretations of the processes that are involved.

The links between children's development and visual art were the basis of numerous projective tests created by psychologists in the early and mid-twentieth century. These tests aimed to use children's drawing as a 'way in' to understanding the child's developing sense of self and their changing capacities. Various stage models of artistic development (Harris, 1963; Koppitz, 1968; Lowenfield, 1947; Machover, 1949) suggested that it was possible to judge children's cognitive, emotional, social and physical development according to the drawings they made. In the latter part of the twentieth century, these tests were discredited through evaluations which showed poor inter-rater and inter-measure reliability. Beyond these challenges from within the field of psychology, researchers outside of a psychological approach argued that it was deeply problematic to see a child's drawing as a direct expression of what they can or cannot do, how they feel, or what they know. As an alternative, researchers from a sociocultural perspective to children's communication and learning suggested that their art-making is too embedded in the unfolding moment, and the various social and cultural dimensions of this moment, for it to be read as a singular representation of the individual child. This is not to say that children's art-making can tell us nothing about the individual child, but rather that there is a level of complexity in the process of 'reading' art-making that must be factored into how we engage with early childhood art (Malchiodi, 2011).

More recent research on early childhood art has tended to focus on the sociocultural insights that can be developed by exploring the visual culture that young children engage with and create. For example, the work of Thompson (2003) on 'kinderculture' has highlighted the extent to which children actively engage with the images that surround them and use art-making as a context in which they can make sense of this wider culture and become active creators of it. Thompson argues that children's engagement with popular visual culture can often create a sense of discomfort in parents and practitioners, who become concerned that through an engagement with commercial visual imagery, children's 'pure' expression is somehow compromised. Dyson (2010) and Hawkins (2002) also offer important insights into the sociocultural dimensions of children's art-making, and in particular into how the act of 'copying' can feed into fluctuating social dynamics between children, playing a role in building and strengthening

social relationships between peers and family members and disturbing notions of self-expression and ownership.

In approaches to early childhood art that have evolved within Reggio Emilia, the focus has been more on physical and aesthetic exploration. Strong-Wilson and Ellis (2007) suggest that a fundamental part of art-making is the exploration of the material resources that are on offer and experimentation with what the resources can do as opposed to what they were intended to do according to adult designers. They offer the example of glue, which we might typically see as something to stick things with, and suggest that children, if encouraged, will invest in a more open-ended process of questioning, through which they consider how the glue feels, what visual effects the glue can create when it is drizzled and the different things the glue will and won't stick together. Linked to this idea of physical exploration is the possibility for art-making to involve processes of organizing and patterning resources, so that we 'artify' (Dissanayake, 2000) the environment that we live in. Nurseries that adopt a Reggio Emilia approach to early childhood art, often promote the fundamental parameters of artifying such as repetition, elaboration and patterning, through the careful placement of resources in the environment.

Although we can engage with young children's art-making in this plethora of ways – focusing on the social, cultural, aesthetic or physical – researchers have suggested that we often reduce our visions and understandings of early childhood art in practice. Perhaps the multidimensionality of art-making is overwhelming, and it becomes tempting to focus on those aspects of art-making which are most easily measurable, particularly in the context of an educational approach that prioritizes developmental targets and attainment according to norms. In observational studies conducted in nurseries, it has been noted that practitioners often make sense of early childhood art through the lens of literacy. In particular, the youngest children's engagement with art-making are seen as examples of experience with inscription tools that will help to build the fine motor skills necessary to hold and control a pencil and therefore embark on literacy tasks like writing their name (Anning, 1999; Wu, 2009). In this perspective, art-making is not seen as art-making but instead as a component of emergent literacy. In a previous work, I have suggested that the term 'mark-making' can be used in practice to cloud distinctions between art-making and literacy, thereby contributing towards a diminishing focus on and understanding of early childhood art as a specific domain of play and learning (Sakr, 2015).

Another extreme is to position all experiences of art-making (and all children who make art) as inherently creative and therefore best left to their own

devices. This is a phenomenon noted by McClure (2011), who argues, building on the terminology of Barthes, that children's creativity is surrounded by 'mythic speech', which constructs their acts of creativity as inherently good, beautiful and self-expressive. While this perspective values the art that children make, it does so in a way that constructs a false distinction between children's art-making and adult art-making, seeing the former as felt and intuitive and the latter as having the potential to be cognitively rich and intellectually stimulating. Linked to this, Hawkins (2002) suggests that we often apply the term 'self-expression' to children's art-making without really thinking about what it means. The term becomes part of a 'final vocabulary' (Rorty, 2000; cited in Hawkins, 2002) that we cannot question but which does not enable us to develop insights into children's thought and feeling processes or the social dynamics that feed into the art-making experience. If all experiences of children's art-making are simply seen as self-expression, we turn early childhood art into a black box that makes it impossible to deconstruct what children do or construct purposeful strategies for support.

In the midst of these various approaches, I argue that we need a new level of confidence when engaging with early childhood art theoretically. In this new confidence, we would refrain from limiting ourselves to only focusing on the aspects of the experience that are easily measurable or identifiable (such as fine motor skills). At the same time, we would also avoid a temptation to under-theorize by applying catch-all terms such as self-expression and creativity, which while apparently positive, actually act to diminish the importance and interest that we associate with early childhood art. I hope that this book will make some contribution to the project of re-theorizing early childhood art.

Digital technologies in young children's lives

The role of digital technologies in the lives of young children is growing. Through their engagement with computers, mobile phones, MP3 players and other technological toys and games, children are rapidly building their familiarity and competence with digital resources (McPake et al., 2013; Ofcom, 2014 Palaiologou, 2016). When it comes to young children's visual art-making, digital technologies can be used in a variety of ways. Some applications enable children to take photographs and organize them into visual or multimodal narratives. Some applications enable children to 'draw' freehand using the mouse or a touchpad as input, or to block-colour pre-made visual templates. Other

applications offer children the opportunity to incorporate ready-made visual material onto the screen, creating something akin to a digital collage.

Media stories about the potential of digital technologies to impact negatively on the everyday lives of young children are extremely popular. These narratives are fuelled by the findings of academic studies that focus on the interplay between the development of digital technologies and our ever-changing culture. Turkle (2011, 2015) suggests that our interactions with increasingly sophisticated and seemingly social technologies may make adults and children less inclined to engage in the messy and complex social interactions of the 'real world'. On a different note, Steinberg's (2014) negative analysis of kinderculture suggests that digital interactivity increasingly renders children the targets of commercial imagery and a consumerist culture stemming from corporate interests. Finally, Edwards (2013) has commented on the tendency for adults to separate the digital and the playful, so that children's free-flow play is rarely associated with digital technologies and we only develop and invest in digital technologies and digital activities that are highly structured and limiting.

While these concerns are frequently voiced in the press and echoed in homes and schools, there are relatively few studies that focus on how digital technologies are actually drawn into the everyday interactions of children. What do children actually do with the digital technologies that are available to them? In particular, how are these digital technologies taken up in contexts of play and creativity? Exceptions to this include the influential work of Jackie Marsh (Marsh, 2004; Marsh et al., 2005), which has focused on children's take-up of digital environments within their everyday contexts, and the fluidity with which children move between digital and physical spaces, creating digital-physical assemblages of play. In this perspective, which sees the physical and digital as inextricably intertwined in contemporary childhoods, it does not make sense to ask about the 'effect' of digital technologies on early childhood. Digital technologies are simply part of the 'sociotechnical environment' (Bruce, 1997) of the child and must be seen as such. This does not mean that we cannot ask questions about the properties of different digital technologies and how these shape specific interactions, but rather that we cannot take the view that digital technologies and childhood are separate enough to position one as having the capacity to have an identifiable effect on the other.

While we might adopt this nuanced theoretical position towards digital technologies, there is no point in ignoring the uncertainty that practitioners express in relation to the role and integration of digital technologies into the early years

setting. Researchers have noted that while early years teachers actively look for ways to integrate digital technologies into the early years classroom (Formby, 2014), there is a tendency for exposure to digital technologies in the classroom to lag behind exposure in the home (Aubrey & Dahl, 2008; McTavish, 2009). Along with resourcing issues, these delays have been attributed to a lack of teacher confidence in facilitating the use of digital resources in creative ways among young children in the classroom (Lindahl & Folkesson, 2012; Lynch & Redpath, 2014; Plowman et al. 2010). This relates to Edwards' (2013) warning that adults may be constructing an unbridgeable gap between digital technologies and playfulness.

In this book, I aim to contribute to our understanding of digital technologies in early childhood through a focus on micro-interactions as they unfold and a commitment to remain open to the playfulness in children's interactions with the digital technologies in early childhood art. If we are to engage with the concerns voiced in the press and by practitioners, we need concrete examples that show how digital technologies are drawn into children's everyday interactions, and particularly those experiences, like art-making, which we associate with playfulness and creativity.

A theoretical framework for my investigations

In order to investigate digital technologies in early childhood art, there are particular theoretical tools that I have found helpful. I do not position myself staunchly within a single theoretical tradition, but instead adopt and apply concepts that have developed from within various theoretical traditions and frameworks to build insights into digital technologies in early childhood art. I have been strongly influenced by social semiotic theory, which repositions meaning-making so that it is embedded in the social and material dimensions of experience. Social semiotics engages us in questions about the 'semiotic resources' that are used in or drawn into art-making experiences and how the 'affordances' of these resources play out or play into the experience. Both concepts – semiotic resources and affordances – have enabled me to unpick how particular digital technologies can shape interactions as they occur. At the same time, the notion of 'embodied interaction', which is popular among researchers in human-computer interaction (HCI), enables a multidimensional focus on the entire physical-digital network of any interaction, and opens up the potential for affordances to be in a state of constant creation through environment-body-object

interchanges. Linked to this, Deleuzian concepts, such as the rhizome, smooth space and assemblages have challenged me to understand children's interactions as being in a state of constant construction, so that there is no 'here' and 'now', but only the 'becoming-here' and the 'becoming-now'. While this is unsettling and can superficially appear to be unhelpful as it prevents us from being able to offer definitive statements about the influence or effect of digital technologies on any domain of experience, it is my contention that this perspective actually helps us to build more productive ways of seeing children's engagements with digital technologies in the everyday. By creating examples of this approach in action, we can foster new ways of seeing early childhood art and children's interactions with digital technologies. Below, I offer a more detailed breakdown of these different theoretical inspirations.

Social semiotics

Social semiotic theory differs from traditional Saussurean approaches to semiotics by placing a greater focus on the social and material dimensions of meaning-making (Hodge & Kress, 1988; van Leeuwen, 2005). In traditional approaches to semiotics, signs are thought to comprise two parts: the signified and the signifier. A simple system operates through which the signified is the concept to which we are referring through the signifier. When I say 'water', the word acts as the signifier and the idea of water to which I am referring is the signified. In this conceptualization, making meaning depends on the formation of a relationship between something that is internal to an individual and something that is external and can be communicated between individuals. Social semiotics challenges this direct and singular relationship between the signifier and the signified, suggesting that this relationship depends on the sociocultural context, and that the materiality of the signifier is a fundamental part of the process of signification.

Prior to the consolidation of these ideas in social semiotic theory, there was recognition among semioticians that signs are steeped in sociocultural references. For example, in Barthes' (1977) distinction between connotation and denotation, images can both denote particular things in the world and at the same time connote meanings that are culturally shared. A child's drawing of a house, for example, can both refer to the object of a house (denotation) and can also induce culturally embedded ideas, for example, the notion of home (connotation). Similarly, Jakobson's (1960, 1973) approach to language posits to the

existence of something that goes beyond a simple signification mechanism that operates between the signifier and the signified:

> When one-sided concentration on the cognitive, referential function of language gave way to an examination of its other, likewise primordial, underivable functions, the problems of the code-message relationship showed much greater subtlety and multivalence. (Jakobson, 1973, p. 21)

Jakobson (1960) suggests that there are various functions at work in language. While one of these functions is referential (the word 'tree' refers to the object of the tree), the other functions are steeped in social, cultural and emotional contexts. The emotive function of language, for example, relates to the capacity of the sign-maker to express an affective layer of meaning through language, and the conative function suggests the existence of sociocultural associations that may only be shared by a small group of individuals (rather than all official speakers of the language). Social semiotic theory builds on these ideas by suggesting that all meaning-making is embedded within a particular sociocultural context, so that the relationship between the signifier and the signified is highly mutable. For early childhood art, this supports the rejection of psychological projective drawing tests since there cannot be a single 'reading' of any example of children's art-making, since the signs are not in their whole existence on the page – they are only in full existence as part of the emerging interaction.

In addition to focusing on the social dimension of meaning-making, social semiotics emphasizes the importance of the materiality of signs. Again, this aspect of social semiotic theory has roots within previous structuralist and post-structuralist research. For example, the notion of the 'floating signifier' (Levi-Strauss, 1950/1987) highlights the possibility that signifiers, whether they be words or graphic inscriptions or gestures, can be used without attachment to a particular signified. Building on this, Derrida discusses 'empty signifiers' as signifiers that are used for pleasure and play and have no referential function at all (Derrida, 1976, 1980). In the idea that signifiers can exist without reference to a signified, there is a new importance for the materiality of the signifier which is seen to carry meaning without carrying a reference point. In this perspective, a gesture is meaningful without being a sign for anything else in particular; the bodily movement is itself of interest and importance. In the context of children's digital art-making, this perspective places an emphasis on the digital-physical assemblages through which the art-making unfolds, without introducing a need to make sense of the art-making with reference to anything else (such as the

emotional state of the child, their cognitive capacities or their engagement in different social relationships).

Multimodality

Within a social semiotic approach, multimodality has developed as a particular field of inquiry. Multimodality focuses on the plurality of modes with which we communicate, the qualities that distinguish these modes from one another and how these modes are brought together in the 'multimodal ensemble' (Goodwin, 2000) of everyday communication. The central premise of multimodality is that meaning-making occurs and can be systematically studied in various modes:

> Meanings are made, distributed, received, interpreted and remade in inter-pretation through many representational and communicative modes – not just through language. (Jewitt & Kress, 2003, p. 1)

Modes are organized sets of semiotic resources and practices. Typical modes that we use to communicate with others include writing, speech, image, gesture and gaze. Modes can be disembodied as in the case of writing and image or can be embodied as in the interactional modes that we use, such as gesture, gaze and speech.

Research in multimodality has highlighted the wide range of communicative modes that are drawn into children's meaning-making. Kress (1997) in *Before Writing* showed how meaning is constantly carried, or transduced, across modes and Flewitt (2011) argues that in order to 'hear' what children really have to say, we have to tune into the wide range of modes through which they communicate and interact. When interactions are analysed from a multimodal perspective, the focus rests on various communicative modes (including body position, movement, gaze, body posture, gesture and speech) in order to develop insights into how activity is organized sequentially (Bezemer & Mavers, 2011) and the 'semiotic work' that particular resources – both bodily and technological – are doing in the wider context of the interaction (Goodwin, 2000; Sakr et al., 2014). Applying multimodality is particularly important in this context because of the wide range of previous research that has highlighted the importance of nonverbal modes of communication in understanding art-making. In addition, disentangling the role that digital technologies have to play in early childhood art relies on carefully unpicking the interactions that unfold around these digital technologies and looking for clues as to how the technologies are contributing to

or shaping the unfolding interaction. In the research contexts of social semiotics and multimodality, two fundamental concepts – semiotic resources and affordances – have developed, which support us in deconstructing the involvement of digital technologies in observations of everyday micro-interactions.

Semiotic resources

In social semiotics, meaning is made through semiotic resources. These resources can be conceptualized as 'actions and artefacts we use to communicate' (van Leeuwen, 2005, p. 3), so semiotic resources are both the physical materials we use in meaning-making as well as the transient activity through which meaning is made. Digital art-making represents a different set of semiotic resources to those available when children make pictures on paper. In order to explore a set of resources further, it is necessary to look at both the 'theoretical semiotic potential' and the 'actual semiotic potential' (van Leeuwen, 2005, p. 4) that these resources possess. For the former, the interest lies in what is possible to be done with the resource given its material properties, whereas the actual semiotic potential refers to how this is realized in naturalistic contexts. Thus, there may be properties of the art-making software or hardware that facilitate particular types of art-making but these are not necessarily made use of. In the terms of Bjorkvall and Engblom (2010), an analysis of the theoretical semiotic potential of a medium needs to be accompanied by investigations that identify the semiotic potential that is realized, or 'semiotized', by everyday users in context.

An analysis of the semiotic potential of a set of semiotic resources can be supported by consulting inventories of these resources. Such inventories catalogue the way a particular resource 'has been, is, and can be used for purposes of communication' (van Leeuwen, 2005, p. 5). A systematic inventory is unavailable for digital art-making, but previous studies that have focused on micro-interactions of digital art-making offer a starting point for developing such an inventory. For example, Labbo's (1996) innovative research on children's digital text-making suggests that an important part of screen-based technologies' semiotic potential lies in the opportunity for children to easily erase material that they place on the screen. This facilitates certain kinds of art-making and inhibits others. The social context of my research, however, is different to that of Labbo's, so I must remain open to the possibility that her findings, while indicative of theoretical semiotic potential, may not map onto the practices that I observe. Whether they do or not, social semiotic theory suggests that there will be contextual reasons

for the way patterns of use develop. So we can trace the influence of a technology on meaning-making through the material properties of the resources on offer as well as the way these are socially constructed in a given context.

Cultures interact with different semiotic resources differently. A culture can put more or less work into a particular set of semiotic resources. The more work that goes into a resource, the 'more fully and finely articulated it will have become' (Jewitt & Kress, 2003, p. 2). Thus, Western cultures have put a vast amount of work into the semiotic resources associated with language and writing, and as a result these semiotic systems have been conventionalized and analysed to a great degree. On the other hand, semiotic resources that are new to a culture will be less articulated in their use. As a set of resources becomes increasingly familiar and increasingly the subject of cultural investment, the patterns and expectations of use that surround it will narrow. Digital art-making represents a relatively new set of semiotic resources, while children's drawing on paper is a more established practice. Examples of the latter are therefore more likely to relate to a 'fully and finely articulated' pattern of use while digital art-making may show more fluidity and diversity and may be harder to contain within the confines of preconceived ideas about early childhood art.

Affordances

Semiotic resources are distinguishable from one another on the basis that they have distinct affordances. Affordances are understood as suggestions of semiotic use. They may be material affordances residing in the medium – what it is physically possible to do with the medium – or social affordances that surround the use of these resources. For example, a set of coloured pencils and a blank piece of paper afford the creation of marks. Through social conventions that surround these resources, they also afford the act of drawing as opposed to writing, since the latter is not typically done with coloured pencils or on blank paper. It is physically possible to write using these resources but social conventions suggest that the appropriate use is drawing. We can also conceptualize these social conventions as the discourse that surrounds a set of semiotic resources: the conglomeration of talk, interaction and action that has surrounded the resources in the past.

Some theorists, particularly Oliver (2005), have criticized the use of affordances in conceptualizing semiotic practices involving new technologies. Oliver suggests that the term, since its first use by Gibson in the 1970s, has been used to refer to an array of ideas, and through its reworkings lost its

usefulness for researchers in the field of learning and technology. He argues that the term has been applied to physical properties of the environment or object; to a user's perceived clues for use; to cultural or learned practices; or to all three. This leads us to question whether affordances can be specifically designed or whether 'all we can work with is socialisation and learning' (p. 406). If the latter is true, why talk about affordances at all? Why not instead rely on theoretical frameworks that embrace social and cultural practices, such as discourse analysis or activity theory? Oliver's argument is thought-provoking and raises some difficult issues in pursuing research that rests on the concept of affordances. However, by limiting ourselves to 'socialisation and learning', we are forcing ourselves to focus only on social associations and to ignore the materiality of the semiotic resources on offer. In the work of Bjorkvall and Engblom (2010), both material and social components are crucial in understanding children's meaning-making on the computer. They argue that the former are 'semiotized' through patterns of use, but they continue to guide how the resources are used. In line with this approach, I argue that the duality of affordances, existing materially and socially, makes them a useful starting point from which to explore how digital technologies can shape early childhood art differently.

Embodied interaction

At their most basic, material affordances refer to what is physically possible and impossible to do within a particular medium. For example, in the context of making art on the screen using a digital application, it may be possible to include ready-made images, rotate them and change their size. On the other hand, it may not be possible to add photographs that you have taken yourself or to change the colour saturation of these images. Research into digital creative practices has so far drawn attention to certain material affordances that are typical of digital environments. These not only include ready-made images but also the ease with which digital material can be covered over and changed, as well as the perceived hindrance of mouse manipulation, which is the typical input device when a desktop or laptop computer is being used. In relation to children, the mouse has garnered diverse commentary. While some have questioned its suitability for use by young children, and have promoted instead the 'intuitive' nature of tangible interfaces, where direct touch is the main form of control (Couse & Chen, 2010; Wyeth & Purchase, 2002), other researchers have suggested that

even young children are adept at using the mouse and demonstrate a high level of control (Donker & Reitsma, 2007).

In reality however, the material possibilities of digital art-making that have been identified may be more or less important when the practice is actually occurring in context as already explained. While some possibilities may be realized, others may not be 'semiotized' (Bjorkvall & Engblom, 2010) or used as the basis for meaning-making. Context in human-computer interaction has been brought to the foreground in Dourish's (2001) theory of embodied interaction. Embodied interaction is a framework within which the physical and social context of an interaction between humans and an artefact is of primary importance. By contextualizing people's interactions with digital technologies, it becomes possible to determine why some material affordances are essential in meaning-making processes and others are less influential. Thus, it is not enough to look at a technology in isolation and identify what is possible and not possible to do with it. Instead, researchers need to see the medium in action and remain open to the social and physical experiences that comprise embodied interaction with it.

Williams et al. (2005), for example, used an embodied interaction approach to look at the way tangible technologies that could be manipulated in a museum in order to produce auditory effects were not used by visitors independently. Although visitors walked around the museum most often by themselves and picked up these objects far away from each other, their movements and patterns of activity revealed the extent to which they were in constant collaboration with one another. Their interactions with the tangible auditory interfaces could be 'read' as responses to others' interactions. Similarly, in digital art-making, what children will do depends on what they have seen their peers do and other crucial elements of the social context. The physical aspect of the experience is also of vital importance. Small details in the embodied, sensory nature of the interaction will change how the interaction unfolds and what affordances come to the foreground. For example, Bianchi-Berthouze et al. (2007) have shown how whole-body interfaces stimulate a more engaged and affective response from game-players. Thus, if children have the physical freedom to use their whole body rather than just their hands, the experience of digital art-making will be different. This makes the details of the physical set-up of the environment in which digital art-making occurs particularly important.

Some designers have responded to the complexity of context by arguing that material objects need to signal their affordances in a clearer way. Donald Norman, in his classic text *The Design of Everyday Things* (1988), argues that good design

rests on the explicit nature of an object's functionality. A user will look for cues as to how they should interact with an artefact. These cues might take a social form (e.g. the user will imitate others' uses) but they might also be material. In the context of digital art-making, a child might use the pictorial symbols available in the software to make sense of the different possibilities available to them. They will be aware of visual effects that occur when they click on these icons and what this tells them about the tool associated with this icon. They might understand quickly, even without prior exposure, that the mouse is a control device that rests underneath the hand because of its shape. On the other hand, the mouse's two buttons might be a misleading cue, because while the right button is not used for control in software like Tux Paint, it has equal physical presence to the left mouse button and this might be taken as an indication that its use should be equally frequent.

In embodied interaction, affordances are not static. Another component of context that is vital in an individual's interaction with a technology is their prior experience with the technology. The affective, physical and social relationship that a user has with a technology will change over time. A shift that is often noted in the use of artefacts is the shift from conscious to unconscious use. In *Being and Time* (1962/1927), Heidegger described this as a shift from tools being 'present-at-hand' to 'ready-to-hand', and used the example of the pen that he was writing with to illustrate this change. When first using a pen as a child, it is present-at-hand since we are aware of the boundaries that exist between ourselves and the physical object. Over time however, the pen will become ready-to-hand as we become more involved in other aspects of the activity and use the pen unconsciously. If however, the pen were to break or the ink were to run out, our attention would once again be drawn to the boundaries between the pen and ourselves. Thus, technologies can move between being present-at-hand and ready-to-hand depending on contextual factors. In the case of digital art-making, how children interact with the materialities of this practice will depend on the affective, physical and social relationship they have with the tools involved. Have they used the mouse previously? Is their attention repeatedly drawn back to the interface, or do they become so engrossed in use that they forget the manner in which the interface is mediating the input-output of the interaction?

Becomings, rhizomes, lines of flight and smooth space

Even with an emphasis on the social and material dimensions of meaning-making, as offered by social semiotic theory, multimodality and perspectives that focus on

embodied interaction, these theories rest on an underlying belief that meaning-making is a linear process in which ideas, thoughts and feelings arise internally in individuals and are then manifested in the world around us. Posthuman perspectives on early childhood on the other hand, deeply inspired by an engagement with the work of Deleuze and Guattari, position children's meaning-making as something which is constantly unfolding and in a constant state of becoming. As I have engaged with children's art-making in different sociotechnical environments and tried to unpick the logic behind how they occur, these perspectives have seemed increasingly relevant and helpful. When observing children's art-making it often seems that the processes involved are not 'readable' in any of the conventional ways suggested by semiotics, social semiotics, developmental psychology or sociocultural approaches, and that rather than trying to ask questions about what ideas underpin the creations of matter that comprise art-making, it is children's investigations and experiments with matter itself that are of interest. In this view, ideas, thoughts and feelings are at work in the matter and its manipulation, rather than being something which precedes or predetermines how matter is acted upon and transformed through art-making. I take forward some of the aspects of this perspective in this book through particular concepts introduced initially by Deleuze and Guattari and since developed by a range of theorists within posthumanism and new materialisms. In particular, I use the concepts of the rhizome, lines of flight and smooth space to make sense of children's art-making and the role of digital technologies within this.

Deleuze and Guattari (1987) present the rhizome as a metaphorical structure that can help to make sense of our experiences in an alternative way. The rhizome is a biological structure made up of endless offshoots from a central structure that has no beginning, no end and is 'ceaselessly establishing connections' (Sellers, 2013, p. xv). In the context of art-making, this moves us away from a presumption that art-making begins with an end in mind or that art-making processes are somehow moving towards a particular endpoint. Instead, the process of art-making is conceptualized as taking flight 'into unforeseen directions, shattering any emerging direction or order' (MacRae, 2011, p. 103). In MacRae's studies of junk modelling, she suggests that each part of the process is one 'line of flight' after another, so that the relations between parts of the process only exist in relation to the immediately preceding and subsequent other parts, rather than linking to a beginning and an end. Through lines of flight, Deleuze and Guattari suggest that we can enter a 'smooth space' free of the rules and hierarchies that characterize much of our everyday lives. Smooth space is an alternative way of being, resonant with the Foucauldian notion of 'heterotopia', which

refers to places in which typical social structures are suspended. For Foucault this might be a ship or a graveyard, but MacRae suggests that art-making could also create this sort of space and experience. When we see art-making in this way, we become deeply aware of the potentials of art-making to offer opportunities for a deep level of playfulness. These approaches highlight the need to see children's digital art-making as experimental and emergent.

My methodological approach

Earlier in the introduction, I discussed the popularity of media stories that present concerns around children's engagement with digital technologies and make generalizations about the effects and influences of digital technologies on children's lives and capacities. I argue that in order to deepen our understanding of digital childhoods, we should not position childhood as something which is separate from the increasing prevalence of digital technologies in our lives. Instead, we must recognize that childhood operates in a particular sociotechnical environment as at any point in history, and that it cannot be understood as existing outside of this environment. From this perspective, it is not meaningful to ask the question 'What is the effect of digital technologies on young children's art-making?' Instead we need to ask simply 'What is happening here?' with regards to situations of children's digital art-making. As such, my methodological approach rests on a desire to interpret how interactions unfold through a network of components that are inextricably intertwined. This network includes bodies, matter, technologies, social interactions, emotions, ideas and more. While we might separate out these components for analytical purposes, my approach rests on a foundational belief that these components cannot, in reality, be distinguished from one another. My interest in how activity within networks occurs has influenced my methods of data collection, which are predominantly located in the observation of interactions as they take place in naturalistic settings.

In thinking about interactions as networks of various components, actor network theory and ecological approaches to human-computer interaction are helpful in drawing our attention to the potentially agentive nature of digital technologies and environments. My interest in bodies and matter, enriched through an engagement with posthumanist and new materialist approaches, influences my analytical approach to the observation data I collect. Analysis tends to focus on the 'becoming-here' and the 'becoming-now' through the

interactions of bodies, space and matter. A multimodal lens is helpful in making sense of what bodies, objects and environments are doing in relation to one another, as are the concepts of semiotic resources and affordances as outlined above. In particular, I have been influenced by the multimodal interaction analyses adopted by Mavers (2007) and Flewitt (2011), and previous studies I have conducted with Sara Price and Carey Jewitt, in which the focus is on the 'semiotic work' of the body in learning environments (Sakr et al., 2014; Sakr et al., in press). Multimodal interaction analysis typically takes a focus on particular moments, making sense of how networks exist through how action plays out in particular moments.

The ideas in this book relate to various studies I have conducted, though all of these involved small-scale observation. I carried out observations in a range of settings looking at different types of digital art-making. Two of the studies were based in a classroom of 4–5-year olds, looking at free-flow play interactions between children clustered around the laptop or the interactive whiteboard (IWB). One of the studies involved close observations of individual 4–5-year-old children engaged in digital art-making on the laptop. Two other studies involved informal observations conducted in the home, one focusing on the interactions between a parent and a 4-year-old child around digital photography, and the other looking at a 2-year-old's interactions with colouring apps on the iPad in the context of an extended family. I have recorded my observations in different ways. Predominantly I use handheld video to capture interactions in naturalistic settings, though the studies presented in this book have also involved the use of audio recording, cameras attached to tripod and the handling of action cameras by children who then capture data as a result of these physical interactions with the camera.

My analysis of the different observations is always informed by multimodal interaction analysis, which aims to focus on a wider range of modes than just language, taking into account body position, gesture, eye contact and other embodied modes of interaction and communication. Depending on the questions of each chapter, the multimodal interaction analysis has been coupled with theoretical frameworks that feed into the analysis. For example, when focusing on affect in the parent-child experience of digital photography in the home, I have drawn on the rhizomatic analysis described by Deleuze and Guattari and later researchers, adopting a poststructuralist perspective on child and adult interactions. On the other hand, when considering children's art-making on the IWB in a classroom context, I have drawn on the work of cultural psychologists on the concept of collaborative creativity. In this way, various theoretical frames of

references play into the analysis and the conclusions that emerge in the chapters in this book.

Overview of the book

Although my predominant method of data collection is naturalistic observations (as outlined above), I start by reporting on interviews with early year teachers that focused on their thoughts and concerns about digital art-making. The idea of this chapter is to ground the following discussions in some of the bottom-up theories that are developing among practitioners in the early years about digital art-making and its potential role in early childhood education. The teachers interviewed for this chapter raise various issues relating to digital visual culture; communality and collaboration; affect and closeness; touch and sensory stimulation; ownership and authorship; and intentionality. Each of these issues is then addressed in the following chapters (Chapters 3–8), which draw directly on observation data of children engaged in digital art-making. Chapter 3 focuses on children's engagement with digital visual culture and ready-made imagery in the context of digital art-making with popular applications. Chapter 4 looks at collaborative creativity and how children can come together in their digital art-making, and in particular how digital devices intended for social use (such as the IWB) do or do not support social interactions in digital art-making. In Chapter 5, I will look at issues of closeness, drawing on a theoretical understanding of affective alignments and moments of meeting and a consideration of how these arise and manifest in the context of child-parent iPad photography. Chapter 6 focuses on touch and the sensory stimulation that occurs when young children engage in digital art-making, particularly through the interface offered by the iPad and other tablet devices. In Chapter 7, I will look at children's expressions of ownership and authorship during digital art-making and consider how these might be different than those that arise during episodes of art-making which involve alternative resources. Chapter 8 considers how children's intentions develop and are displayed during digital art-making and how we can examine meaning in contexts of digital art-making when our preconceptions about intentionality no longer seem to apply. In the concluding chapter, these various issues and topics are brought together to consider how play and playfulness can be encouraged and facilitated in children's digital art-making. Thus, Chapter 9 explores, from a practitioner's or parent's perspective, what we can

know about digital technologies in early childhood art and what adults can do to support children's engagement with digital art-making and their interactions with digital technologies more generally.

While this book focuses on digital technologies and aims to unpick the role that different digital technologies play in early childhood art-making, a secondary aim is to offer insights into early childhood art more generally. In my observations and investigations of young children's digital art-making, I have become increasingly aware of the gaps and problems in how we make sense of early childhood art. As McClure (2011) suggests, our approaches to early childhood art in practice are typically contradictory, being both overly prescriptive and under-theorized. The chapters outlined above open up questions which extend beyond the role of digital technologies and prompt us to engage with philosophical conundrums that surround our conceptions and perceptions of art-making in the early years. I will return many times to the question of how we understand the relationship between ideas and matter in the context of early childhood art, and I will address this again in the concluding chapter, where I hope to suggest an alternative approach to early childhood art, which is both responsive to the contemporary sociotechnical environment and better suited to enabling playfulness.

Early Years Practitioners' Concerns about Digital Art-Making

Introduction

The purpose of this chapter is to focus on the impressions, thoughts and concerns of early years (EY) practitioners about digital technologies in early childhood art. The findings reported in this chapter, stemming from interviews with practitioners, will be a foundation for the later chapters in which the issues raised by the practitioners will be explored further through observations of children making art using digital technologies. These issues include ready-made imagery; sensory stimulation; intentionality and meaning-making trajectories; ownership and expressiveness, social interaction and closeness. As well as setting up the investigations and discussions that will be had throughout the book, this chapter places discussions of digital technologies in early childhood art in an educational social context. In particular, it raises questions that stem from adopting a 'classroom-ness' lens (Burnett, 2014), in which practitioners' concerns are brought to the fore and examined in relation to the everyday practices that children engage in.

Why is the adults' voice so important? In particular, why does this initial chapter focus on the practitioner's perspective rather than what children are doing? I am using the thoughts of EY practitioners as a starting point for my explorations for two reasons. First, these thoughts offer a grounded introduction to the issues and themes that are interesting to explore when looking at digital technologies in early childhood art. These themes relate directly to the concerns and questions of significant actors in the lives of young children. Second, the subtitle of the book, 'enabling playful experiences' relates to a desire for the book to offer helpful insights to those who adopt a facilitatory role in children's learning and play experiences. With this in mind, by starting with questions that such facilitators are asking, the book can develop in dialogue with these questions

and by doing so can achieve its aim of offering some initial guidance as to how we can enable playful experiences when children involve digital technologies in their art-making activities.

The following background sections offer an overview of (1) art-making in the context of early childhood education; (2) perceptions of digital technologies in the EY teaching community and (3) the features of digital technologies that have previously been identified by adults as having implications for young children's art-making and may therefore correspond to concerns and issues raised among the EY practitioners. Following an outline of the study design, the findings are reported according to five themes, each of which constitutes an area of concern expressed by practitioners. In the discussion, I consider how these concerns might be addressed through changes to the classroom practices that surround digital technologies, and also how they encourage us to productively challenge our thinking and underlying assumptions about art-making in early childhood. In the conclusion, I highlight the way in which the threads raised in this chapter will be picked up throughout the remainder of the book.

Art-making in the context of early childhood education

In England, early childhood education, including in the expressive arts, is shaped by the early years foundation stage (EYFS). The current framework, published in March 2012 and updated in January 2015, suggests that support in early childhood should be organized around three principal areas of child development: communication and language; physical development; and personal, social and emotional development. Given the wide range of purposes that art-making has, it can be seen as relating to all three of these general areas, though it is not explicitly mentioned in relation to them. It is explicitly addressed in one of the framework's specific areas of development: expressive arts and design, which has the purpose of 'enabling children to explore and play with a wide range of media and materials' (EYFS, 2014, p. 5). Examining these guidelines is important for understanding the role of art-making in EY education in the UK because documents such as the EYFS guidelines have been found to significantly influence how practitioners and other adults in the EY classroom understand and support children in their activities (Roberts-Holmes, 2012; Stephen, 2010; Stephen et al., 2008).

Approaches that adults take towards children's art-making can be positioned on a spectrum with two opposing poles as suggested by Gardner (1980): the 'unfolding' perspective and the 'training' perspective. The former is characterized

by a non-interventionist approach to children's art-making, which is conceptualized as a primarily self-expressive pursuit. The latter is characterized by the notion that art-making involves skills that should be developed through guidance and practice. Although Gardner positions these views as oppositional, elements from both approaches can be seen in guidelines relating to EY education. For example, EY practitioners often relate art-making to spontaneous emotional expression and the formation of social relationships (McLennan, 2010). Simultaneously however, as mentioned briefly in the Introduction, art-making is sometimes seen by practitioners as a way for children to become more adept in the fine motor manipulation of tools, including inscription instruments that will be key in the development of emergent writing skills (Anning, 1999; Wu, 2009). Thus, art-making is positioned in the EY as both a practice that unfolds instinctively, supporting emotional and social development, and one that benefits from training in order to become a strong foundation for other skills, particularly emergent writing.

Perceptions of digital technologies in the EY teaching community

Previous research suggests a high degree of uncertainty among practitioners in EY settings about how digital technologies should be integrated into the everyday experiences of young children. Findings made in nurseries and preschool settings have focused on practitioners' lack of confidence in facilitating the use of digital technologies among young children (Chen & Chang, 2006; Plowman & Stephen, 2005). Thus, formal educational settings tend to be low on technology use in comparison to experiences in informal settings. It has been suggested that this could lead to a tension between the identities children construct at school and at home (McTavish, 2009).

Few research projects have looked at how digital technologies are drawn into young children's art-making in EY education. Within this landscape of research, there have been some important exceptions. For example, Schiller and Tillett (2004) conducted an action research project with 7-year-olds, in which the children took digital photographs with each other and with adults to express and communicate thoughts about their school. The researchers found that the unfamiliarity of the medium positioned both the children and the practitioners as students in this activity. This produced new opportunities for exploratory learning. The study highlighted the extent to which technologies could be powerful

tools for learning not simply through their physical properties, but also in their capacity to reconfigure social relations and modify the practices of those in the learning environment. Other notable studies include the research of Bjorkvall and Engblom (2010), which focused on how children engaged with the images that are available through searchable internet databases, and how through their collection and management of these digital resources, the children represented aspects of their identity and forged meaningful social relationships around interests and passions. Focusing on wearable rather than on screen-based technologies, Buccholz et al. (2014) have looked at children's interactions in design tasks, exploring how children's practices with the technologies are gendered and how this manifests. These research investigations represent important contributions in understanding how digital technologies are taken up in classrooms for playful and creative pursuits.

Affordances of digital technologies that have implications for art-making

As explained in the Introduction, from a social semiotic perspective, digital technologies constitute a distinct set of semiotic resources (Jewitt & Kress, 2003; van Leeuwen, 2005) through which to make meaning. Different semiotic resources have distinct affordances, that is, they afford certain types of interaction and engagement. From this perspective, particular digital technologies have affordances, which arise both through the physical properties of the technologies and the social associations that individuals have with the technologies (Kress, 2010). Affordances are constructed both through material and immaterial factors, conceptualized by Burnett et al. (2014) as a web of physical and digital facets of the unfolding experience. When we consider the activity of art-making, the affordances of the technologies being used shape the art-making processes and products that emerge. Previous research and popular reporting on the role of digital technologies in the lives of young children has drawn attention to the influence of three such affordances that are important when considering children's digital art-making. These are (1) the presence of ready-made digital material and its incorporation into creative digital texts; (2) the nature of touch with a digital screen interface and (3) how digital technologies tend to be used and shared by groups. The emphasis on these affordances in previous research and popular media is likely to influence and be influenced by practitioners' questions and concerns around digital technologies in the

everyday lives of young children. These affordances are considered in more detail in the following sections.

Digital art-making often offers the potential to include ready-made digital material, including images and sounds. The abundance of ready-made material has been observed to lead to practices of 'remix' (Lankshear & Knobel, 2006) or 'mash-up' (Lamb, 2007) in art-making, whereby representations are not made from scratch, but are instead combined, manipulated and edited to create a new effect through the use of existing material. Depending on a practitioner's perspective on art-making, this may be seen as more or less supportive for children's creativity and imagination. Some perspectives on art-making emphasize the necessity of open-ended activities, suggesting that no prescribed templates or ready-made stimuli should be available to the child (McLennan, 2010). On the other hand, some suggest that creativity always constitutes the remaking of existing templates and schemata, and that the selection and remix of existing visual material is therefore a vital part of the art-making experience whether or not it occurs digitally (Dyson, 2010; Thompson, 2003; Wilson & Wilson, 1977).

Recent studies suggest that children use touch differently when they are engaging with a digital interface for creative purposes, as compared to a non-digital interface. Crescenzi et al. (2014) compared the quality of children's touch when it was applied to an iPad during a finger painting activity, and when children were finger painting on paper. The researchers found that children engaged in more touch and with a greater range of touch types in relation to the iPad. On the other hand, it must be recognized that when physically engaging with a screen or touchpad, children are interacting with a single surface type, while non-digital art-making is likely to involve a breadth of sensory experience. Kress (2005) argues that this is a 'loss' involved in the use of digital interfaces, and given the emphasis placed on sensory and somatic experience in early learning, it may also be conceptualized as an important loss according to practitioners in early childhood who are likely to value messy play and physical stimulation in the context of early childhood art.

Another aspect of digital art-making that has been brought to the fore through previous research and echoed to a notable extent in the popular press is the nature of the social experience that surrounds the interaction. Concerns have been raised that children's interactions with digital technologies and particularly social media are inhibitory for their social capacities more generally (Turkle, 2011, 2015). On the other hand, most studies that have focused on a day-to-day level, considering particular interactions that unfold involving children and digital technologies, have suggested a reordering rather than a breakdown in

the social dimensions of creative processes. For example, a modest but interesting body of studies suggest that, as a result of adults' relative inexperience with some digital media, using digital technologies for creative purposes can lead to a dynamic of greater equality and mutual contribution between adults and children than is the case for activities that do not involve digital tools. Chen and Chang (2006), similar to Schiller and Tillett (2004), observed practitioners and young children compiling photographic journeys together and commented on the presence of a distinct social dynamic, with the adults often asking for the children's help. In previous work, I have argued that since digital art-making applications are not so common in EY settings, there is an increased need for children to negotiate among themselves how such applications should be used; thus, digital technologies in the classroom are often accompanied by intensive peer dialogue about what to do with the technologies (Sakr et al., 2016). Similar findings have been made by Burnett and Myers (2006) and Bjorkvall and Engblom (2010) in relation to the discussions that children have about how to use and incorporate the ready-made material they encounter in a digital creative environment. Finally, digital story-making applications have been observed to heighten levels of closeness between children and adults engaged in using these applications collaboratively as a result of the prioritization of personalized content, which, through digital photography, can be collected and immediately reflected on together (Kucirkova et al., 2013).

Interviews with practitioners

Through interviews, I aimed to develop insights into the concerns that EY practitioners have with regards to children participating in art-making through digital applications and tools. In examining the complexities of these concerns, I was aware of the specific sociocultural and historical influences that shaped each participating practitioner's perspectives, and the process of inquiry was therefore conducted from an interpretivist, qualitative perspective, with a general aim of using the expressed concerns as a way to open and enrich dialogues, rather than as a means for developing generalizations about what all EY practitioners think. Interview responses were analysed thematically, drawing on a theoretical understanding of children's art-making and how adults relate to and support it, as explored in the background sections. The study addressed the following research questions: What specific concerns do practitioners raise about the integration of digital technologies into children's art-making? How do these concerns relate to

practitioners' conceptualizations of young children's art-making in general and their perceptions of digital technologies in more widely?

Three state schools in the UK were recruited to participate in the study because they were eager to participate, were locally situated in relation to the university where I was based at the time and represented a range of pedagogical approaches. All of the schools implement the EYFS framework through a combination of structured input ('carpet time') and free-flow activity time. However, the different schools emphasize these aspects to different extents. School A and School B are both foundation-stage schools that seek to minimize structured input and maximize child-led activities. School C is a primary school with a reception class that takes a more structured approach to early learning, dedicating more time to whole-class teaching. My focus in each school was on the reception class (4–5-year-olds) and practitioners responsible for supporting learning and teaching in this class. Each of these classes, made up of thirty to forty-five children, had access to either one or two desktop computers and an interactive whiteboard (IWB) with a touch screen. The children accessed digital art-making on these devices in activity free-flow time via basic software packages that enabled them to 'paint' on screen, or apply ready-made images. The practitioners' own descriptions suggested that digital art-making was a relatively infrequent activity in the classroom and that few pedagogical and material resources were specifically targeted towards it.

Within each school, I conducted interviews with two members of the EY teaching team (see table 2.1). In School A and School B, the head teachers and the reception class practitioners were interviewed, and in School C, the two reception class practitioners were interviewed. These participants were in a position to comment extensively on children's art-making experiences and the potential role of digital resources in this activity. The participants in this study represented 'information-rich cases' (Patton, 2002, p. 230) in that all those involved were practitioners who had been present in the school while previous studies on digital art-making had been conducted. This meant that they had previous opportunities to develop insights and reflections on young children's digital art-making, as well as to establish rapport and trust as part of a 'longer conversation' (Lillis, 2008) with the research focus.

Semi-structured interviews lasting 20–30 minutes were conducted with each interviewee. In Schools 1 and 2, a one-to-one interview format was used, while in School 3, a group interview was conducted with both participants at their request. Each of these interview formats presented constraints and opportunities. One-to-one interviews offered participants a relatively private space in which to share

Table 2.1 Schools and interviewees

School	Interviewees
A – a foundation-stage school	A.1 – head teacher A.2 – reception class teacher
B – a foundation-stage school	B.1 – head teacher B.2 – reception class teacher
C – a primary school	C.1 – lead reception class teacher C.2 – reception class teacher

their reflections and thoughts, but also gave them less to respond to or challenge. In the group interview, the participants were likely to be more aware of how their responses reflected on them as professionals, but this set-up also stimulated a more lively discussion about young children's digital art-making and brought the tensions that exist in relation to this matter clearly into focus.

Questions in the interview centred on practitioners' conceptions of digital art-making in early childhood, including 'how would you expect young children's digital art-making to be different to their paper art-making?' and 'what role do you think digital art-making has in the EY classroom?' To stimulate the development of the practitioners' reflections, they were shown examples of young children's digital art-making that had been created in a previous but related research study, which had taken place in these schools. These examples were shared and questions were asked about the relationship between these and the points that the practitioner had been making previously in the interview. For instance, the practitioner was asked: 'Are these examples of digital art-making different to paper art-making in the way you had imagined?'; 'Do any of these examples particularly support the points you have made about digital art-making?'; 'Do any of these examples change or challenge the way you think about digital art-making?' These visual references enabled the interviewees to make points more forcefully, to develop their ideas further and to reflect, with criticality, on the points they had previously made. As with visual elicitation more generally, it also helped to make the interviewees feel comfortable and to articulate their experiences more fully (Hurworth, 2012). These visual examples were not themselves part of the analysis involved in the research presented here – only the interview transcripts were treated as data to be analysed.

The first step in analysis was the transcription of interviews. Following transcription, I became familiar with the data through repeated reading of the transcripts. Examples of talk that related to questions about digital art-making were

identified and noted. Through the identification and categorization of keywords and phrases, initial codes were developed. Through an iterative process, moving between the emerging themes, the theoretical background and the transcripts, these codes were grouped into broader categories of concern according to the processes outlined by Braun and Clarke (2006) and King and Horrocks (2010). Although quotations from individual practitioners are used to illustrate and explain each of these broad categories of concern, conceptions expressed by individuals were taken as ideas and thoughts that exist within the EY teaching community more generally. It is therefore not the purpose of the analysis to offer profiles of each of the individuals that was interviewed, but instead to present key concerns that arise in the context of EY practitioners' conceptions of digital technologies in early childhood art.

Concerns raised by the practitioners in relation to digital art-making

This analysis led to the identification of five areas of query or concern, each of which related to the belief that digital art-making would reduce children's opportunities to engage in important facets of experience. These are presented below and elucidated through particular comments of the practitioners. After giving a sense of these concerns through quotations and the discussion of these quotations, I reflect on what the practitioners' contributions can tell us about the classroom practices that surround digital technologies in the EY classroom. Looking at digital art-making through a critical 'classroom-ness' lens (Burnett, 2014) is important if we are to engage with the perspective of the facilitator and consider what can be done to foster playfulness and creativity in the context of young children's digital art-making. I finish the chapter by discussing how the questions raised by the practitioners are the basis for the subsequent chapters in this book, which, through this sense of ongoing dialogue, help to foster tentative guidance around facilitating playful and creative engagements with digital art-making and digital playfulness more generally.

Reduced opportunities for sensory experience

There was a concern among the practitioners that digital environments could only offer abstracted experiences to children and not the levels of sensory

stimulation that children would be most used to and would most benefit from art-making activities. They were concerned that the medium was, as A.1 described, 'slightly removed'.

> This offers some things ... but I would always weight towards the concrete. I think this kind of removes it slightly ... and it makes it clean and dry and tidy. And you know that's not really early years-ish ... we like mess. (A.1)

A.1's comment demonstrates a tension between practitioners' conceptions of early childhood activity and perceptions of the digital resources that would be used for digital art-making. Digital technologies like desktop computers and IWBs are seen as neat, sharp and rigid environments, while early childhood art is more likely to be associated with messy, fluid and horizontal spaces, which allow for activities to move beyond typical physical boundaries such as desk edges.

All of the practitioners interviewed remarked on the difference between digital and non-digital art-making in terms of how cause and effect is enacted and experienced in each context. When a child moves a paintbrush loaded with paint over paper, a co-located mark is immediately left behind. In contrast, digital art-making is often enacted through an instrument, like a computer mouse, or even when activated through touch, as with the iPad or IWB, the mark that appears on the screen is 'locked away' from further impression though it might be erased or covered over. In addition, in digital art-making, the type of mark left behind is determined by a choice between functions that are positioned on the side of the screen as opposed to through immediate physical choices, such as pressing harder with the paintbrush:

> It feels to me like it's a less immediate medium for the children than having to mark-make with their hands ... it's like another stage between just using a pencil or a paintbrush on paper ... I think it's one more causal step up. (B.1)

The complexity of this pattern of cause and effect – the sensory distance between the causes and effects of digital art-making – was constructed as a barrier in achieving rich sensory experiences in young children's art-making.

Reduced opportunities for componential representation

There was a concern among practitioners that ready-made visual material available in digital art-making environments would constrain children's opportunities to understand componential representation, that is, how whole representations are made up of particular parts. Practitioners suggested that drawing on paper

on the other hand would encourage children to think about the essential features of an object they wished to represent:

> If you think about when they draw a car, they kind of go 'well I don't know how to draw a car' and you go 'there's the circles for the wheels'. (C.2)
>
> You know, it's the kind of level of what makes it a car ... the discussion that might only really happen around drawing it. (A.1)

Both these comments suggest that the semiotic choices involved in early visual meaning-making are an important part of understanding the world in terms of essential features (Kress, 1997). The practitioners voiced a concern that the immediacy of representations created through digital art-making was not conducive to this thought process, since images did not need to be constructed through essential features and could instead be applied as ready-made elements, as in the use of 'stamps' within Tux Paint (Figure 2.1).

> I suppose they don't have to think about it as much. They think 'that's a car', rather than 'it's made out of circles'. (C.1)

Reduced opportunities for expressiveness

The practitioners expressed a concern that digital art-making resources, particularly software packages like Tux Paint (as shown in use in Figures 2.1, 2.2 and 2.3), are too prescriptive to enable free expression among children:

> I think there is an element of limitation to it because it's predetermining how things look. (A.1)

A particular area of concern in School B was the availability of ready-made images, which they felt had the power to inhibit children's own creative output. This philosophy was explained in detail by the head practitioner B.1:

> We actually don't like using ready-made images in that kind of way ... so I'd never use anything like this that had the stamp. I think there's a temptation when there are ready-made images or stamps like this, then the child is put off attempting their own representation because they feel they have to try and make an adult representation. (B.1)

In this perspective, freehand drawing is conceptualized as truly expressive while the use of ready-made images, which often feature in digital art-making software in some capacity, is not. Such ready-made images are constructed as adult-created impositions on child art, which are likely to make children feel that their

Figure 2.1 'Wizzy woo patterns'.

Figure 2.2 'That child clearly had a purpose'.

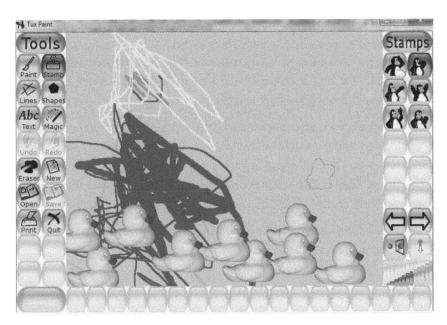

Figure 2.3 At the duck pond.

own representations of the world around them are inadequate. In addition, practitioners suggested that the speed with which visual material accumulates in the context of digital art-making might prevent children's expressive intentions from being realized. Aspects of the child's internal world would be replaced with the vast visual offerings of the external digital art-making environment. These concerns relate to a notion of expression and expressiveness in which priority is given to internal and personal ideas, which are at threat from external, adult-led stimuli (as discussed in Dyson, 2010; Malin, 2013; Thompson, 2003).

Reduced opportunities for intentionality

Practitioners expressed an opinion that art-making environments for young children were ideally those in which they felt most in control of the resources they were using. They linked intentionality in representations to being familiar with the art-making resources, and in the case of digital art-making, they were concerned that sufficient familiarity would be unlikely:

> Part of it is the familiarity and fluency of the medium. So these children who don't seem to have much conscious intentionality within this medium

might be very consciously intentional in another field where they've had more practice or it's a more natural thing to them. (B.1)

Once they've kind of had that experience, they then can begin to think 'I want to do that' or 'I want to quit' or 'I want to do the magic wand because I really like that one and I want to do blue.' (A.1)

Without adequate experience of digital art-making in place, the practitioners predicted that children would be 'distracted by all of the functions and the tools' (B.2) and commit their efforts to exploring these rather than expressing particular meanings. This was echoed in the comments of A.1 in response to one of the digital artworks created by children attending her school (Figure 2.1):

They look to me like someone who's gone 'right, this is the first time I've done this and I'm making these lovely wizzy woo patterns with my mouse'. (A.1)

In responding to the artwork created through digital art-making, the practitioners tended to favour examples that demonstrated a clear link to the referential intentions of the maker as they were perceived by the practitioners. This intention was most obvious to the practitioners when there was a clearly discernible object in the artwork. For example, Mischa's use of the paintbrush tool to create a face (Figure 2.2) and the subsequent use of the stamp tool to place a hat on top of the face was the subject of positive comment from both the practitioners in the school where it was created. They suggested that the product demonstrated Mischa's ability to use digital tools in order to carry out her purpose rather than being led away from her intention as a result of the novelty of making art digitally.

The child clearly had a purpose, and that's very skilful, the mixing of the hat with the face … I think that's a mature way, that's mature use … getting towards more proper, grown-up use of the medium isn't it. (B.1)

Oh, that one's lovely. See, she's not doing that, she's actually thinking about what she's drawing there and using those for a purpose which shows that maybe she had some experience of things like that, maybe more than these others. (B.2)

The concern that digital art-making was likely to be less familiar and therefore less intentional led to practitioners' suggestions that the practice needed to pass through a stage of familiarization before becoming a valid medium in which meaningful content and children's intentions could be explored and represented. Some practitioners therefore limited their initial observations of a child's digital

art-making to understanding how familiar the child was with the medium: 'I'd be looking for the way they use the programme … how confident they are with it.' (B.2), rather than engaging with the representations that children created in this digital environment.

Reduced opportunities for social interaction

All the practitioners interviewed were able to describe examples of computer use that involved a high level of social behaviour among the children they observed. Despite this, there were still concerns among practitioners that children would interact less with their peers when engaged with digital art-making.

> They do get involved with other children when they're on the screen, but it tends to be less socially interactive, there is a point in which they are negotiating, laughing together, having fun together, sharing it together, and that's the really good side of it, but the downside of it, well, the worst extreme of that involvement, engagement in the screen is that switched off nature from the rest of the environment. (A.1)

The practitioners were aware that they themselves did not participate in much interaction around the computer. A.1 readily noted that the computer was probably a part of the classroom that practitioners dedicated the least time to. As a result, the practitioners explained that they were less aware of the social behaviours that occurred around the screen.

Another element of the concern regarding social interaction stemmed from practitioners' prediction that children's talk surrounding digital art-making would be related to experimenting with tools rather than representational content. When examples of other kinds of talk were shared with the practitioners, these were met with positive surprise. For example, when A.1 was told about a child's narrative about the duck pond, composed during an episode of digital art-making (Figure 2.3), her opinions of the practice became more positive:

> It's stimulated that idea and discussion and language. I mean, that's the ideal. You get something that gets and grips their imagination so that you can get that kind of language and discussion with a child and especially if a child is particularly motivated by a screen, they're going to get more out of it hopefully. (A.1)

Generally however, practitioners expected children to communicate more about the content of the art and intentions underlying it when they were engaged in non-digital art-making. They expected talk surrounding digital art-making to be more practical in nature whereby the children are simply 'talking about what they're doing' (C.1).

Reflecting on the place of digital technologies in the EY classroom

Practitioners' interview responses suggest specific concerns that they have about digital art-making. Towards the end of the chapter, I will link these areas of concern to the lines of thought that are developed in the subsequent chapters of the book. First however, I wish to engage with these concerns in relation to previous literature on digital art-making and take this opportunity to reflect critically on the classroom practices that surround digital technologies. In addition, I will raise questions and constructive challenges about some aspects of practitioners' thinking that relates to art-making in early childhood more generally. This relates to the book's wider aim to contribute towards a better theorized and more confident approach towards early childhood art, regardless of the resources and technologies that are being drawn into the processes. In particular, in this section I will make three arguments: (1) that digital interfaces which prioritize rich sensory experience and social interaction should be more available in EY learning environments; (2) that, just as importantly, the classroom practices which surround digital technologies need to foster the use of these technologies in rich sensory contexts (e.g. outside), and the use of these technologies amidst high levels of social interaction, including adult-child interaction and finally (3) that practitioners' thinking about young children's art-making places too much of an emphasis on the child's self-expression, at the expense of engaging with practices of remix and experimentation, which are brought to the fore in a digital context.

As noted earlier in the chapter, digital environments may lead to particular gains and losses in relation to sensory experience (Kress, 2005), and one likely loss is in relation to the diversity of textures that children feel and engage with (Crescenzi et al., 2014). Having said this, not all digital technologies are lacking in the diversity of felt textures or level of 'mess' that they can allow. Over the last ten years, interest among researchers in HCI has grown in non-screen digital interfaces, which might be particularly suitable in early learning contexts. These include soft toy interfaces (Abeele et al., 2012), vibrotactile feedback (Johnson

et al., 2013) and whole-body interaction (Price et al., 2015). Similarly, technologies that are specifically designed to foster collaborative use, such as multi-input tangible tabletops, have garnered recent interest in pedagogical contexts (Dillenbourg & Evans, 2011). Despite this, screen-based devices continue to be the norm in EY classrooms – most typically with the commonplace use of desktop computers, IWBS and tablets. This leads us to question the extent to which practitioners in the EY are exposed to a wide range of technologies and have input in bringing digital technologies into schools and nurseries that have the characteristics they think are best suited to the needs of young children.

It is not however, just a question of the technologies themselves and how these can be improved through design and selection. From a social semiotic perspective, the influence of material properties of technologies on interaction and communication is accompanied by the influence of social construction of technologies through everyday use (Vannini, 2007). For example, in this study, the practitioners tended to construct digital technologies as devices that would be used individually and would not facilitate high levels of collaboration. This conception is in tension with findings from previous research which has suggested that micro-interactions surrounding digital technologies can and often do involve high levels of negotiation and cooperation between children (Bjorkvall & Engblom, 2010; Sakr et al., 2016), not to mention the practitioners' own forthcoming examples of high levels of social interaction during episodes of digital art-making. If the use of digital technologies in particular ways is not materially determined, practitioners need space in which to reflect on how the technologies are being 'made' as social or solitary through everyday use in the classroom. Are children learning that digital technologies are for work or play; for solitary or collaborative engagement; for competition or cooperation? What signs are they 'reading' which enable them to construct digital technologies in particular ways and what role do practitioners have in creating these signs? On a concrete level, if digital art-making and other digitally mediated activities are to be constructed as social experiences, digital technologies need to be fully integrated into the free-flow activity of the EY classroom, by placing them in central locations, adjacent to areas of high levels of practitioner input (e.g. the writing table, modelling space or carpet area; see Edwards, 2005).

Finally, some of the concerns expressed by the practitioners open a rich dialogue about how young children's art-making is perceived and supported by adults in general, regardless of the technologies that are used in the process. The practitioners expressed a concern that children would use fully formed representations of objects in their digital art-making rather than engaging in

componential representation that emerged from a conscious and pre-existing desire on the part of the child to represent something in particular. The practitioners were most impressed by examples of digital art-making that used few ready-made images and used images in particular ways – as careful additions to a pre-existing scene. Placing value on 'internally' born intentions exists within a vision of childhood creativity that emphasizes the self-expression of the individual and constructs children as 'uncorrupted and unintentional conduits of creativity' (Malin, 2013, p. 7; see also Dyson, 2010). On the other hand, the use of digital ready-made images has been celebrated in theories of 'remix' (Lankshear & Knobel, 2006); 'mash-up' (Lamb, 2007) and even 'parody' (Ivashkevich & Shoppell, 2006), as explored further in the subsequent chapter. These practices have been increasingly valued in the research literature because it is thought that through these processes, children can develop their critical awareness of visual culture (Beudert, 2008; Duncum, 2002). So, by engaging with concerns about digital art-making, we can re-engage in a wider dialogue and debate about the nature of expressive arts in early childhood, and problematize adults' notions of what it means to make art as a young child.

Conclusions: How these findings relate to subsequent chapters

The concerns raised by the practitioners in the interviews reported in this chapter have acted as inspiration in the organization of the subsequent chapters and the themes and issues that they each address. The practitioners' insights into the sensory distance that exists between cause and effect in digital art-making environments are explored further in Chapter 6, which focuses specifically on sensory stimulation with digital technologies. The questions raised about componential representation and whether children are engaged at a deeper level of thought when they do not have access to ready-made digital visual stimuli are further investigated in Chapter 3, which looks at how children use ready-made images as part of their art-making, and in Chapter 8 which asks how discourses of intentionality are challenged by digital environments for art-making. Chapter 8 relates directly to practitioners' suggestion that digital art-making was less intentional, and more 'wizzy woo' than other forms of art-making. The suggestion that digital art-making might be more prescriptive and not as expressive as other art-making environments is again probed in Chapter 3 on ready-made images, but this is also examined in

Chapter 7, which considers whether and how children express personal own-ership and authorship during digital art-making. Finally, practitioners raised questions about the quality and quantity of social interactions that would sur-round digital art-making and this is probed further in Chapter 4, which looks at collaborative creativity around digital technologies, and in particular the classroom's digital device of choice: the IWB. It is also explored in Chapter 5, which considers the potentials for closeness in child-parent engagement with digital devices in the home, particularly those that allow photography and personalized story-making. Each of these chapters exist in dialogue with the concerns voiced by practitioners. The hope is that in providing a greater theo-rization of the relevant research and practice fields – of digital art-making, digital technologies in early childhood and early childhood art more gener-ally – there will be no loss of an emphasis on the facilitation of playfulness and the 'real' situations in which this facilitation can occur.

3

Remix and Mash-Up: Playful Interactions with Digital Visual Culture

Introduction

A feature of creativity in digital environments is the prevalence of ready-made material that can be incorporated into texts as they are made. Ready-made material might constitute sound files, video clips or images that can be used and manipulated as part of art-making. In the case of children's visual digital art-making and the applications that are used to support it, this most often takes the form of ready-made images which can be selected, applied to the screen and manipulated in size and position. For example, in the digital art-making software Tux Paint, which is aimed at children aged 3–8 years, users can choose to apply and manipulate a wide range of stamps that are available. The stamps constitute images, drawn or photographic, that can be applied in endless quantities as part of the art-making as it unfolds. Ready-made images are by no means exclusive to digital art-making environments; non-digital processes such as collage also involve the selection and organization of ready-made images. However, digital environments for art-making are more likely to offer this opportunity, either through a predefined set of tools in the software or through the potential to incorporate ready-made imagery which is accessed through online searches.

The ready-made images that are available to children in the context of digital art-making can be conceptualized as an aspect of children's visual culture. It exists in dialogue with other features of this culture, such as television, online gaming and non-digital publications that are targeted at children, such as magazines and books. Thus, when we consider children's hands-on engagement with ready-made images in digital art-making, we are exploring not only their micro-interactions with these particular semiotic resources, but also the wider relationship that exists between children and their surrounding visual culture. In considering this, we must grapple with notions of 'kinderculture' (Steinberg,

2014; Thompson, 2003) and 'visual busyness' (Tarr, 2004), in which children interact with, participate in and construct the visual culture that surrounds them. This in turn asks us to consider difficult questions around children's agency and whether we think about children as co-constructors of culture or whether they are reduced to passive recipients of an adult-made visual world that is primarily of commercial benefit to adults. Therefore, when we examine children's interactions with ready-made images in digital art-making, we are engaged in a broader discussion about what it means for children to develop a playful, empowering and humanizing relationship with the visual culture that surrounds them.

This chapter will consider how children use ready-made imagery in their digital art-making. Thus the aim of this chapter is to address the wider question of how children can be supported to interact playfully with the digital visual culture that is increasingly prevalent in their lives. It will do this through close observations of children's engagement, which are conceptualized through Dyson's (2010) notion of 'child agendas' in order to emphasize the proactive and idiosyncratic nature of children's digital art-making. Before reporting on these observations, the chapter will consider the debate in current literature and guidance that surrounds children's use of ready-made images in their arts practices. Within this debate, there are those who see ready-made imagery as a potential constraint on children's creative activity and their self-expression – a term that needs to be carefully considered and unpicked (Hawkins, 2002), and those who see playing with ready-made imagery as a vital part of a new digital creativity that enables remix (Knobel & Lankshear, 2008; Lankshear & Knobel, 2006), mash-up (Lamb, 2007), parody and iconoclasty (Ivashkevich and shoppell, 2012) – terms which also need to be deconstructed.

Ready-made images constrain creativity

To understand why some might make the argument that ready-made images would constrain children's creativity, we have to start by considering how adults' perspectives on children's art-making might differ from one another. As discussed in the previous chapter, Gardner's (1980) classic research on early childhood art suggested two opposing approaches to the facilitation of children's art-making by adults: the unfolding perspective and the training perspective. In the unfolding perspective, children allowed to follow their instincts when it comes to art-making, and the process is seen as something that springs from an internal source of inspiration. In the training perspective, art-making is

conceptualized similarly to other skills that children might learn, and specific types of support are offered to facilitate children's development as artists, such as how to hold different inscription instruments and how to observe closely when drawing from reality. Gardner's model recognizes that these approaches exist on a spectrum, and that different elements of each approach might be drawn into the same individual adult's work with children so that different conceptions of children's art-making come to the fore at different times. From an unfolding perspective, children's engagement with ready-made images that are made by others might be seen as a diversion from a child's 'inner voice', to which children should be encouraged to listen when making art. From this perspective, images made by adults will attune children to adult-led views of the world around them, which are then difficult to escape from or supersede. Take, for example, the presence of an image of a princess in the context of a digital art-making environment. This image could be seen as imposing particular cultural stereotypes and inserting them into children's art-making experiences. Tarr (2004) refers to these commercialized adult-made images as visual busyness and warns against their inclusion in environments designed to encourage children's free-flow play. In the context of a training approach on the other hand, adult-created images might have pedagogic use in that they act as a template from which children can learn to create their own culturally acceptable depictions of the world around them.

Much critique, particularly in art education, as also in early childhood education research, has been levelled at approaches that are seen as romanticizing a perceived inner voice of the child and prioritizing the role of internal inspiration in children's everyday meaning-making. In the previous chapter, in considering and problematizing practitioners' emphasis on intentionality, I highlighted the work of Hawkins (2002), which describes how the term self-expression has come to exist as a piece of 'final vocabulary' (Rorty, 2000, cited in Hawkins, 2002) in the early years, in that it is used frequently to guide adult approaches to children's art-making without ever itself being questioned or challenged as a concept. According to Hawkins, EY practitioners are likely to see an approach as good if it is seen as facilitating self-expression, without questioning the notion of the 'singular, pure, pre-existing self' (p. 209) on which the notion of self-expression in turn rests. Linked to this, the research perspectives of Dyson (2003; 2010) and Thompson (2003), which involve close observation of children's everyday text-making and art-making, show how children's creativity and art-making can often be observed in situations that we might not typically associate with free-flow expressiveness and creativity. Thompson (2003) shows how the trajectories of art-making that young children enact are influenced by

a wide range of sources, including images from popular culture. The way in which these materials are drawn into individual art-making trajectories may be idiosyncratic, but to come back to the wording of Hawkins (2002), there is no sense in which these trajectories are traceable to a singular, pure, pre-existing self. Thompson argues that there is an increasing need for adults to engage fully with the wide repertoire of imagery from which children gain inspiration for their art-making, and not to turn away from the popular culture references that appear in children's art. Similarly, Dyson (2003) notes the tendency of adults to want to construct childhoods that exist outside of children's everyday engagement with popular culture, in an attempt to construct childhood as something pure and innocent (see also McClure, 2011).

Along with self-expression, other terms make up the final vocabulary of early childhood education, which in turn influence our outlook and opinions on the presence of ready-made images in digital art-making environments. One such term could be 'open-ended', which is most typically applied to describe children's free-flow play, as explained and explored in the foundational work of Tina Bruce (Bruce, 1996, 2006). Activities are considered to be open-ended when they do not have a predetermined or 'correct' ending, and the trajectories of the activity unfold in the moment through the ongoing interactions of the participants in the activity. In the context of art-making, we tend to understand particular activities and resources as more open-ended than others. For example, McLennan (2010) laments the provision of stencils, stamps and templates for young children's art-making, arguing that these resources do not enable open-ended activity. It is highly problematic however, to conflate open-ended activities with open-ended resources, since the resources we might typically see as more or less open or closed are often transfigured through use. Drawing on van Leeuwen (2005), this can be explained as the difference between a resource's theoretical semiotic potential (the meaning-making we think it will encourage) and its actual semiotic potential (the meaning-making it is actually drawn into). Thus, while we might see ready-made images as a resource that are less open than tools through which we can achieve componential representation (e.g. a pencil and paper), this does not mean that ready-made images cannot be drawn into open-ended art-making. Indeed, since the images can dictate nothing of where they are positioned, how they are manipulated, and what they are placed next to, there is a strong argument to suggest that digital art-making with ready-made images will always manifest as an open-ended activity.

The concerns that surround digital ready-made images do not simply relate to the pedagogic values of play and creativity. Such imagery relates to wider

political and sociocultural debates about what children are exposed to, particularly through digital media. A discourse prevalent in early childhood education relates to the fear that children are being subjected to adult-created ideas and stereotypes, which will in turn lead to a 'homogenised global childhood' (de Block & Buckingham, 2007, p. 2) and usurps children's personalized and localized ways of seeing the world. In this perspective, children's art-making might be seen as a potential 'safe haven' into which they can escape from the highly commercialized and consumerist world in which they live and be given an opportunity to express and explore their everyday existence. To return to Thompson (2003), Dyson (2003, 2010) and McClure (2011), the desire to hide children away from the wider world and to only celebrate their text-making when it appears to refrain from a dialogue with this world, will prevent us from noticing how children constantly interpret, engage with and construct culture, making it their own and inhabiting it as part of their messy everyday lives. By dichotomizing a global adult-made kinderculture with children's everyday narratives, experiences and inspirations, we are failing to see how the former is inextricably interwoven with the latter, and how it all feeds into children's art-making practices.

Ready-made images facilitate digital creativity

Understanding popular culture references in children's art-making has been a common theme in the field of art and design education since the 1970s. A paper by Wilson and Wilson (1977) argued vehemently against the notion that children's art is best seen as stemming from an internal pool of inspiration and should be kept free of the external 'stuff' that pervades our everyday, media-ridden worlds. They argued that practitioners who were keen to protect children from externally created visual stimuli and prevented any form of 'copying' among children were holding onto a romanticized view of childhood in which children are constructed as 'uncorrupted and unintentional conduits of creativity' (Malin, 2010, p. 7). Instead, they suggested, all art-making is a dialogue with external stimuli. Even when children are not accessing images directly, the schemata that they represent in their drawings can be seen as a type of ready-made imagery that they have selected, applied and manipulated. In this way, children's componential representations of the world around them are not fundamentally different from their use of stamps or stencils or stickers. In both cases, they are accessing resources from their previous experiences and the world around them and crafting these within idiosyncratic creative trajectories.

Wilson and Wilson's de-romanticized – or what they called 'iconoclastic' – view of young children's art-making has taken much longer to catch on within the context of early childhood education than within academic approaches to art education. As outlined in the earlier section and in the previous chapter, there remains a tendency among some EY practitioners to hold onto the notion that children's art-making should essentially be free and internally oriented and that this means offering resources which are as free of ready-made images as possible (McLennan, 2010; Syzba, 1997; Tarr, 2004). At the same time, research has shown that EY practitioners particularly value children's art when it strives to be a 'realistic' representation of the child's personal, everyday life. Rose et al. (2006) conducted a survey of 270 children aged 5–14 and found that a majority of the participants expressed a belief that their teachers would value realistic representations over abstract art-making. Anning's (2002, 2003) observations of child-practitioner interactions around drawing also suggest a tendency to favour realistic representations. Thus, while practitioners are keen to hold onto the notion that children's art-making should be free, their notions of what this freedom corresponds to a particular view of art-making, in which visual realism is particularly valued. Paul Duncum has urged researchers and practitioners to widen their appreciation of children's art-making by moving away from linear developmental models of art-making in which visual realism is held up as the gold standard and instead to move towards an acceptance of the 'multiple pathways' and the wide range of reosurces, including ready-made imagery, which can be incorporated in children's art (Duncum, 1999, 2010).

Concepts of remix and mash-up challenge us to reconsider how children's digital art-making relates to the sociocultural and political spheres touched on earlier. Conceptualizing the selection and manipulation of images as a remaking of those images suggests that these acts are empowering (Serazio, 2010). This contradicts constructions of digital visual culture and childhood in which adult-made images are seen as something which controls and dominates the child's outlook. As Ivashkevich and shoppell (2012) suggest, images can be remade as acts of parody in which the underlying meanings and associations of images are deconstructed and reconstructed in playful and appropriating ways. Remaking images can therefore be a means for consciously interrogating popular visual culture. In the approach of spectacle pedagogy, as outlined by Garoian and Gaudelius (2008), the remaking of images can itself lead to a more questioning and critical engagement with popular visual culture. This theory suggests that by playing with images that are present in the wider culture, the individual can be drawn towards a more questioning stance in relation to that culture. In the

context of early childhood education, this offers us a particularly powerful possibility in which having the opportunity to remake ready-made imagery in the context of digital art-making could potentially foster criticality as well as creativity among young children, empowering them to be active co-constructors of a global kinderculture.

Researching children's interactions with digital visual culture

Much of the research on digital visual imagery and its impact on children's art-making has remained theoretical. When empirical observations have been made, these are often used as evidence for either side of the existing debates outlined earlier, rather than inspiring new theoretical dimensions. On the other hand, Dyson's (2010) powerful concept of child agendas highlights the importance of engaging with what children actually do in the creative processes and using this as a springboard for the development of new theory around early childhood creativity. While the practices of remix and mash-up have the potential to empower children, observations of children engaged in art-making may show that these practices do not unfold in expected ways and the theoretical assumptions may remain distant from the social and semiotic work that children are actually doing with the images they use. Ethnographic research in early childhood art-making has suggested a huge amount of diversity in how children engage with the processes of art-making (Frisch, 2006; Malin, 2013; Thompson, 2003). In the work of Malin (2013), for example, close observations of children engaged in art-making were used to develop deeper understandings about the various roles that art-making can play in the interactions of young children. Rather than categorizing children's activity on the basis of existing theory, these observations were used as a way of enriching our knowledge about the diversity in children's art-making and actively celebrating this diversity.

Following on from this, in the context of digital text-making, research conducted by Burnett and Myers (2006) suggests that children engage with ready-made material in digital environments in a variety of ways. They based their findings on two studies. In the first study, two classes of children participated in an email project, collaborating via email to create PowerPoint presentations. The researchers analysed the emails and presentations composed by the children. Further data came from a study of six 10–11-year-olds, which involved observations of these children as they made texts on screen using Word and PowerPoint and follow-up interviews about their experiences. In these contexts,

images available within text-making software were shown by the researchers to inspire the development of creative textual content, with children, according to the researchers, demonstrating 'considerable awareness of the semiotic potential of these elements' (p. 20). Having said this, interviews conducted as part of the research also suggested that some children felt limited by the availability of ready-made stimuli. Thus, the researchers suggested that 'digital resources may both prompt and confine individual composition and creativity' (p. 22). So, when we conduct close observations of children engaged in digital text-making, we are likely to see plurality in the ways in which digital visual culture is drawn into the processes of art-making as they unfold. If we are only hoping to incorporate these observations into an existing framework, particularly a dichotomous framework (empowerment vs disempowerment; creativity vs constraint; schematic vs subversive), then we will miss the wide variety of social and semiotic work that children are doing through their uses of digital ready-made imagery.

With a strong conviction that close observations of children can facilitate new understanding, my own research has involved observations of 4–5-year-old children engaging in digital art-making, with a focus on how they use ready-made imagery. I have undertaken these observations in two different contexts: first, by observing individual children engaged in digital art-making experiences, and then by observing them as they engage, often collaboratively, in digital art-making as part of the free-flow activity time in the classroom.

Individual observations

In the first study, I observed eighteen children aged 4–5 years as they engaged in digital art-making. The children in the study came from reception classrooms in three settings in the south-east of England. I took children out of the classroom to engage in digital art-making, which I supported in an open and uninterventionist way. In these interactions, we used Tux Paint for the digital art-making, which has been introduced in previous chapters (see Figures 2.1, 2.2 and 2.3). I was interested in what the children would create during these sessions, but more than their products, I was interested in the various ways that the children would use ready-made images over the course of their art-making. To capture more about these processes, I made audio recordings of the children and wrote field notes immediately after each episode. The audio recordings captured the 'directive talk' (Dyson, 1986) of the children – that is, the speech they used to direct and account for their action, as well as the conversations that occurred between me and the child. Cox (2005) and Frisch (2006) have highlighted the

importance of employing methodological approaches that enable the process of art-making to be prioritized over the products. I transcribed the audio recordings, and at the same time made notes about aspects that I remembered from the action as it unfolded, which were in turn evoked by the audio recording.

Classroom studies

Observations of how young children incorporate ready-made images into their digital art-making also came from two classroom studies. The first of these studies involved a period of intensive observation over four days. I carried out video observations in a reception classroom with forty 4–5-year-old children, which focused on the children's use of a laptop and the connected interactive whiteboard (IWB). In the second study, I made audio recordings of children's interactions around a laptop that was positioned on a small table on the carpet area in a class of thirty 4–5-year-old children in a different school serving the same locality as in the first study.

Again, the children used Tux Paint in the digital art-making activity. As the observations were taking place as part of the free-flow activity of the class, many of the observations focused on children's collaborative engagement with digital art-making, as well as some instances of solitary use. While I did support when any particular issues arose, I was interested in how the children would choose to engage with digital art-making when they were free to explore the resources in whichever way they chose and to negotiate for themselves.

Analysis

Across the video, audio and written data outlined earlier, the aim of the analysis was similar: to identify broad categories of how children could differently incorporate ready-made images into their idiosyncratic art-making trajectories, and the different types of semiotic and social work that the images could be used to achieve. In this analysis, I was not attempting to develop a comprehensive list of all possible types of use, or to document how often a type of use was brought to the fore, but instead to construct a sense of how different child agendas could come into play with regards to the use of ready-made images in digital art-making. Although the theoretical debates outlined in the earlier section of the chapter were in my mind, the thematic coding of the data was inductive, and child agendas were seen to emerge from moments in the data. I thought about these findings as a way to understanding the actual semiotic potential

(van Leeuwen, 2005) of the ready-made imagery, while the debates outlined earlier engage much more with the theoretical semiotic potential of ready-made images. In the final section of this chapter, I try to bring these aspects together to enrich our understanding of how ready-made images, as a set of semiotic resources, feature in children's digital art-making practices, and what this means for the playfulness of the experience and the creativity and criticality of their engagement.

Child agendas in digital art-making with ready-made images

The observations of children engaged in digital art-making involving ready-made images suggested at least five child agendas according to which children were using images as part of their digital art-making. The agendas presented in this chapter are not necessarily exhaustive and they are not singular in the way they apply to observations of children. That is to say, each episode of children's image use is not characterized by a single agenda, but rather, different agendas can come to the fore at different points in the episode of art-making, and different types of uses are interwoven with one another. Linked to this, although particular children might show particular patterns in terms of how they tend to use ready- made images, understanding individual preferences was not the aim of the research reported here. By presenting different ways in which ready-made images can be drawn into digital art-making, I hope to elucidate some of the ways that children can engage with ready-made imagery, and to put these observations in dialogue with the debates presented in the first part of the chapter. In the following sections, different child agendas are presented in more detail; these are: experimentation; aesthetic impact; making conversation; schematic representation and narrative-building.

Experimentation

Ben's talk, the sequence of his actions and the visual product of his art-making suggest that the representational content of the ready-made images he chose to include in this art-making was not a significant influence on his actions as they unfolded. By this, I mean that the identification of the objects he included as 'cherries' or 'top hats' did not seem to influence either his selection of the ready-made

Figure 3.1 Experimentation.

images or how they were applied to the screen. To draw on poststructuralist terminologies of meaning-making, we can think about these images as 'empty signifiers' or 'floating signifiers' (Barthes, 1977; Derrida, 1980), which are not clearly anchored to one particular signified meaning. In Ben's art-making, images of cherries were not first and foremost representations of cherries, and images of top hats were not, first and foremost representations of top hats.

If Ben was not choosing to apply these images because of what they conventionally represent, what made him select these images? It is possible that Ben applied these images in his art-making because they have a particular visual impact. Perhaps it was the shape of the top hat that Ben was interested in sharing through his art-making, or perhaps it was the colour of the cherry, or how it would look when it was repeated in its application across the screen and positioned in particular ways. However, Ben's directive talk focuses very little on these aspects of aesthetic impact – for example, he does not mention colour in his talk or refer to the positioning of the images on the screen. Following on from this, when we consider the visual impact of the overall product, there is little impression of visual coherence. When we consider Arnheim's (1974/1954) construct of 'visual completeness' in relation to Ben's art-making, or Winner and Gardner's (1981) notion of 'visual balance', it does not meet the criteria for achieving aesthetic order within these frameworks. This suggests that aesthetic

impact was not of primary importance to Ben in his application of empty or floating signifiers.

While Ben's directive talk was not concerned with spatial positioning, pattern, shape or colour use, it was most concerned with the manipulation of ready-made images in playful ways. This was suggested through the prevalence of non-linguistic utterances ('wee wee wee') that accompanied the application and manipulation of images, and the questions he asked ('What is this?' 'What does this one do?') about what the different tools available would do to the image he had selected. Ben experimented with tools that had not been part of my short interactive demonstration of Tux Paint at the beginning of the session, turning images upside down and changing their size. These actions and the accompanying talk suggest that in the case of Ben, images inspired an experimental approach towards the art-making experience, where the focus was on tools rather than the artwork itself.

Experimentation as a child agenda is often neglected when we think about children's art-making. Malin (2013) and Kolbe (2005), in their studies of children's art-making have suggested that experimentation is a common purpose or attitude that children can adopt in relation to their art-making, despite its tendency to be neglected in the literature. Children's experiments with visual media have not been analysed in a systematic way. Most often, they have been treated as a necessary precursor to the creation of discernible visual representations. There is no evidence, however, to support the assertion that experimentation can only take place in the early stages of art-making; indeed, art educators have argued that experimentation with the medium continues to be a key principle in later art education (Eisner, 2004). In Heydon's (2012) observations of an intergenerational art class, children were keen to experiment with the non-digital ready-made images that they gathered as part of making collages. Playing with the shape, form and positon of these images appeared to be something they were enthusiastic to do, especially when compared with the older participants' tendency to treat images only as representations of what they conventionally represent. Linked to this, Wohlwend (2009) has noted the high proportion (45%) of play activities in the classroom that involve children exploring materials, and so Ben fulfils an expectation that such a purpose would underpin at least some cases of image use.

Observations of visual experimentation are important in the context of wider debates about the appropriateness of children using ready-made images in their digital art-making. First, the act of experimentation suggests that children do not see the images that are available to them as untouchable representations of what they are intended to represent. This suggests something about the relations of power that exist between the individual child and the wider digital visual culture

with which they engage. In particular, we can contrast the practices of experimentation with the notion of passive exposure. As de Block and Buckingham (2007) explain, the latter notion is often used to describe children's relationship to digital visual culture – they are exposed to images, which influence their perceptions and interpretations of the wider world. Through experimentation, however, exposure is only the very first part of the art-making trajectory, and external stimuli are subjected to the child's playfulness through the experimental potentials facilitated by the digital art-making environment. Through experimentation, images are visually remade, and through this their influence or power comes undone. While this might seem a far-fetched proposition when we're considering Ben's art-making, since the images he was visually playing with were uncontentious, it is a more exciting idea when we imagine what the effect would be if the image were an image of a princess or a knight: observing a princess turned upside down or a knight made tiny in relation to a frog would encourage us to engage with the radical potentials of visual experimentation as a means to play with and even subvert the cultural stereotypes that are likely to be present in popular visual culture.

Beyond this potential, observing experimentation also encourages us to recognize that semiotic resources, as described by van Leeuwen (2005), involve a network of affordances, which, when activity is unfolding, cannot be disentangled from one another. While one important feature of the digital art-making resources is the potential to include ready-made images, another equally important feature is the potential to visually manipulate and play with these images through the various tools available. We cannot ask what the impact of ready-made images on children's art-making is without considering what they are able to physically do with these images in the art-making context. In relation to social semiotic theory, this highlights the need for a conceptualization of affordances that conveys the interconnectedness of material properties and social associations, and does not simply list affordances as though they are discrete influences on the unfolding action.

Aesthetic impact

As with Ben's art-making, Nina's art-making suggests little significance attached to the conventional representational content of the images that are included in the artwork. She does not talk about these images in terms of what they are (the strawberries and the apples). Unlike Ben however, Nina's art-making

creates an impression of strong visual coherence. There are multiple copies of the apple image, stamped around the screen so that they are evenly spaced. The dual impression of the strawberry, placed side by side but not overlapping, has a strong visual impact. The artwork achieves symmetrical unity as a result of 'complete fill' (Winner & Gardner, 1981), whereby the lack of blank space on the screen creates a sense of 'visual completeness' (Arnheim, 1974/1954; Golomb & Farmer, 1983). There is also a sense of coherence in the colour that is used. There is a striking but complementary contrast between the green and the pink/red, and these colours are echoed in various details – the differently coloured apples, the colours involved in the depiction of the strawberry, and the colours applied through the background and the paintbrush tool. Through her directive talk, Nina drew attention to visual, rather than referential coherence, and was concerned with position and colour. For example, she spoke aloud the colours that she wished to add and carefully talked through the process of changing the colour of the apple from green to red and back again. These verbal clues suggest that Nina was interested in making aesthetic choices relating to position and colour and that ready-made images were drawn into this purpose or attitude.

In the classroom observations of children's digital art-making, there was often a strong emphasis on aesthetic impact. Many of the children spent a long time discussing the placement of images across the screen and creating

Figure 3.2 Aesthetic impact.

Figure 3.3 Aesthetic impact: Classroom examples.

patterns through this placement, for example, by positioning the images in the corners of the screen and then evenly spacing across the sides of the screen. In the Figure 3.3, you can see a selection of digital artworks created by children in the classroom context that similarly appear to prioritize positioning and colour. These artworks achieve an impressive level of aesthetic design and impact.

Little research has focused on the aesthetic aspect of children's art-making, although some studies have highlighted children's interest in engaging with the aesthetic qualities of their art (Kolbe, 2005; Malin, 2013). The lack of focus on understanding the aesthetic techniques employed by young children may be due to an overemphasis on children's intentions that relate to the representation of content. When ready-made images are being used, we tend to focus our attention immediately on the signs that these images relate to rather than considering the possibility that these images might be treated as aesthetic elements, with distinct semiotic potential as a result of their colour, shape and textural quality. Surveys by Rose et al. (2006) and observations by Anning (2002, 2003) suggest that adults often see and judge children's art-making as attempts at 'realistic representations', whereby the emphasis is on what is being represented, rather than how it is being represented. In the Rose et al. surveys, a majority of children echoed this tendency to prioritize the 'what' aspects of pictures, and to prefer discernible representations as opposed to abstract art-making. On the other hand, prior research by Winner and Gardner (1980) found that a majority of 4–5-year-olds stated a preference for abstract paintings over clearly referential paintings,

suggesting that the aesthetic dimension of art-making might have importance to children when they are younger, but that this is shifted through interactions with adults where there is a perceived value on visual realism (Chandler, 2007).

Considering the aesthetic potential of ready-made images in digital art-making challenges the debate that was outlined at the beginning of this chapter, which is based on the assumption that images in children's art-making are seen by children primarily as what they conventionally represent. By observing children treating these images as visual elements in a process of design, we are confronted by the potentials for children to engage in art-making that is abstract and non-referential. In thinking about the image of a princess in the context of children's art-making, we might be so concerned with the 'princess-ness' of this image, that we neglect the colours of which this image is made and the expressive possibilities associated with these colours, particularly when they are positioned in relation to other aesthetic elements of the art-making process. Digital art-making that prioritizes aesthetic impact alerts us to the possibilities of engaging with our 'felt' connections with colour (Hosea, 2006), and the use of colour as an important aspect of design (Kress & van Leeuwen, 2002). The same is true for other aesthetic aspects of design, such as shape, texture, contours and so on. Engaging directly with children's agendas in incorporating ready-made images into their digital art-making remind us that these images can be much more than simply the objects they are intended by designers to represent.

Narrative-building

In Jack's art-making (see Figure 3.4), experimentation with the tools available led to the development of a narrative that he created about cars in a car park that become trapped behind a net. He arrived at this narrative through applying the ready-made image of a red car many times to the screen. He then declared: 'See, these ones are in the cark park.' Once these images were on the screen, he changed the tool that he was using to the paintbrush and again the activity on screen became the key driver underlying narrative development – the cars became trapped behind the net he had drawn with the paintbrush.

The example of Jack's art-making shows how the conventional representational aspect of images can be important to children and that this representation can be a means for developing a narrative. In Jack's art-making, the application of the same image multiple times was an important aspect of building the narrative of the car park. In another example, Gertrude stamped multiple images of

Figure 3.4 Narrative building in Jack's art-making.

a duck across the screen and declared that she was creating a duck pond. These examples suggest that the potential multiplicity of images can be a key part of the narrative-building that unfolds around art-making. Applying multiple copies of the same image was something that many of the children were eager to do, and this was afforded through the material organization of the tools in digital art-making, which made it easy to apply duplicates of an image, since in Tux Paint, an outline of the image continues to hover over the screen immediately after an initial application so that copies of the image can be applied at the single click of a button.

The multiplicity of an image can be a stimulus for narrative-building, particularly in relation to setting a scene – a duck pond or a car park in the examples presented earlier. A key aspect of this child agenda is that once this narrative has been initiated, the child is eager to remain within its parameters, meaning that referential coherence between selected images is particularly important. When an image of smoke was applied in the duck pond picture, it was quickly removed since it did not have referential coherence in the narrative context that had been developed so far. The positioning of images in Gertrude's artwork also attests to her desire to create a referential scene, since the ducks were clustered around the bottom of the drawn figure, thereby creating a groundline in the picture (Golomb & Farmer, 1983; see Figure 3.5). The use of images in Gertrude's

Figure 3.5 Narrative building in Gertrude's art-making.

art-making for the purposes of storytelling relates to a category of children's art-making suggested by Malin (2013) and has been observed in various studies which link children's art with the creation of multimodal narratives (Ahn & Filipenko, 2007; Coates, 2002; Wright, 2012).

In much of the research around children's narratives in art-making, there has been a focus on the idea that these narratives start within the child and are externalized through the processes of art-making. When we observe how oral and multimodal narratives might be built up through interactions with ready-made imagery, this notion is challenged and we can see how external stimuli can guide children's development and communication of stories. Returning to wider debates about the influences of ready-made images on early childhood art, this might suggest that the content of children's narratives will be different depending on the presence of ready-made images. Rather than engaging in personalized accounts of their everyday lives, the use of ready-made images might encourage children to develop imagined, fantastical narratives, which draw in external stimuli rather than relating to stimuli which is of immediate importance and relevance to the child's concrete circumstances. In my observations of children's narrative development through drawn representations on paper, children were more likely to engage in anecdotal narrative accounts of everyday experience than when they were using images as part of the digital art-making environment (Sakr, 2013).

Making conversation

While there was a methodological focus in the observations on the talk around the texts that the children made, for some children, the talk around the text seemed to be their primary focus in the unfolding experience. The process of making art was a way of engaging in and developing conversations. For example, Adie discussed each image that she used in terms of what it represented and the associations that she had with this representation in relation to everyday experience (see Figure 3.6). The images that she applied in her art-making were linked thematically since they all represented things that Adie liked to think, talk and joke about, including different types of food and colourful flowers.

When images are used to stimulate conversation, there is less of a focus on experimentation and visual manipulation, or on the aesthetic qualities of the images that are chosen. Images are instead used by the child as schemata, so that images of flowers represent flowers in general, rather than being a flower seen from a particular perspective, or a certain type of flower with distinct visual properties. Drawing on the Deleuzian distinction between 'common sense' and 'sense-making', the use of images to evoke general conversations suggests a common-sense approach, whereby the stimuli refer to object categories, which are recognized according to existing schemata (Lambert, 2005; Surin,

Figure 3.6 Making conversation in Adie's art-making.

2005). This is different than the use of images in experimentation or for aesthetic impact, where the visual differences between images – even the minute differences – are important and have an effect on the unfolding trajectory of art-making. When instead images are used as general schemata, they have the potential to shape the conversations that occur around the digital art-making experience. To return to the example of the princess image, within the context of the conversation-making child agenda, the princess image would guide the development of conversations around princesses and children's associations with the schema of the princess.

Previous research has highlighted the importance of art-making in the development of children's social relationships (Frisch, 2006). For example, Malin (2013) observed the relational dimensions of art-making and the potential for art-making experiences to connect children to others, both those who are immediately present and also those who are distant in time and/or place. In the field of art therapy, the potentials of art-making as a way of engaging children in rich emotional interactions with others, and deeper dialogues about experience, has been noted (Hosea, 2006). When considering digital art-making, Labbo's (1996) early research suggested that children's digital texts were more likely to act as a starting point for performance and play compared with texts on paper, so that children prioritized the social process-based aspects of the text over a static product. If we consider ready-made images in the context of this previous research, then perhaps we can think about these images as a kind of social token that is used and exchanged within the unfolding social interaction. These images can inspire conversations and enable children to perform their associations and understanding of the world around them. While this is based on the interpretation of images as schemata, the way in which children develop their own dialogues and performances around these images suggest that these images become personalized through the expressive practice of talking or performing through other modes. Thus, while the images might not be visually manipulated, and while there might be little care for where the images are placed or the colours they contain, the images are to some extent remade through the talk and multimodal action which surrounds them (Wright, 2012).

Representation and visual realism

In the last two child agendas that have been considered – narrative-building and making conversation – the images are used as schematic object representations,

but they are used in order to achieve some type of social work that goes beyond the text itself. In the final child agenda considered, the image is used as a schematic representation that is incorporated into an art-making process where the primary aim appears to be a product that constitutes conventional representation. In Mischa's art-making, she started by using the paintbrush tool to create a human figure (see Figure 3.7). This image of the human figure is a common schema created when children are using non-digital art-making resources. After creating this figure, Mischa looked through the ready-made images that were available, and after a prolonged period of searching the images, she found one that would complement this human figure representation. She chose the image of the hat and applied this carefully to sit on top of the drawn head. The impact that this image has is similar to the impact that a drawn, componential representation of a hat would have. That is, it leads to the creation of a referentially coherent and schematic representation of a human figure.

Mischa's meaning-making in this example, and her incorporation of ready-made images, is markedly restrained. She uses just the single image and applies it just once, while the vast majority of other examples of art-making, both in the classroom studies and the observations of individuals, involved the use of multiple copies of the same image. As soon as the image was applied, Mischa withdrew from the experience altogether. The use of the

Figure 3.7 Schematic representation in Mischa's art-making.

image appeared to be secondary to her desire to depict a human figure. It is interesting to note that drawing on paper is something that Mischa considered herself to be particularly good at and she had received much adult recognition in the past for her drawing. This raises the possibility that Mischa was restrained in her image use because this aspect of digital art-making had to be balanced with the desire to do what she knew she would be good at and would be congratulated for. Indeed, the teachers in Mischa's school were particularly excited by her digital art-making product (as discussed in the previous chapter). They showed particular admiration of Mischa's artwork, declaring it to be an example of 'mature use' of the media. They compared it favourably to 'wizzy woo' examples of digital art-making, which were characterized by extensive use of the various tools in digital art-making and contained no clearly discernible representation. This highlights the common perception in EY education that children's art-making is a journey towards visual realism (Duncum, 1999; Soundy & Drucker, 2010). Mischa's digital art-making relates to this approach, including in its particularly careful application of a single ready-made image.

The example of Mischa's art-making shows us two things. First, it suggests that it does not make sense to talk about digital affordances as if they are a static set of characteristics of the technology. Technologies are what children make of them and affordances are whatever practices are afforded, regardless of what was intended by designers or what is thought by adults as most likely to occur. Second, the teachers' positive reaction to Mischa's art-making emphasizes the priority given to the recognition of discernible and componential representations in how adults respond to and value children's artwork. In my interviews with EY practitioners (Chapter 2), I found that teachers and teaching assistants are likely to look for discernible representations and referential coherence in the context of children's art-making, and on finding them, adults are likely to see these examples of art-making as more mature. This developmental outlook stems from the desire of practitioners to understand where children can be placed on a developmental trajectory, but it also stems, I believe, from a desire to recognize a child's intention and to get inside the mind of a child while they are making art. The latter is much easier when the product contains a discernible representation. So even though we have a desire to see children playfully engaging with ready-made images, we might be unsettled when they use images in ways that are not representational, where instead experimentation, aesthetic impact or the performance around the text is prioritized.

Conclusions

By engaging with children's art-making through close observation and focusing on their use of ready-made images, I have argued that children use images in a variety of ways to do a wide range of semiotic work. These child agendas go beyond the polarity of a debate in which images are either seen as constraining or creatively stimulating, and instead suggest that ready-made images are what children make of them. Images are sometimes used playfully and sometimes not; sometimes children adopt an empowered stance in relation to the images, and sometimes they follow the lead that these images offer in terms of content. As a result of recognizing this diversity, we can reframe the questions we ask so that we are considering how best to encourage and facilitate forms of image use that are playful, subversive and critically aware. For example, the experimentation child agenda has exciting potentials in relation to spectacle pedagogy: an approach which suggests that visual manipulation and play can in turn enable individuals to question and challenge the status quo that manifests through the imagery of popular culture (Garoian and Gaudelius, 2008).

Observing the diversity with which children use ready-made imagery forces us to question many of the popular perspectives and discourses that surround children's art-making. For example, theoretical perspectives which see art-making as an opportunity for children to respond to an inner voice can be troubled by the way in which children are inspired by external images to create stories, make conversations and construct visually exciting texts. Children's use of images can also challenge our tendency to prioritize visual realism, and to construct visual realism as the goal to which children are always aspiring when they create art. Considering examples where children prioritize the aesthetic impact of their art-making show how this linear, developmental approach does not do justice to the diverse and dynamic processes that children are engaging with. Finally, children's use of images can help us, as adults, to see the world differently. They can help us see beyond what the image shows in referential terms and remind us that images constitute endless differences in terms of textural quality, colour and shape, and endless possibilities in terms of visual manipulation and effect. These insights encourage a perspective towards early childhood art that goes beyond the typical developmental perspective, and instead moves us towards a poststructuralist, post-developmental and potentially posthuman perspective on children's art-making that particularly values the material qualities of the resources we use (Knight, 2013; MacRae, 2011).

In the context of debates around kinderculture and children's digital visual culture, observing children's use of ready-made images in digital art-making reminds us of the importance of considering what children can physically and visually do with the images that are shared with them. Rather than exposure and consumption, their practices in relation to these images suggest that they are more active in their relationship with visual culture than these words would suggest. Children can physically manipulate the images that they are exposed to in the digital art-making environment – they can, literally, flip the images on their head. This kind of visual power might in turn relate to a type of thinking power, whereby images are remade in their denotations and connotations, and in what they encourage children to think about the world that they live in. Having said this, children will not necessarily assume the power to physically manipulate the images that they work with, and as we saw in the schematic representation of Mischa, images might be used in quite constrained and potentially constraining ways. In this context, the role of the adult could be to support children to engage playfully with the images that they encounter in digital art-making.

In all of this, what seems to be vital is the understanding that creativity in digital art-making, and elsewhere, is a distributed process which includes a wide array of social and material resources that children have to draw on (Glăveanu, 2015). Images are not simply used by children but nor can we think about them as being imposed on early childhood art-making. Instead, digital visual culture is an active player within a network of material and immaterial influences on children's art-making processes (Burnett et al., 2015). These images are a set of semiotic resources that can do particular types of work – we can think theoretically about this type of work, but we can also observe the actual semiotic potentials of the images which will unfold differently depending on an array of contextual factors (van Leeuwen, 2005). A focus on images highlights the need to consider children's art-making as a process which unfolds through a network of influences and resources and can be empowering or disempowering depending on the orientation that is taken towards the images and the extent to which they become objects of play and playfulness.

Collaborative Creativity: Forms of Social Engagement during Digital Art-Making

Introduction

In this chapter, I will consider how collaborative creativity plays out in the context of young children's digital art-making, looking particularly at an interface designed to encourage collaborative use in educational settings: the interactive whiteboard (IWB). The term 'collaborative creativity' refers to situations in which individuals make new meanings and generate new ideas together. Recent research on creativity has increasingly conceptualized creativity as something which happens between people, rather than as an individual skill or process. When applied to art-making, this way of thinking about creativity encourages us to conceptualize art as something that unfolds in an intersubjective and intercorporeal space. This means that when we consider the influence of digital technologies on early childhood art, we need to explore how particular affordances of the digital might shape the interactive spaces between individuals' minds and bodies differently.

I will begin this chapter by expanding on the idea of collaborative creativity by surveying previous literature on how collaborative creativity is shaped when individuals have access to a large digitally interactive surface, such as tangible tabletops and the IWB. This will highlight some of the particular affordances that might be relevant in making sense of digital technologies in early childhood art when it is conceptualized as a process of collaborative creativity. To develop this investigation further, I will report on a small-scale observation study I conducted looking at 4–5-year-olds' art-making interactions with the IWB during free-flow activity time in the classroom. I will show how children engaged in a range of behaviours when interacting with the IWB, some of which

facilitated collaborative creativity, and others which hindered it. My observations emphasize the physicality of collaborative creativity and the importance of bodily modes in negotiating the resources available and creating spaces in which collaborative creativity can occur. As well as thinking about what the resources themselves afford, as conceived of by designers, my observations highlight the importance of taking into account the 'classroom-ness' (Burnett, 2014) of the context in which the IWB is being used, an issue I touched on in Chapter 2. The organization of time and space around the art-making resources is fundamental to how the activity unfolds. This highlights the importance of focusing on the wider sociotechnical environment in which children's digital art-making unfolds. While large, digitally interactive surfaces may have some physical properties that facilitate collaborative creativity between children in educational settings, as previous literature has suggested, the social context in which these physical properties manifest is paramount.

Collaborative creativity

Research on creativity has passed through various phases of development. Most recently, as Hämäläinen & Vähäsantanen (2011) note, research has focused on creativity as a social, collaborative phenomenon rather than as a capacity or event of the individual human mind. Glăveanu (2010, 2011) describes this as creativity in the 'We-paradigm', contrasting it with the 'He-paradigm' and the 'I-paradigm', which both suggest creativity to be something that happens within the individual. Glăveanu situates his research on collaborative creativity within the discipline of cultural psychology, which posits the interdependency of mind and culture. He draws on Vygotskian notions of creativity, which stress the importance of a network of cultural factors on the development of new ideas. From this perspective, collaborative creativity is conceptualized not as being affected by external social factors, but rather as a phenomenon which arises in situated interaction and through constant dialogue with the sociocultural realities of everyday life. On the other hand, Csikszentmihalyi (1988, 1999) conceptualizes the relationship between the individual, the social and the creative as more of a system, in which creativity manifests through interaction between a person, a field (a social system) and a domain (a symbolic system).

At its simplest, we can think about collaborative creativity as the development between two or more individuals of a shared idea or reference point (Chen, 2011). For Craft and Wegerif (2006), however, collaborative creativity is

more than just a momentary correspondence between two individuals' cognitive processes; instead, it also constitutes physical and spiritual togetherness. This perspective highlights the importance of engaging with the various dimensions that are at work in a collaborative creative interaction, including the bodily and emotional aspects of the unfolding interaction, and the need for methodological approaches to collaborative creativity that foreground affect and embodiment. Collaborative creativity happens simultaneously within and between individuals. In Winnicott's (1971) notion of 'potential space', the personal representational space and the common representational space are inextricably linked. Individuals develop an individual sense of creativity through their engagement with the collective, and the collective will draw on individual contributions which flow into a shared representational space.

This chapter draws on the theoretical background outlined above by positing that collaborative creativity: (1) unfolds through the semiotic work of bodies and visibly manifests through embodied interaction; (2) is an emotional and spiritual experience for the individual, as well as an intellectual one; (3) is a phenomenon that arises in individual minds and between individuals, and that these two facets of the phenomenon are inextricably linked and (4) is a network of sociocultural factors, which include the technologies and material artefacts that are drawn into the interaction, and their sociocultural and historical associations.

Collaborative creativity and interactive digital displays

It has been suggested that interactive digital displays are well-suited to support collaboration and collaborative creativity. Rogers and Lindley (2004) describe the affordances of interactive digital displays as 'accessibility, visibility, "shareability"' (p. 1134). They note however, that there are differences between horizontal and vertical displays. They compared adult collaboration between a vertical and horizontal interactive digital display and found that in the horizontal condition, there was more sharing of the resources available and more informational resources were drawn into the interaction as it unfolded. In contrast, in the vertical condition, participants were more divided in their contributions to the task and reported feeling more removed from the overall process. Despite these differences between the vertical and the horizontal interactive digital display, the researchers found that both conditions compared favourably to a non-interactive digital display (i.e. a computer which was accessed through an external input device), where rates of collaboration were found to be at their lowest.

In the context of childhood education, Mercer et al. (2010) have investigated whether the IWB can help to create a 'dialogic space' (Wegerif, 2007; Wegerif & Davies, 2004) in which children can collaborate effectively. This study suggested that successful groupwork can occur when children use the IWB, as long as scaffolding occurs in relation to techniques for effective collaboration. The researchers argued that the IWB lends itself to collaboration because it enables the physical manipulation of symbols by multiple individuals, though this aspect of collaborative creativity may have been difficult to gauge from the data in this specific study which constituted verbal, rather than multimodal transcripts of the interaction.

As well as considering the materialities of interactive digital displays and how these relate to collaborative creativity, it is necessary to examine the sociotechnical environment in which these displays operate and what users do with the technology, as much as what designers think that users will do. Russell et al. (2002) have noted that while large public interactive displays are thought to be well-suited to group use and to enable productive imitation between group members, many adult users can feel unsure of how to make use of the interactive displays and how to maximize interaction and collaboration with each other. As they describe, the 'etiquette of multiple person use is unclear' (p. 232) and time is needed for effective collaboration practices to evolve. When these practices do evolve, they are likely to be particular to the groups who are using the interactive display, so that collaboration involving interactive digital displays will not always manifest in the same way.

There is a lack of research that focuses on interactive digital displays in EY settings. Research on IWBs has tended to focus on primary or secondary school classrooms, rather than on free-flow play-based early learning environments (Harlow et al., 2010; Higgins et al., 2007). Furthermore, these studies have often focused on how teachers integrate IWBs as part of their practice and what children gain through the teachers' use of the IWB, rather than considering how children themselves take up the IWB as a tool and resource during free-flow activity time. When looking at early childhood education, the IWB during free-flow activity time is accessed by children often without any adult input, and they must take responsibility for negotiating the resources and establishing the 'etiquette' of using the IWB.

In addition to the need for more research that looks at IWBs from the young child's perspective in the context of early childhood open-ended expressive arts activities, there is also a need for research to use measures and adopt methods that prioritize a focus on the embodied interaction as it unfolds. The claim by

Mercer et al. (2010) that the physical manipulation of symbols is important for collaboration and the creation of a dialogic space can only be probed further by investigating the multimodal orchestration of activity that occurs around the IWB, rather than focusing only on talk as many of the studies outlined above have done.

Observing young children using the IWB
for collaborative digital art-making

In the previous chapter, I briefly introduced my observations of a reception class of thirty 4–5-year-olds in the reception class of a state primary school, which focused on the interactions of children with digital art-making on the IWB and associated laptop during free-flow activity time. To expand on this, over the course of one week, I made observations of children's activity around the IWB during free-flow time, which equalled about four hours of each day. On the first day of observations, it became clear that the children had access to only a very limited repertoire of programmes and applications to use on the IWB. These were all focused on literacy, numeracy or 'topic' learning (e.g. costume in a particular historical period). As I was interested in children's use of the IWB for the purposes of art-making, I was concerned that such programmes would not enable children to engage in this way. On the first day therefore, at lunchtime, I asked the class teacher whether it would be possible for me to download the free art-making software Tux Paint onto the laptop connected to the IWB and she was very happy for this to happen. Following this, most of the children's use of the IWB during free-flow activity time involved using Tux Paint, although they still had access to the programmes they had previously been using.

I conducted the observations in the final weeks of the academic year, so for almost nine months, the children had had the opportunity to interact with the IWB. The board was often available to them as a resource that they could use during free-flow activity time, so this aspect was not new to them, though Tux Paint was, as outlined above. Interacting with the IWB was something that the children could choose to do, and there were often times during free-flow periods when no child was using the IWB. I did not actively encourage children to use the IWB but waited for them to engage with the IWB when they wished. I would then find my camera or iPad in order to make video observations of their interactions as they occurred. These observations were made from a small distance away from the children, though I would move back or forth depending on the

activity that was occurring and what seemed to be the best angle in the moment from which to capture the interaction and engagement of the children.

Although I aimed to intervene as little as possible with the unfolding activity that surrounded the IWB and the laptop, it was sometimes necessary for me to step in to support with practical issues, particularly when a conflict between children was escalating to a level where I felt a practitioner in the class would have stepped in or when technical support was required, for example, if the Tux Paint window disappeared from the screen. I was a participant in the wider field of study, acting as something of a teaching assistant within the classroom activities. This made it necessary to shift between participant, observer and reflector roles on a frequent basis, and these shifts are sometimes visible in the video footage, such as when I am stepping towards the children in order to help them find a particular icon, or to stop one child from pushing another one out of the way, and then moving away again in an attempt to just observe and not be drawn into the activities.

Other adults in the classroom did not interact with the children during their use of the IWB and connected laptop. Of the more than 1.5 hours of recorded footage that I gathered, there were no recorded interactions between children and adults in this activity space. The lack of adult interaction is likely to have arisen as a result of the practitioners' conception of the activity as a research activity and they did not want to interfere with the interactions, or to be caught on film. Although practitioners were told to interact with the children as they typically would, they may have been reluctant to do so given the presence of the recording equipment. Beyond this, having been a participant observer in the class, it was clear to me that the teaching assistants and teachers were often having to complete prearranged activities in the children's free-flow activity time, for example, working with particular groups of children on literacy or numeracy activities, or making formal observations that were contributing to the children's end of year assessments.

Across the week, I made 32 video observations, ranging from four seconds in length to 29 minutes and 43 seconds. In total, the video observations constituted one hour, 39 minutes and 20 seconds of footage and the average video observation lasted for 3 minutes and 6 seconds. For each video observation, the number of participants actively engaged with the activity ranged from one to seven children; on average, the observations involved between two and three children. Across the 32 video observations, a total of 20 different children were captured as active participants in engagement with the IWB or the connected laptop, with some children appearing in as many as 12 video observations. Clearly, some

children were more drawn to the activity than others, and were therefore more likely to be visible in the video observations. On the other hand, some children in the class were not ever seen engaging with the IWB during free-flow activity time. In addition to the video observations, I made written field notes at lunch time and at the end of the school day, which totalled around 1–2 pages for each of the four days of the study.

Analysis was microgenetic, focusing as it did on specific moments of collaborative creativity as they unfolded (Rojas-Drummond et al., 2008). To enable this type of fine-grained analysis, I made a multimodal transcription of all of the video data. Through multimodal transcription, the importance of bodily, nonverbal modes, alongside verbal communication, was clear; multimodal transcription also enabled a close focus on how material artefacts and resources were a fundamental part of the interaction. Following transcription, I developed themes in response to my research questions around digital artmaking as a process of collaborative creativity; these themes emerged through an iterative engagement with the video data, multimodal transcripts, analytical commentaries, field notes and common elements in the previous literature (such as the suggestion that the IWB acts as a dialogic space in Mercer et al., 2012). By interrogating these initial themes further, and through organization, I identified three phenomena which related to collaborative creativity as it manifested in this context: turn-taking, interactive audiences and the recurrence and imitation of bodily practices. In turn, each of these phenomena could be broken down into the indicative behaviours (what these phenomena looked like in action), affordances (how the behaviours were afforded by the IWB as it exists materially and as a social construction) and how these behaviours related back to the literature on collaborative creativity. In the following sections the three phenomena are considered with reference to relevant literature, and still shots from the video data are used to illustrate how these phenomena visibly manifested through the multimodal orchestration of activity.

Turn-taking

Indicative behaviours

Often, the children would finish their go by rubbing out whatever visual impact they had made on the board. They would laboriously cover over the marks they had left on the board with the eraser tool. Through this rubbing out process, the children were preparing the IWB for the next child's interaction and

metaphorically drawing a line under their own 'go' or 'turn'. When children did not rub out what they had made piece by piece, they might end their go by starting a new file and thereby preparing a blank canvas for the next individual interaction. When the outgoing child did not cover over what they had created or start a new file, most often the next child to begin interacting would do this. When Lexi for example stepped away from the IWB without starting a new file or covering over her artwork, Molly, who was starting her interaction looked at the board in silence for a few seconds and then looked to me for help with starting a new file. Another behaviour which indicated that the children were experiencing their interactions with the IWB as having an individual turn was the queuing that was seen around the IWB. Children would stand in single file behind the person who was physically interacting with the IWB, often physically crowding the current user and pushing them towards the board. Sometimes, children who were waiting in the queue to interact with the IWB would become engrossed in watching the visual activity as it unfolded on the laptop screen and they would come to sit in front of this screen. If others then moved towards the IWB, they would quickly jump up to reclaim their place in the queue.

Not all children cared as much about removing what they had created or about beginning again when it was their go. Some children, like Molly, were unsettled by the possibility that what had been visibly created by an individual could be left open for further input by somebody else, but other children would interact with a text that had been left open, as described further, in the phenomenon of 'recurrent bodily practices'. Similarly, queueing behaviours did not always manifest and when they did, they did not always occur in the same way. For example, while waiting in the queue, some children would engage through speech and pointing with what was happening on the IWB, making suggestions to the person who was physically interacting with the IWB, and in this way beginning to engage in collaborative creative practices. So the behaviours that related to turn-taking were not fully conventionalized for all the children present in the class. As Russell et al. (2002) noted in their study of adults interacting with a large digital display, there was still room for negotiation as to how the resources would be drawn into the interaction and the 'etiquette' of social practices that would unfold around the resources.

Affordances

In terms of the material properties of the resources, the tendency to take turns and to organize practices around the principle of turn-taking could be related to

the 'oneness' of the input at the IWB. The children in the class were aware that the IWB would respond negatively to multi-touch input, and that this would sometimes lead to the computer crashing and the whole system having to be rebooted by one of the adults in the room. As a result, the children were regulating each other in order to protect the resources. As Lindley and Rogers (2004) note, passing around the act of input to a digital interface requires a high level of organization and is not always intuitive among groups.

As well as considering this physical aspect of oneness, we must engage with how the classroom context encouraged turn-taking practices. As one of the teachers explained to me, it was difficult at the beginning of the year for teachers to regulate children's interest and engagement with the IWB. As a result, the adults had put in place a regulatory turn-taking system in which an egg-timer would help the children to decide when their go was up and when they should hand over if another child was waiting. While the teacher noted that this system might not have been necessary for the entire year, becoming less important as children developed their skills of collaboration and grew more familiar with one another over the course of the year, she noted that the system had never been formally removed or changed, so that the children were still engaging in the same turn-taking behaviours as they had been taught to do so at the beginning of the year.

Links to collaborative creativity

The invitations and openings which are necessary for collaborative creativity to occur in art-making visibly manifest through the leaving of a started text in the state of process available to others' physical manipulation. In my observations, the children most often ended their interaction with the IWB by closing down what they had created and thereby closing down the opportunity for others to contribute. While interactive digital displays are designed with collaboration in mind, notions of what it means to begin and finish an interaction and expectations around turn-taking can prevent this collaboration from occurring.

These observations also demonstrate that sharing is not the same as collaborative creativity and that too strong a sense that resources are scarce and need to be shared 'nicely' can hinder collaborative creativity. The children were kind and considerate in terms of thinking about others' use on the IWB. The repeated act of covering over what had been created seemed to relate as much to a desire to be helpful to the person whose go it was next, as it did to a desire to protect what they had created, particularly as the process of covering over essentially undid

what they had created. In EY education, there is an emphasis on children learning how to share with others, but fostering collaborative creativity involves the active negotiation of resources. Simply passing resources over at a preplanned point in time cannot constitute the complexity and potential 'messiness' of collaborative creativity. In the case of the IWB in the EY classroom, there might not be the social space and time for this type of complexity to unfold; instead, children are encouraged to share and to be fair, and this limits how much creative togetherness can be achieved.

The practitioners in the classroom had a huge impact on how the IWB was used and the practices that developed around it. As mentioned, at the beginning of the year, they had placed an egg-timer next to the board that would help the children to manage the length of their interactions and to ensure that everyone had an opportunity to have a go. Through the egg-timer the board was constructed as something through which the children could play games, rather than as a tool for creative and open-ended interactions, with the scope to involve playful collaboration. With children's use of games with rules, interactions are constructed in terms of 'having a go' rather than as a process of making something. Through the egg-timer, the children each took roughly the same amount of time interacting with the IWB, and when someone stepped outside of this template 'go', they were admonished by other children for taking too long and being unfair. The construction of the IWB as a game-playing instrument rather than as a set of art-making or text-making resource relates strongly to previous findings that digital technologies are often seen by EY practitioners as being suited to games rather than open-ended creative and expressive activities (Edwards, 2013; Formby, 2014).

Practitioners would not typically think of regulating children's art-making on paper in a similar way. If children were painting, it is unlikely that there would be an egg-timer present to suggest when they should start and end their turn at painting. This is partly because the physical resources involved in painting are less scarce and so multiple children can be painting at any one time, moving fluidly between solitary, parallel and collaborative engagement, meaning there is less of a demand for careful sharing to occur and to be managed. However, we must also ask whether the practitioners saw the spaces as different beyond this parameter of scarcity; was the IWB seen by practitioners has having the potential to constitute a space in which creative trajectories could unfold in their own, distinct ways, unbound by time? It is difficult to know what the practitioners thought the children were doing when they engaged with the IWB since their own interactions with children around or about the IWB were not forthcoming.

The interview responses of practitioners reported in Chapter 2 would suggest that they did not imagine much potential for collaborative creativity to occur in the context of digital art-making on the IWB.

Interactive Audience

Indicative behaviours

Sometimes the children who were waiting to use the IWB would position themselves around the laptop, which was perched on the teacher's chair, to watch the visual activity on the laptop. The primary user, who was interacting directly with the board, would move between the space in front of the IWB and the space around the laptop. In this way, the space around the laptop would become a place for collective reflection and dialogue. Around the laptop, there would be conversations about what was being created and what should be done next. This was done through speech and also through the gesture of pointing, which was essential for the children's suggestions to each other about what should be done next. A common sequence of interaction involved a child touching the IWB, hearing the response of the children clustered around the laptop, stepping back to look at the laptop screen and engaging in an exchange with the children at the laptop about what should be done next. At this point, the main user would move back towards the IWB and stimulate further visual activity according to these interactions.

We can think about the children clustered around the laptop as constituting something like an audience. This audience was participatory to a greater or lesser extent depending on the particular interaction. Sometimes the audience would simply respond to the visual activity that they were watching on the laptop. For example, Amal clapped excitedly at the unfolding activity on the laptop, which was created through Corey's direct touch to the IWB. On the other hand, when the roles were reversed and Corey was sitting in front of the laptop and Amal was interacting with the IWB, Corey repeatedly tried to get Amal's attention and to direct her actions by showing her, through pointing, what was happening on the laptop and making suggestions about the next tools she should select. As well as a connection between the audience and the performer, there were collaborative creative processes unfolding between the members of the audience. For example, Amal and Corey both watched the visual activity on the laptop as Ewan had his go on the IWB. They would look at each other often

and use pointing to draw attention to particular aspects of the activity. Through these processes of consultation between user and audience, I would argue that a process of collaborative creativity was achieved, though this might not be how collaborative creativity was imagined by the designers of the interactive digital display. Previous literature from a design perspective suggests that digital displays support collaborative creativity through joint or shared physical manipulation of resources (Rogers & Lindley, 2004) while collaborative creativity was differently manifesting in these user-audience interactions.

Affordances

Moving back and forth between the IWB and the laptop was afforded by the two sites of visual display. The presence of the laptop screen meant that children could watch the visual activity without being in the way of the child engaging with the IWB. This was important as confrontations and conflicts arose when children crowded too closely around the IWB and the primary user felt that their turn was being infringed upon. The laptop thereby created a safe distance between the performer/user and the audience, but was also a key part in the construction of these roles and their distinct contribution to the collaborative creativity. The laptop was an important site of reflection, dialogue and collaboration partly because the physical activity of the art-making was more visible on the laptop then it was on the larger interface of the IWB. This was the result of the placement of the board in a direct shaft of light from skylights in the classroom which made it difficult to see what was occurring on the board. As a result of this difference in visibility between the smaller and the larger screen, the audience were more empowered than they might otherwise have been, since they could see more clearly the visual activity than the person who was physically manipulating the resources in order to produce this activity. This also contributed to the primary user's desire to step back and to look at the laptop screen, thereby sharing the space of the audience and fostering the participation and interaction that in turn contributed to collaborative creativity.

Of course, when connected to an IWB, a laptop is not only an alternative site on which the visual activity can be viewed; it is also a potential site of physical manipulation. In most of the observations I conducted, particularly earlier on in the week of observations, the children did not seem to realize that they could impact on the visual activity on the IWB through the touchpad of the laptop. Once this had been realized by children in the class, it often had devastating effects on the interaction that was unfolding and the sense of collaboration that

the interactive audience seemed to facilitate. This level of interaction, whereby the audience started to physically involve themselves in the visual activity on the IWB, would typically cause distress and anger in the primary user who communicated that their turn was wrongfully being intercepted and infringed upon by others. This leads us to consider an interesting dynamic in the facilitation of collaborative creativity, whereby collective reflection and idea-sharing can be seen to 'cross a line' if joint physical manipulation occurs without an explicit invitation from the primary user. This highlights the importance of stepping back in the context of collaborative creativity; it was in times of no or little physical manipulation that the children would share ideas and reference points with one another and make suggestions for how they could create together. On the other hand, physical manipulation, and certainly physical manipulation at two separate sites, seemed to inspire confusion, unmanageable complexities and ultimately conflict.

Links to collaborative creativity

In her classic ethnographic study of children's text-making on the classroom computer, Labbo (1996) suggested that one of the ways in which children could construct computer text-making was as a performance. She suggested that the visual activity on screen was sometimes used by children to entertain others in a way that places the priority on the process as it occurs and how this impacts on others in the here and now, rather than on a finished product that will be appreciated by others who are distant from the act of making the text. In my previous work, I have shown how art-making on a shared laptop in a classroom can also lead to this dynamic of performance (Sakr et al., 2016), and that there can be a high level of interaction between the audience and the performer, with the audience making it clear to the performer what they would like to see. In this study, involving the IWB, the same dynamic was present but the performer-audience interaction was shaped by the distinct affordances of having two viewing sites (the laptop and the larger screen) and two potential interfaces (the laptop touchpad and the board itself, both manipulated through touch). Furthermore, the interactions were shaped by properties of the resources which were particular to the context of this particular EY classroom, such as the poor visibility of the IWB as a result of the skylights positioned above.

We can think about the space around the laptop as a reflective, participatory space which enabled a level of collaborative creativity to occur in the form of interactions between a performer and their audience. The children had never

been taught or explicitly guided by the practitioners to construct the space in this way. This type of interaction pushed beyond the rigid turn-taking practices which I outlined in the theme described previously. Audience participation is a method sometimes used in pedagogic practices in the EY classroom where, for example, children will engage in 'shared writing' which is scribed by the teacher at the front of the class. The audience participation noted here is exciting though because it occurs without any teachers present and relates to an open-ended activity in which there is no right or wrong; the suggestions from the audience are ideas for an undetermined trajectory, whereas in shared writing the teacher is likely to have an idea about the end goal. Although audience participation might not meet strict definitions of collaborative creativity, where exchanges and interactions are more fluid and more equal (Rogers & Lindley, 2004), audience participation perhaps represents a productive starting point for collaborative creativity. It offers a structure through which children can move beyond turn-taking managed through an egg-timer, while still avoiding the conflict which was seen when multiple sites of interaction were available simultaneously.

The phenomenon of the participatory audience highlights the importance of multimodal orchestration in collaborative creativity. Verbal, gestural and manipulative modes of communication all play a distinct and essential role in the interactions which constitute this proto-form of collaborative creativity. These modes of communication had the power to push interactions into a state of conflict, or alternatively they could be vital in maintaining positive relationships and the demonstration of respect between audience and performer/user. For example, pointing and eye contact were fundamental in allowing children to make positive suggestions to one another about how the visual activity should progress. If physical manipulation was added in as a communicative mode, for example, when members of the audience stood up and touched a tool icon on the IWB, this put the collaborative process in jeopardy as the primary user felt that their turn was being infringed upon. While Mercer et al. (2010) mentions the importance of physical manipulation in the potentials of the IWB to act as a dialogic space, understanding how collaborative creativity manifests around different resources and is shaped differently by these resources requires a more fine-grained approach in the analysis of the multimodal orchestration, and a closer look at how particular modes are drawn into the unfolding interaction.

In a previous work conducted with Sara Price and Carey Jewitt, I have written about the role of the hands in scientific inquiry with older children and the ways that speech, gesture and manipulation can correspond to different thinking processes which enable collaborative inquiry (Sakr et al., 2014). In this research,

we argued that how these modes are drawn into the processes of inquiry are context-dependent, but that the same types of work (in the case of inquiry, the work of demonstration and generalization) can be achieved through the shift between modes, particularly in the shift between the modes of touch and gesture. In the case of this study, the movement between verbal, gestural and manipulative modes played a fundamental role in managing and negotiating collaborative creativity. Gestures were positive in fostering the sharing of ideas and reference points, while touch (other than that of the primary user's) infringed upon the positive dynamics between children engaged in activity with the IWB.

Recurrent practices and imitation

Indicative behaviours

There were two ways in which practices on the IWB would recur between children. First, children could continue from each other when the text that one child was making was left unfinished and remained as an open invitation for further visual input. This happened when there was a clear line of continuation, for example, when the process of covering over the screen in a single colour would be started by one child and then finished by another. Sometimes this continuation seemed to be accidental on the part of the child who had started the process, but at other times, one child would actively include another child to continue or finish what they had begun. This happened, for example, when Davey was unable to reach the uppermost edges of the board while covering over the screen and asked Ayman, who was waiting in the space around the IWB, to stand on the box in front of the board and cover over the places that he could not reach.

Alternatively, the imitation of particular practices could happen when children were working on different texts, that is, when a new file had already been started. For example, Lexi watched Liam covering over the board and then stamping one of the ready-made shapes around the board so that these shapes were evenly spaced and dotted all over. Once Liam had finished and had left the IWB (closing his file and starting a new file), Lexi practised the same processes of covering over and stamping ready-made images about the screen. In order for this to constitute collaborative creativity rather than just imitation, we need to see evidence that children's input built on others' engagement rather than just copying it. With Lexi, Liam and Eve, who all practised the same rubbing out and stamping sequences, we can see the development of layers in this visual activity,

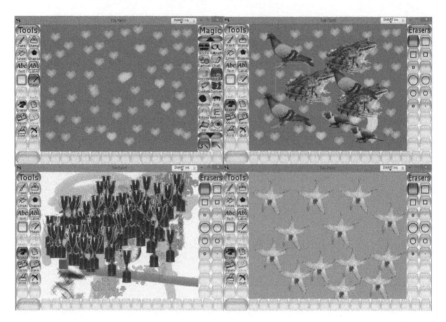

Figure 4.1 Imitating and developing the bodily practice of rubbing and stamping.

so that in the first go, the same single shape is repeated many times, but in texts that occur after this, there is a greater range of shapes being used and being layered on top of each other (Figure 4.1).

Affordances

Of course, imitation is not specific to digital art-making or the IWB. Imitation has been documented in all areas of children's activity and with all sorts of material resources. However, when we think about imitation in the context of art-making with more traditional resources, such as paper and pencils, we are likely to think about the schematic representations that children copy from each other and also from the adults around them, such as drawings of people and houses that follow the same schematic forms. In the context of the IWB, I did not see imitation in terms of pictorial representation, but instead in terms of a set of bodily practices that would lead to a particular type of representation that was abstract and did not contain a single discernible or coherent visual representation other than the content of the ready-made images themselves. This suggests that it was not the idea or interest that was being imitated among the children, but instead children saw what others were doing with their bodies and copied and developed this.

The IWB might afford this type of imitation as a result of its size and the way in which the whole body is engaged when interacting with it. The children could easily see one another and see what bodily practices a child engaged with when making art on the IWB. In fact, this aspect of the activity was more visible than the art-making itself, since the body of the child was in the way of much of the board and, as previously noted, the light in the classroom often made it difficult to see the screen of the IWB. Children could watch as someone used the IWB from close up or from far away, meaning that bodily patterns of interaction could diffuse throughout the whole class without any active demonstration. This builds on previous research, which notes the capacity of large interactive displays to bring the whole body to the fore and to heighten the physicality of the experience of engaging with this kind of interface (Fatah gen Schiek & Moutinho, 2012; Snibbe & Raffle, 2009).

Links to collaborative creativity

We need to question whether the observations of recurrent and developing bodily practices constitute a form of collaborative creativity. Existing models of collaborative creativity tend to place an emphasis on shared ideas and imaginative experiences, rather than shared forms of physical engagement (Chen, 2010; Craft & Wegerif, 2006).However, I argue that children are demonstrating similar levels of creativity when these bodily practices recur, since they are imitating each other and then building their own expressive movements on top of this baseline of response. When looking for collaborative creativity in spoken dialogue, we might look for the articulation of an idea, followed by another's recognition of that idea and suggestion for how it could be developed further. If we extend this sequence of events to other modes, then the imitation of a movement or form of manipulation, followed by a distinct but related movement or distinct form of manipulation, would also constitute collaborative creativity. So by focusing on the IWB and art-making resources that offer primacy to whole-body interaction, which is readily visible to others, we can open up our notions of collaborative creativity which might otherwise focus too heavily on the verbal dimensions of the process.

As well as privileging the body, looking at collaborative creativity in this context prompts us to engage more fully with experimental and abstract art-making practices, particularly when they involve pattern. As discussed in previous chapters, voices in art education have lamented the extent to which visual realism is constructed as the desirable endpoint in children's art-making (Anning, 2002,

2003; Duncum, 1999; McClure, 2011) at the expense of alternative forms of creative engagement. When the physicality of the art-making process is the focus of the analysis, rather than the unfolding visual activity, we are in a good position to become more aware of the thinking and doing processes that matter in the context of art which is non-representational. For example, through these observations I became aware of the importance of symmetry to the children when applying shapes around the board and the extent to which embodied geometrical understandings were shaping the interaction. As Kolbe (2005) notes, children's pattern-making is often a neglected area of pedagogy and research in art education. When children make art together on the IWB, pattern-making comes to the fore. Thus, the IWB is potentially more than just an environment in which collaborative creativity manifests; instead, it can extend and deepen our notions of what collaborative creativity is in early childhood art and what it looks like.

Conclusions

Through my observations of children engaged in digital art-making on the IWB during free-flow activity time, I have explored manifestations of collaborative creativity in digital art-making and how this may be facilitated or hindered by practices that occur in this context. In particular, I have considered turn-taking, audience participation and recurrent bodily practices as types of engagement that hinder or enable collaborative creativity. In considering how these particular practices are taken up and developed by children, I have looked at affordances of the IWB as a shared interactive digital interface and shown how these affordances are inextricably connected to a wider set of expectations and suggestions for use which are set up within the wider environment of the classroom at large. The notion of classroom-ness (Burnett, 2014) is important for understanding how digital art-making on the IWB is both constrained (e.g. through the need for children to 'share nicely') and transformative of the classroom environment (e.g. through a shifting focus of children to bodily movements as they occur in art-making and how these can be copied and developed).

In the introduction, I described collaborative creativity as an intercorporeal and intersubjective phenomenon. The observations described and analysed in this chapter demonstrate the primacy of the body in the togetherness that constitutes collaborative creativity in the context of art-making on the IWB in the EY classroom. The bodies I observed created and negotiated experiences

together before the emergence of a verbally articulated idea. The constant shifts in gesture, gaze, manipulation and gross movement were so fundamental to the processes of making art together on the IWB that without a focus on these modes, which are not speech, there could have been no understanding of how collaborative creativity occurred in this context, and how it was facilitated or hindered by the resources and the organization of time and space around these resources.

Focusing on the body not only challenges our working definitions and analyses of collaborative creativity, which tend to focus on the verbal articulation of ideas, but also helps us to expand our notions of art-making to look not just beyond the product, but also beyond the intellectual process verbally articulated, towards the bodily processes and sequences of action and interaction which comprise art-making. In having this focus on the body, we can see other trajectories than those we are used to focusing on in young children's art-making. In particular, thinking about art-making as a bodily experience, both one that is felt within and one that is visible through bodily doing, we move away from privileging art which is representational. Looking at the body helps us see the importance of pattern and experimentation in the art that young children make, and these have been neglected facets of early childhood art in previous research and pedagogic practice (Kolbe, 2005).

I am not arguing that previous research on collaborative creativity has not engaged with the physical dimensions of the practices which feed into it. Indeed, the literature on collaborative creativity with interactive digital displays often emphasizes the importance of physical manipulation in the 'dance' of collaborative creativity. Mercer et al. (2010), for example, mentions this as an important affordance in the construction of the IWB in a primary school classroom as a 'dialogic space'. Rogers and Lindley (2004) look for the passing of the instrument of physical manipulation as a measure of the effectiveness of the collaborative process. However, the tendency to place an emphasis on manipulation and impactful touch on the digital interface may prevent us from seeing other aspects of the embodied interaction that are equally important. In my observations, I was fascinated by the intricacies of the intercorporeality of collaborative creativity, whereby small shifts in gaze, gesture and movement were fundamental to the negotiation of the resources, though they had no immediate impact on the visual activity unfolding on the screen. In the phenomenon of audience participation, outlined above, the heights of collaborative creativity were present when no physical manipulation was occurring and when instead the children were gathered in the interactive audience space around the laptop reflecting

together on the 'what if' of the situation and possibilities for the next step to be taken; often this collaborative what if-ing was done through gestures and eye contact, as well as through speech. This finding relates to the work of Vass et al. (2008) which notes the importance of small nonverbal cues in collaborative creativity, such as glancing and giggling, and suggests that these are often more important than verbal dialogue in young children's collaboration. So in taking a multimodal approach, we must engage with the richness of the multimodal orchestration and not assume that it is the direct bodily input to the digital interface which matters most in collaborative creativity.

Just as we need to avoid focusing only on the physical interaction with the digital interface, when thinking about affordances, we have to look beyond the materialities of the device and consider how space and time are organized around the device in context-dependent ways. In the field of human-computer interaction (HCI) there is a tendency to locate affordances in the device itself. In the HCI literature on interactive digital displays, for example, the large surface area is often cited as an important property which affords collaboration (Rogers & Lindley, 2004). As I saw in my observations though, if an egg-timer is placed beside the IWB, this will also have a fundamental part to play in shaping how use of the resources manifests, and may even counter the affordances that designers consider to be present.

When we think about the work that is done by the egg-timer in the situation I have described, it is useful to invoke Burnett's (2014) notion of classroom-ness in the construction of digital resources. In this framework, the classroom is seen as both a distinct space that impacts on how resources are used in particular ways, while also being a constantly transforming space, which can in turn be changed through the presence and use of those same resources. In the case of the IWB in the EY classroom, the turn-taking practices which I saw were a fundamental aspect of classroom-ness in early childhood education, whereby sharing is an important part of social development in the eyes of practitioners and in the objectives outlined in guidance documents on early learning. At the same time, the introduction of the IWB into this classroom space could change and shape differently our notions of turn-taking and sharing.

Clearly, it is important to think about how practitioners construct the space and time that is organized around the IWB. As discussed previously in Chapter 2, practitioners' organization of the space and time around digital art-making resources, in this case the IWB, suggests something about their perception of creative potential in these resources or rather the lack of it. Whether wrongly or rightly, when rating creative potential as high in an activity for children,

practitioners will often stand back and construct looser relations between the activity, time and space, so that there is less regimentation and regulation in how the activity unfolds. As McClure (2011) argues, the 'mythic speech' that surrounds early childhood art involves the idea that creativity is inherent in young children and should be allowed to develop without interference from adults. It is unlikely that an egg-timer would feature in an activity of painting because this would suggest that creativity could be bound within time, and practitioners in early childhood are unlikely to make this association. In the case of the IWB however, the organization of time through the presence of the egg-timer, and the organization of the space through the presence of a box that the primary user could stand on, suggests that the activity of interacting with the IWB was not seen to be one with much creative or collaborative potential. This relates to previous findings that suggest that a line is often drawn in EY practice between digital technologies and free-flow play and creativity (Edwards, 2013). How space and time can be constructed differently around digital technologies, including the IWB, would be an interesting avenue for practitioner-led inquiry or action research in the future.

While it is important to recognize the influence of the practitioners on collaborative creativity as it was manifest in this context, it is also important to note that the negotiation of the resources between the children was ongoing. As Russell et al. (2002) note about the use of the large interface for adults in a public space, the etiquette of interactions around whole-body digital interfaces needs to be negotiated and established over longer periods of involvement. It is interesting to note that while the children had been interacting with the IWB during free-flow time for almost a full academic year, how they would engage with and construct the resources was diverse. As noted in my findings on turn-taking, children would leave texts open or closed to further interaction from others to different extents. We can make sense of this by predicting that the etiquette of the interaction will become more 'fully and finely articulated' over time (Jewitt & Kress, 2003, p. 2), or we can suggest that resources are diverse in what they afford, and that these diverse, sometimes contrasting, affordances can coexist and simultaneously shape processes of collaborative creativity.

Affective Alignments and Moments of Meeting in Child-Parent Digital Art-Making

Introduction

In popular media, digital technologies have been presented as hindering close-ness between individuals and damaging our social skills. Recent newspaper articles lament that 'digital technologies and TV can inhibit children socially' (*The Telegraph*, 2014) and 'access to screens is lowering kids' social skills' (*Time*, 2014). Advertisements for the latest mobile digital technologies, including tablets and phones, typically show a single person using them, suggesting that they are devices designed for solitary and individual use. When an emphasis on connect-edness is made, the focus tends to be on relationships between individuals who are distant in time and/or space (e.g. connections enabled through social media or video calling) rather than on facilitating closeness in the here and now between individuals using technologies together at the same time and in the same place. In the case of early childhood education, where pedagogic approaches empha-size immediate relationships developed in shared spaces such as the home or the classroom, the rise of digital technologies in these environments is accompanied by concerns that children will not engage socially with one another or collaborate effectively (as the interview findings in Chapter 2 highlighted).

This chapter explores further how closeness can manifest in situations of digi-tal art-making. It focuses particularly on the closeness that can occur between a child and parent when they engage in digital art-making together, and considers a situation of child-parent iPad photography around the home as an example of this. To consider how closeness and emotional engagement can manifest in this type of situation, I use discussions of affect and the concepts of affective alignment and disalignment. To analyse the closeness as it unfolds, I use the notions of 'moments of meeting' (Stern, 2000, 2004) and 'rhizo mo(ve)ments' (Sellers, 2013) as a practical means through which to access how social closeness

and distance are physically visible. Both of these notions draw attention to the instances in which individuals are attuned emotionally to one another. Through video observation of two episodes of iPad photography in the home, I focus on when and how these instances of closeness occurred and whether the activity of iPad photography can be seen as supporting the development of these moments.

As I will show, the findings from this study suggest that iPad photography can support closeness between a child and a parent because of the activity's capacity to focus their joint attention on dynamic aspects of the surrounding environment. While static art-making requires collaborators to create the content of the art-making between them, I will show that mobile art-making, as facilitated by iPad photography, enables the art-making to focus outwards instead and for both partners to draw inspiration from the external environment together. In addition, the portability of the iPad (or similar mobile digital devices) means that the activity of art-making – in this case, taking photographs and then organising them into a multimodal narrative – can occur in a wide range of physical environments, including informal environments. This in turn means that children and adults can come together in moments of physical closeness in environments that are conducive to affection and intimacy.

On the other hand, I will also explore how moments of affective dis-alignment can arise during episodes of iPad photography, and what these moments can suggest about the limitations on closeness in children's digital art-making. Affective dis-alignment occurred as a result of discrepancies in the child's and adult's approach to taking photographs. In this chapter I argue that these dis-alignments do not suggest that digital art-making contributes towards the erosion of social skills in general, but rather that dissonance and distance in children-adult interactions during digital art-making encourage us to consider how much young children have to teach us about alternative ways of understanding and doing photography, and other types of digital art-making practice. At the end of this chapter, I argue that digital mobile photography is an exciting activity for strengthening positive relationships between children and adults and for encouraging adults to listen to children's voices in art-making and to learn from the different ways that children see and frame the world around them through the practice of photography.

Closeness in child-parent art-making

Art-making has been noted as an important context for heightening closeness between individuals. Proulx (2003) suggests that making art together enables

individuals to be more responsive to one another and as a result, closeness is heightened in contexts of art-making. Collaborative art-making involves the creation of a situation in which individuals strive to have a shared reference point and to develop on the ideas of one another (Chen, 2010; Craft & Wegerif, 2006). This requires that individuals are ready to attune to one another and assume knowledge of the other's thinking. The potentials of art-making to foster closeness and attunement are important when we think about child-parent relationships. Collaborative art-making has been used in therapeutic contexts to help children and parents come closer to one another and develop more positive relationships. Hosea's (2006) research focused on the interactions of six mothers and their young children while making art together. Through video analysis of the interactions, Hosea noted moments of particular attunement between children and mothers and attempted to trace the aspects of the art-making environment that were particularly supportive of these moments. Hosea found that the children and their mothers became closer in relation to particular facets of the art-making experience, including the use of colour, the enjoyment of making a mess together and the use and interpretation of symbolism within the art-making process. The research suggested that art-making acted as a leveller between the children and the adults in this situation, helping the mothers to be more aware of their children's wants and needs than they might have otherwise been: the mothers had 'space to see their child as a thinking, creative being in his or her own unique way' (p. 70).

While Hosea draws attention to colour, mess and symbolism, others have suggested that the physicality of art-making and its emphasis on nonverbal interaction and somatic knowing are the means through which it can powerfully affect individuals' relationships. When we make art together, the typical emphasis we place on language decreases, and other modes, such as body position, gesture and facial expression, come to the fore. Vass et al. (2008) found in a study of collaborative creative writing among 7–9-year-olds that even though the task related to verbal outcomes, much of the idea generation manifested through nonverbal modes, such as giggling and touch. Vass et al. refer to these as 'affect-driven discourse markers' and suggest that they play a larger part in collaborative creativity than we tend to expect, as I touched on in the previous chapter. In art-making, the physicality of the activity is even more pronounced. The movement and manipulation of objects and materials is a fundamental aspect of art-making that gives collaborators another means through which to develop a level of somatic attunement with one another (Denmead & Hickman, 2012; Springgay, 2005). The materials become a physical language in their own

right, and through the emphasis on bodies and embodied knowledge, individuals can experience closeness in new ways and to new extents. For children and adults this might mean moving away from the potential barrier of language and towards a more level platform where both parties communicate through the body and the art-making materials.

Closeness in child-parent digital art-making

As mentioned in the introduction, popular media often portrays digital technologies as a hindrance to children's sociality. This has been echoed to some extent in the academic literature. For example, Turkle's (2011, 2015) ethnographic work suggests that as a result of increasing dependency on digital data and environments, individuals are less successful in their 'real' relationships. According to Turkle, the ease and predictability which characterize our interactions with digital technologies mean that we have less understanding of face-to-face confrontation with others and we are less able to cope with this situation when it arises. Increasingly, she argues, we are turning to our digital devices for feelings of social and emotional reward, since they offer us a stress-free and relatively predictable environment to inhabit.

However, Turkle's concerns are not supported by a growing body of small-scale studies that focus on micro-interactions involving individuals and digital technologies. Many of these studies suggest the opposite of what Turkle argues – that digital technologies, depending on the way in which they are used, can bring individuals together and help to foster collaboration and community. For example, Kucirkova et al. (2014) looked closely at the interactions between a mother and a young child as they took photographs with the iPad and arranged these photographs using the multimodal story-making app Our Story. The researchers found that the processes of taking the photographs and incorporating these into a shared narrative helped to facilitate moments of shared positive affect between the child and the parent. Through the processes enabled by the iPad, the dyad developed a shared understanding of the experiences they had recorded together through the photography.

Similarly, Mavers (2007) conducted a case study focusing on an email exchange between a six year old child and her uncle. She found that through email the child, Kathleen, was able to develop a new sense of closeness with her uncle. She was less troubled by formal conventions of communication than if she had been composing a letter on paper. Instead her emails were written in an

enthusiastic tone and stemmed from the desire to share news immediately. This suggests that digital tools can enable closeness through their association with informality and immediacy.

It is not only in the home that small-scale studies have suggested the possibility that digital technologies can have positive impacts on closeness, collaboration and community. Carter-Ching et al. (2006) looked at the use of digital photography in a primary classroom and found that episodes of photography were characterized by distinct dynamics between the children and teachers, in which the teachers relinquished some of their authority and worked more collaboratively with the children in their class. In this study, digital art-making (in the form of photography) acted as a leveller between the children and the adults and enabled them to become closer.

So while popular media and some longitudinal ethnographic research suggest that our relationships with digital technologies are detrimental to our social lives and how we forge connections with others, studies focusing on micro-interactions tell a different story. They suggest that when individuals use digital technologies together, they can be supported in attuning to one another and sharing positive affect. In particular, I have focused on studies that suggest that children and adults can develop new forms and levels of closeness through their collaborative use of digital technologies, and particularly through their collaborative engagement in the activity of digital photography. In the following section, I will consider more fully how we can investigate closeness through the concept of affect, understanding affect as something that is made visible in interactions through affective alignments and dis-alignments. I introduce the concepts of moments of meeting and rhizo mo(ve)ments as a way to access affective alignment and dis-alignment through the analysis of observations of embodied interaction.

Affect

To develop insights into the idea of closeness, I am using theories of affect which conceptualize affect as an intersubjective phenomenon that flows between individuals, keeping them together or driving them apart. Affect is a term that has been used in various ways and within a vast range of disciplines. In the context of phenomenological approaches to the reception of cultural artefacts, Shouse (2005) suggests that affect can be understood as an experiential shift in the intensity of feeling. According to this notion, affect is something which precedes labelling through the culturally defined categories of emotion and it is thought

to exist in the preconscious experience of the individual. When conceptualizing affect in this way, it makes sense to measure it through physiological probes capturing heart rate or skin arousal (Shami et al., 2008) and potentially through self-report, though this relies on the preconscious experience having been brought into consciousness.

Within the affective turn in the social sciences, however, affect has been conceptualized as a phenomenon that exists between individuals rather than as something which occurs within the individual. When considering how affect plays into interactions with digital technologies, Shami et al. (2008) suggest that there needs to be more of a focus on 'group affect' and an understanding of how affect arises in social situations. Poststructuralist perspectives building on Deleuze and Guattari's writing on affect go further than suggesting the coexistence of individual and group layers of affect. Instead, they suggest that affect is best understood as an entirely intersubjective phenomenon – as the potential to affect others and be affected (Fox & Alldred, 2014; Ringrose, 2011). In this conceptualization, affect is understood as an 'action position' towards the world (Bradley & Lang, 2000), which is always relational to the surrounding environment and always in flux. To capture this, the term 'affect flows' draws attention to how affect is always moving and being produced in what Goodwin (2007) describes as the 'constellation of language, environment, body and action' (p. 61).

How can we investigate or capture affect flows? Ringrose (2011) and Fox and Alldred (2014) both borrow the notion of 'schizoanalysis' from Deleuze and Guattari in an attempt to develop methods that engage with affect as an intersubjective phenomenon. Ringrose (2011) describes schizoanalysis as a way of 'mapping complex, embodied, relational, spatial, affective energies' (p. 599). In Ringrose's study of adolescents' interactions in and around social media, this was approached through the collection of interview responses recounting events. These recounted events were then analysed in relation to the theoretical notion of affect and an understanding that how affect flows between individuals can either reinforce or destabilize the striated space of day-to-day interactions, either consolidating or disrupting existing hierarchies that exist in a social context.

This approach honours an understanding of affect as something that exists between people and determines the dynamic that unfolds between different individuals, as well as the relationship between these interactions and wider society. However, the approach does not suggest anything specific about how affect is made visible in interactions and how it can be observed by the researcher. The example of rhizoanalysis outlined earlier relies on the recounting of events by participants and analysis of these narratives, rather than by observing

interactions as they unfold. The work of communication studies experts can be helpful in determining how to approach an analysis of affect which focuses on interactions. Goodwin (2006) approaches affect as something that happens through embodied interaction, including through speech and other modes of communication, such as body posture, position, movement and so on. In her study of everyday family interactions, Goodwin shows how the trajectories of an interaction can lead to 'affective alignments' (p. 516), which are visible through the organization of the participants in space.

Building on this, with a focus on the affective alignments and dis-alignments between a father and a daughter during an episode of homework, Goodwin (2007) suggests that affective alignments are dependent on the organization of bodies into participation frameworks. This builds on the seminal work of Goffman (1961, 1972), which refers to the creation of a participation framework as an 'ecological huddle' in which attention is shared between participants and meaning is made together. The ecological huddle is an observable phenomenon in which bodies come together and construct a shared physical reference point. Goodwin argues that establishing this type of participation framework is particularly important in situations of apprenticeship where 'the participants create a public, visible locus for the organization of shared attention and action' (p. 58). So in a situation of a child and parent making art together, affective alignments would be characterized by the creation of an ecological huddle between the child, the parent and the materialities of the art-making experience or skill that is being invested in. Through a joint focus on these materialities, the child and parent construct a shared orientation towards the world that enables them to see the world together and to establish an affective alignment, achieving new levels of closeness. In an affective dis-alignment, bodies move in a way that disrupts the ecological huddle and breaks the common reference point.

A concept that complements and helps us to operationalize the notion of affective alignment is moments of meeting. Stern (2000, 2004), an infant psychologist, introduced the concept of moments of meeting to describe moments of heightened attunement between children and parents. In these moments, children and parents behave in a way that is based on a 'mutual knowing of what is in the other's mind' (Stern et al., 1998, p. 4). Through moments of meeting, children and parents feel closer and experience a new 'intensity of joy' (p. 6), which in turn strengthens their overall relationship. For Stern, moments of meeting are observable. Typical examples would include explosions of mutual laughter during play and instances when a parent supports a child to do something that they might have previously been scared of doing, such as using a

slide in the playground. Stern does not offer strict rules for identifying these moments, just as Goodwin and Goodwin do not offer rigid guidelines for identifying affective alignment and dis-alignment. However, all these researchers suggest that the emotional dance of child-parent interactions is something which plays out through observable embodied interaction. This supports the use of a multimodal interaction analysis as a way to develop insights into closeness as it unfolds in a particular episode of joint activity.

Similarly the concept of rhizo mo(ve)ments (Sellers, 2013) suggests that the moments in which we distance ourselves from others emotionally are visible through bodily formations that correspond to the disruption of closeness and hierarchy. It suggests that affective disalignment is visible through individuals physically moving apart or losing a common reference point for their embodied interaction. According to Sellers (2013), rhizo mo(ve)ments are moments in which a 'line of flight' is taken and the interaction moves away from expected behaviours and striated interaction. Thus, rhizo mo(ve)ments need not be understood as a negative phenomenon, though they are disruptions in closeness between individuals.

Investigating child-parent iPad photography in the home

To look in more depth at closeness in the context of digital art-making, I want to explore whether and how children and parents can be brought closer through the shared activity of digital photography using the iPad. In this chapter I present two observations of a child and a parent as they engaged in episodes of iPad photography. My focus in these observations is on how affective alignment and affective dis-alignment are realized and made visible in the context of the interaction, and how these are shaped by the activity of photography and by the affordances of the iPad.

The observations are of my three-year-old niece and her father (my brother). At the time of the study, the girl was the only child of the family. She attended an inner-city London nursery each weekday between 8.00 am and 5.30 pm, where she was described by the nursery practitioners as making above average levels of educational progress. Her father was thirty-fve-years-old at the time of the study and worked as a journalist. The father picked up his daughter most days from the nursery and the pair frequently engaged in shared activities when at home, and this sometimes, though not often, included making art together. More typically, according to the father's self-report, they engaged in

physical play or text-making that they constructed as 'writing' rather than as 'art-making'.

The observations were part of a wider study I conducted in the child's grandparents' home over the course of three months. The entire study looked at artmaking with various materials over the course of eight weekday evenings, but the observations I focus on in this chapter stem from just two episodes of activity, both involving iPad photography. During each episode, I provided the iPad with a preloaded app, Our Story, for use by the child and her father. I used a handheld video camera to record the episodes of interaction. I was careful to interrupt the child and father's activity as little as possible, though of course, as the child's aunt, I was sometimes drawn into the interaction and tried to respond sensitively.

I approached the video data through the lens of multimodal interaction analysis. As mentioned earlier, multimodal analysis is appropriate given my emphasis on how affective alignments and dis-alignments are made visible through embodied interaction. Multimodal analysis enables a focus on different modes of interaction and for equal weight to be given to these different modes, avoiding the tendency to prioritize language in interpretations of collaborative action. The first step of this analysis was to create a rough multimodal transcript of both episodes. The transcripts documented verbal and nonverbal actions against time stamps. By annotating these transcripts while simultaneously watching the video files, I developed an interpretation of when and how affective alignment and dis-alignment was occurring. To be in a position to offer more concrete examples of affective alignment and dis-alignment, I identified moments of meeting (as moments of affective alignment) and rhizo mo(ve)ments (as moments of affective dis-alignment). I looked for moments of meeting and rhizo mo(ve)ments and marked on the transcript when these appeared to be occurring. In 'reading' the bodies of the child and the father, I was heavily influenced by the works of Goodwin (2006) and Goodwin (2007), and their focus on participation frameworks, which builds on Goffman's notion of the ecological huddle.

Once I had isolated moments of meeting and rhizo mo(ve)ments, I conducted an in-depth analysis of these segments of the video data. My interest at this stage was in how the activity of digital photography and the device of the iPad were being drawn into the unfolding interaction and how they were contributing to the closeness or lack of closeness manifest in that particular instance. In this chapter, I offer an overview of the moments of meeting and rhizo mo(ve)ments that I identified, as well as examples which are presented as 'impressionist tales' (van Maanen, 1988) of the action. The accompanying commentaries suggest

how the activity and the device contributed to and shaped the moments of meeting and rhizo mo(ve)ments that were occurring.

Tables 5.1 and 5.2 are designed to offer an insight into what the moments of meeting and the rhizo mo(ve)ments looked like in the context of the activity observed. Brief descriptions of the interaction suggest how these moments visibly manifested. A summary of each table helps to offer an overview and provide some broad categories for the different types of moments of meeting and rhizo mo(ve)ments that were observed. A commentary following each table provides analysis of how the activity and the device fed into and shaped these moments.

Moments of meeting

As Table 5.1 demonstrates, moments of meeting between the child and the parent manifested in different ways. They occurred through the joint manipulation of the device by the child and the parent, as when the parent was physically guiding the child's initial use of the iPad and showing her how to take a photograph. This type of interaction created a close physical connection between the child and the parent which was mediated by the device. There were also heightened levels of physical affection at various points in the two episodes. These typically occurred when the child and the parent had finished taking photographs and were collaborating to decide how to position these in the story using the app *Our Story*. Finally, moments of meeting occurred when the child and the parent responded together to changing elements in the external environment, such as the phone ringing. Their mutual response to these events drew them closer together in the activity and led to participation frameworks which in turn suggested strong affective alignments.

Different properties of the activity and of the device seemed to contribute to the manifestation of affective alignment in these various ways. The joint manipulation of the device by the child and father, which in turn facilitated a mediated physical closeness, was enabled through the size and weight of the device, which made it possible for the device to be handled in this way (see Figure 5.1). It was not just the physical properties of the device however that contributed to the joint manipulation. The father used joint manipulation as a way of structuring the activity at the outset and offering some of the skills to the child that he saw as essential for the activity of taking photographs. By positioning the child in front of him and taking turns to manipulate and interact with the device, the child was learning which button to use to take photographs and how to frame

Table 5.1 Moments of meeting

Instance (Time)	Brief description	Features of the moment of meeting
iP1.1 (0.00–0.10)	D and M are holding the iPad together. D is holding the iPad and M is leaning in towards the iPad, looking down at it. D asks: 'Shall we tap it?' M whispers 'yeh.' D has turned the camera so that it is looking up at M and D. He says: 'That's me and you, shall we take a photo?' M whispers 'yeh.' 'Press the button then.' M presses the button.	Shared activity involving close physical contact and a shared intention.
iP1.2 (0.50)	D and M are holding the iPad together. D is positioned behind M holding the edges of the iPad and helping to direct the iPad. He says 'And when you're ready, we'll press the button, ok, shall we take one of Mona?' D starts to reorientate the iPad so that they rotate the angle of their bodies and of the iPad towards the researcher and then they take a photograph.	Shared activity involving close physical contact and a shared intention.
iP1.3 (2.35–3.00)	Phone rings and the researcher goes to pick it up. M and D follow the researcher, who picks up the phone and says 'Hello' M walks right up to the researcher, holding the iPad out in front of her, D puts a hand on her shoulder and whispers 'that's it, stand here'. He is moving M backwards a bit M's gaze is on the iPad screen D crouches and helps M to position the iPad, they take a photograph Researcher replaces the receiver and whispers.	Shared activity involving close physical contact and a shared intention to capture a particular moment. Also a sense of conspiratorial activity as indicated by the whispering.
iP2.1 (0.36–0.56)	The iPad is on the floor with the camera pointing upwards at M's face. M looks down and presses the button lots of time while making funny faces. D says M's name repeatedly in a funny voice. M looks at the researcher and laughs.	Sharing positive affect – laughing and smiling.

(continued)

Table 5.1 Continued

Instance (Time)	Brief description	Features of the moment of meeting
iP2.2 (6.26–6.46)	D and M are lying on the bed creating their 'story' by dragging images into the timeline at the bottom of the screen. M says: 'I want to put it, I want to put it.' M tries to drag the image onto the storyboard. First time is unsuccessful and second time is successful. D praises her – 'Good job.' M cuddles D and he laughs 'you're funny.' 'Daddy, I love ya.' 'I love you too.'	Close physical and verbal affection.

Table 5.2 Rhizo mo(ve)ments

Instance (Time)	Brief description	Features of the rhizo mo(ve)ment
iP1.1 (1:52–2:20)	M points the camera at a bag in the hallway. D stands back 'What is it?' 'Mona's bag.' M already walking away and positioning the camera to take another photo – of the phone. 'And what's down there? Wait to take it, that's it.' D walks towards the front room 'Shall we go in the front room?' But M repositions the camera around where she is and takes more photos. D laughs. 'Shall we go in the front room and see what we can see?' D begins to open the door to the front room, the gaze is on M who is looking at the iPad screen, and continues to take photos of the objects around her. D tries to get M's attention – 'M?' His hand is pushing the door open. 'Yeh?' M asks distractedly. Then M walks towards the front room and through the door 'I've finished.' They walk into the front room, M first, D following.	Pulling in different directions both in terms of the activity and physically. Father wants to move on in a particular direction and with a particular pace; child is resistant and continues to take photographs of what is of interest to her.

Table 5.2 Continued

Instance (Time)	Brief description	Features of the rhizo mo(ve)ment
iP1 (3:30–4:00)	M takes a photo of the door. And then comes out of the bathroom. 'Careful, careful, don't be too rough with it.' M tries to go behind the door 'hey' and D helps her so she can take a photo of the shower.	Chastisement for child's handling of the iPad. Child resists adult's expectations in terms of direction and pace.
iP1 (4:40–4:46)	D points into the kitchen 'what about the rubbish bin in there?' 'Done!'	Child resists adult's suggestions about how the activity should unfold. Child and adult feel perceive having finished differently.
iP1 (5:00–5:30)	'We've got to see the photos that we took and we've got to make a story out of them … Shall we try that?' D tries to pull M onto the couch but she moves away. 'No, that's not what Mona said. 'Shall we ask Mona what does she want.' 'Yeah.'	Different interpretations of the activity.
iP1 (6:44–6:53)	'We need to choose the good ones … Oh, did we take this one?' 'Yeah.' 'So we're going to drag this one.' 'No I want to do something.' 'No because they're not the ones we took.'	Different interpretations of the activity. Different interests in the content of the photography.
iP1(12:20–12: 27)	'We take a picture of a chair.' 'Good girl' D kisses M on the head. 'Daddy, what time is it?' Looking at D's watch.	Child loses interest in the activity and pulls against her father's instructions and encouragement.
iP2 (3:40–4:00)	M looks at the researcher – 'Mona can you be Tatty?' D goes through the other apps on the iPad, distracted. M looks, smiling, between D and researcher.	Child and father's attention is on separate activities. They do not have a joint activity.

(*continued*)

Table 5.2 Continued

Instance (Time)	Brief description	Features of the rhizo mo(ve)ment
iP2 (8:56–9:10)	'Now we have to do the speech … now we have to tell the story of what we did, so how do we do that?' M leans on D, looking away from the screen of the iPad. 'We add a title.' 'Noo, daddyyy' M is making a whining noise.	Child loses interest in the activity; father continues.
iP2 (10:00–10:20)	D finds how to make the audio. 'No I'm not going to bite you, I'm going to tell a story, I'm going to tell a story,' Tatty and M play. D is trying to get M's attention 'M, add sound to this one, what's happening in this photo?'	Attention is not shared.

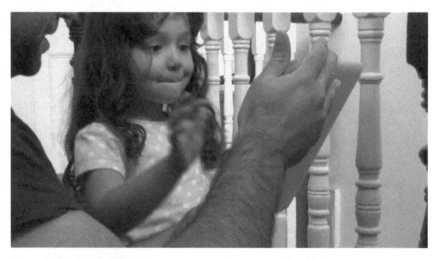

Figure 5.1 Joint manipulation.

the photograph in the way the father recommended. Beyond the perceived need for tuition or apprenticeship, joint manipulation was also a response to the perceived fragility of the device and the concern on the part of the father that the device would drop and break. At various points in the activity, when the child was manipulating the device by herself, the father would say, 'careful, don't drop it.' This suggests that he may have felt more comfortable with joint manipulation because it was a way to protect the device.

The shared immediate mutual responses to the events in the environment, such as the phone ringing, were enabled by the nature of the activity of photography. Collaborative photography creates a situation in which the shared gaze is turned outwards to the environment and hones in on events and experiences that are of interest. While non-digital photography might place a particular focus on scenes of interest or beauty, digital photography enables the photographer to try and capture fleeting moments of interest or beauty, rather than scenes that exist beyond just a transient moment. The increased storage available through digital photography and the potential to review and discard photographs that have been unsuccessful means that more risk can be taken in order to capture these interesting moments of flux and change. Multiple photographs attempting to capture the same moment can be reviewed later and either saved or deleted. In the episodes observed in this study, these aspects of photography helped to forge the closeness of the child and the father since they became closer in the pursuit of these passing moments and in responding to them together. For example, they ran together quickly down the stairs towards the phone in order to capture the moment of me picking up the receiver and in doing so, shared an instance of particular attunement.

The heightened physical affection that I observed (see Figure 5.2) was facilitated through the mobility of the iPad, which made it more likely that it would be used in physical contexts associated with informality and physical closeness. While the other art-making activities I observed between the child and the

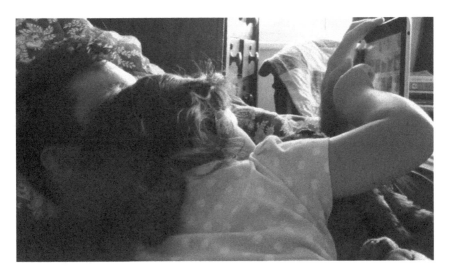

Figure 5.2 Affection in informal environments.

father were conducted while sitting side by side at a table, their photography happened all over the house. The activity of collating and organizing the photographs together happened in typical contexts of closeness – on the living room sofa in the first episode and on a bed in the second episode. In these environments, the child and the father adopted a much more relaxed body posture than if they had been sitting at the table. The child move closer to her father in both situations resting her head on his body and they responded to this physical proximity with words and actions of affection.

Rhizo mo(ve)ments

As Table 5.2 shows, rhizo mo(ve)ments could occur in a range of different ways. At times, the child and the father appeared to be pulled in different directions while taking photographs. In these moments, they had different perceptions of what would be an interesting subject matter for a photograph and different perceptions of how the activity should be conducted, for example, the extent to which it was necessary to frame photographs or take them while still. Once the child had developed the skills necessary for taking photographs, she was more independent in the task and the father would follow behind making suggestions. At times, he would chastise the child for her handling of the iPad telling her to 'be careful' and 'don't drop it'. These comments were not met by any response from the child who carried on with the activity she was engrossed in. Rhizo mo(ve)ments also appeared during the activity of collating the photographs and organizing them into a multimodal narrative. The father adopted a leading role in this activity and the child frequently lost interest, changing the subject or suggesting that they should do something else.

Affordances of the iPad and perceptions of the activity clearly had a role to play in how the rhizo mo(ve)ments outlined above unfolded. As mentioned, the child and her father sometimes appeared to pull in different directions when taking photographs. This was physically apparent through their distinct bodily orientations towards the environment and the dissonances between the pace that they each adopted in the activity. The father's conceptions of how photography should be done were being challenged by the child's interest and engagement in the activity. Typically, the father would adopt a regular pace as he moved through the environment, suggesting at regular intervals that they stop and take a photograph of a clearly defined object – the phone, the bag, the radiator and so on. On the other hand, the child was much more likely to become absorbed

in taking photographs of the same object, changing her physical orientation towards the object of interest ever so slightly and then taking a stream of photographs which caught an impression of motion in which the particular object was not discernible. The father displayed confusion but also interest in the child's desire to take these kinds of photographs. The child and the father clearly had different perceptions about how the activity 'should be done' and this created moments of diversion, where their bodies and intentions seemed to be pulled apart (see Figure 5.3).

In thinking about moments of meeting, the perceived fragility of the iPad device came up as an attribute that facilitated the joint handling of the device. At other times though, this perceived fragility led to affective dis-alignment between the child and the father. This would occur when the father chastised the child for her handling of the device and suggested that she was not being careful enough. The child did not explicitly respond to the comments that the father made suggesting that she needed to be more careful. She continued to engage in the activity of taking the photographs. It was not clear whether she had not processed what had been said to her or whether she was wilfully ignoring her father. In these moments however, the participation framework or ecological huddle became unstuck. The child was in close connection with the device and the father's involvement manifested as interference in this connection, rather than helpful guidance. As Goodwin (2006) notes, in order for an expert-apprentice relationship to develop successfully in a particular moment, it is important that

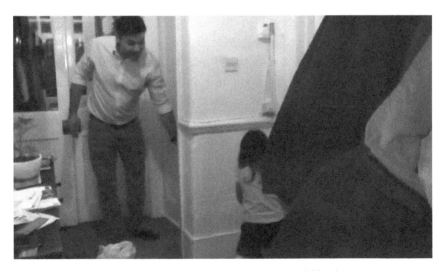

Figure 5.3 Different perceptions of how photography should be done.

both parties are aware that they share a common reference point, ideally moving their gaze between each other and the artefacts that are the subject of the apprenticeship. In the moments of dis-alignment reported here, the child's visible attention remained on the iPad and she showed no sign that she had taken in what had been said to her by her father.

The child and father applied a different level of attention to the activity of collating and organizing the photographs that had been taken into a multimodal story using the app Our Story. In both episodes, the father applied more attention to this task than the child, who was keen to finish and move on from the task. He described the child's participation as 'a bit distracted' in the post-episode questionnaire. This difference suggests that the child and the father had different perceptions of what constituted the task and/or different perceptions of how important it was 'to finish' the task. For the father, the task was complete through the creation of the story and the playback of that story. For the child, the task of taking the photographs and then reviewing the photographs for the creation of the story were two separate activities. Her enjoyment of, and interest in, taking the photographs was not jeopardized by not making a story using the photographs.

Opportunities and limitations in closeness during digital art-making

Photography as a shared activity may have a special potential to forge a shared responsiveness to the external environment since it encourages individuals to focus on the transient environment (Barthes, 1977). In collaborative photography then, individuals can come together in a recognition of and response to this transience, and in sharing a 'momentary stillness' (Knight, 2013), may develop new levels of closeness with one another. Another aspect of child-parent art-making that has been highlighted in previous literature is its physicality. It has been suggested that art-making can be an equalizing force between children and adults since there is less emphasis on verbal articulation and instead nonverbal communication and expression comes to the fore (Denmead & Hickman, 2012; Springgay, 2005). The physicality of the activity appeared to be important in the episodes of child-parent iPad photography reported here. There were many moments of joint manipulation and physical affection in which the collaborative processes unfolded almost entirely through nonverbal modes of communication.

It was interesting to note, however, that at other times there was a dissonance in the level of verbal communication engaged in by the child and the father.

In moments when the child was going 'off track' in the eyes of her father or was losing interest, the father increased his level of verbal communication while the child was unresponsive. A similar phenomenon was reported by Goodwin (2007) in their study of family directive-response sequences, in which parents would increase their verbal input during moments of potential tension. As discussed in previous chapters, research on children's art-making has highlighted the tendency of adults to have preconceptions about how art-making will and should unfold (Clark, 2012; Knight, 2013; MacRae, 2011). It seems that when these preconceptions are challenged by how children actually engage in an activity, adults may resort to verbal communication as a way to bring the task back towards what they had expected. Further research on child-adult interactions during art-making is needed to identify whether there is such a shift from nonverbal to verbal communication in moments of affective dis-alignment.

Previous studies on children's micro-interactions with digital technologies have suggested how closeness can be impacted by the particular affordances of digital devices and activities. In a case study of child-parent interaction, Kucirkova et al. (2014) suggested that constructing a shared multimodal narrative using photographs that had been taken together helped to develop closeness. Those findings were not repeated here as the child was most likely to lose interest during the narrative construction element through the app Our Story. On the other hand, Mavers's (2007) finding that the informality and immediacy of the digital environment can facilitate closeness between children and adults was supported by findings from this study. The portability of the iPad enabled it to be used in informal contexts and for a mutual response to flux in the external environment; these were both important contributing factors to the moments of meeting that manifested in the episodes that were observed. In a classroom study of collaborative digital photography, Carter Ching et al. (2006) suggested that collaborative photography could create new child-teacher dynamics since teachers were just as likely to learn from the children during this activity as the children were likely to learn from the adults. My observations suggest that this type of effect is dependent on the level of experience of the adults in engaging with digital photography. Here, the father, who often took digital photographs, positioned himself as the expert at the beginning of both episodes. Having said this, the findings of Carter Ching et al. were also supported by the way in which the child's style in taking photographs did challenge and intrigue the father. This suggests in future episodes of taking photographs together, if both parties were open-minded, they would learn and take inspiration from one another.

Conclusions

While there have been suggestions in the popular media that digital technolo-
gies are detrimental for children's social skills and their closeness with others,
research on children's micro-interactions with digital technologies suggest that
they can reconfigure closeness and potentially even enhance it. In this chapter,
I have explored this further through the concept of affect and an understanding
of affect as an intersubjective and embodied phenomenon. I have used observa-
tions of how closeness between a child and a parent manifests during episodes
of iPad photography around the home in an attempt to probe further how the
iPad device and the activity of photography may differently shape the closeness
that develops between the child and the parent. The work of Goodwin (2006)
and Goodwin (2007) on participation frameworks offers a helpful lens through
which to analyse affective alignments and dis-alignments during episodes of
digital art-making.

By charting moments of meeting and rhizo mo(ve)ments across two epi-
sodes of child-parent iPad photography, I could trace patterns in how social
closeness and distance were made visible through the interaction and iden-
tify broad categories into which these moments could be organized. Affective
alignment manifested through joint manipulation of the device; mutual
responsiveness to the external environment and heightened physical affec-
tion. Affective dis-alignment manifested through physical differences in how
to approach the task and the father's chastisement of the child for her han-
dling of the device. By examining particular moments in-depth, I explored
the affordances of the device and the activity that appeared to contribute
to these forms of affective alignment and dis-alignment. While the activ-
ity directed mutual attention towards the external environment, and this
appeared to strengthen participation frameworks, the different perceptions
of how photographs should be taken and of what it meant to finish the task
created situations in which the child and the father appeared to be pulling
in different directions and this contributed to dis-alignment. Although we
can conceptualize this as affective dis-alignment, the child's challenge of the
father's notions about how to take a photograph and what should be done
with those photographs once they have been taken, suggest that collaborative
photography can also help to produce situations in which parents learn from
their children, and not just the other way around.

What can we learn about digital art-making in general from these episodes of child-parent iPad photography around the home? The analysis I have presented in this chapter highlights the importance of paying attention to the physical details of the digital art-making situation in which a child is engaged in. The properties of the physical-digital artefacts that they use, along with wider aspects of the situation they are in, will shape how closeness can unfold during digital art-making. If we are interested in enhancing potentials for closeness in digital art-making, it is necessary to look at what the particular device being used can afford. If it heightens the mobility of the activity and enables individuals to engage in art-making in informal environments, it is likely to support the creation of moments of closeness. At the same time, we need to recognize that when children playfully engage with digital art-making, they can disengage from the adult expectations that surround the activity. This might appear as a type of distance and dissonance between children and adults engaged in the activity, but we should value children's ingenuity in digital art-making and in doing so, we may be looking for moments of dissonance.

Sensory Experience: Stimulation, or Lack Thereof, during Digital Art-Making

Introduction

Touch and sensory stimulation are important features of art-making and the relationship that artists develop with their materials. When using screen-based digital technologies in art-making, the sensory experience is radically altered. Mangen (2010) suggests that screen interfaces are characterized by 'intangibility' in that how touch affects the screen and the digital output is fundamentally different to how touch affects objects in the physical environment. Some researchers have characterized the felt experience of interacting with a screen as a reduction or loss (Crescenzi et al., 2014; Kress, 2005). On the other hand, Flewitt et al. (2014) suggests that interacting with digital technologies involves distinct and new layers of touch, which may extend on what happens in physical environments rather than being seen as an impoverished version of physical or 'real' touch. The issue of touch in digital environments is further complicated by the distinct theoretical and methodological orientations that researchers in HCI have taken in their investigations of it. While some have focused on touch as a visible mode of interaction which impacts on the world and makes things happen, others have prioritized notions of touch as part of felt experience, so that they focus more on how things are felt within the individual as opposed to how touch is used.

To contribute to these discussions, in this chapter I describe observations of a 24-month-old 'finger painting' on the iPad via two apps designed for children's art-making. In order to explore touch as both a mode of interaction and a facet of felt experience, I integrated an action camera into the child's activity as part of these observations. This picked up different visual perspectives and offered a fuller sense of the 'messiness' and networked nature of how touch and sensory stimulation unfolds in naturalistic settings. Through the findings from

this study, I will argue that the iPad screen simultaneously diminishes touch experience, offering little immediate feedback through the sense of touch, and widens the meaning and repercussions of touch, since digital environments have the potential to open up worlds of previous sensory experience and draw these into the here and now. This chapter also argues for the development of methodological approaches to touch and sensory stimulation in children's digital art-making that consider the whole body and the whole device. If we focus only on the hands as instruments of touch and only on the screen, our conceptions of how touch is enacted and experienced in physical-digital environments will be severely constrained, since children's interactions are often with the entire size, weight and texture of the digital device, and can be carried out through various parts of the body. Finally, I argue that action cameras, offering something of the object's perspective on the unfolding experience, can provide new insights into how sensory stimulation unfolds in its wider context and how sensory engagement is a facet of the entire ecology of an interaction, and not just the 'body-thing dialogue' (Larssen et al., 2006).

Sensory stimulation in early childhood art

Specialists in early childhood art often place an emphasis on bodily experience, and some even prioritize this facet of art-making over representational intent. As Jarvis and Lewis (2002) argue, for example, early experiences of art and design should be highly exploratory and playful so that through an interaction with materials, children can invest in the processes of problem-making as well as problem-solving: 'an apparent aimlessness can be a virtue' (p. 127). The focus on the body over internally driven intentions leads to a simultaneous focus on the materialities of the art-making assemble, so that early childhood art is understood as an 'entwinement' of places, bodies and materialities (Løkken and Moser, 2012). In this view of early childhood art, the bodily relationship between a child and the materials that they use is conceptualized as an active negotiation, in which the materials provoke responses through their physical resistance and properties. Springgay (2008) and other poststructuralist thinkers have offered us a language for making sense of this relationship; the assemblages of early childhood art are framed as 'forces, oscillations, intensities and energies' (p. 2) that put the emphasis on the processes and entanglements through which the body, and thereby sensory stimulation, are drawn into art-making.

Artists try to invoke particular types of bodily experience through their organization of and engagement with materials. Denmead and Hickman (2012) draw attention to what adult artists value in the materials they use in the context of pedagogical projects and in their own art-making practices. They suggest that artists seek bodily relationships with materials that enable 'slowliness', which is conceptualized as 'an immersive pleasure state free from past prescription and future expectation' (p. 2). The physical properties of materials can contribute to the achievement of slowliness or can hinder its development. For example, the artists interviewed as part of Denmead and Hickman's study had a desire to use materials with children which had a large degree of 'slippage', that is, materials that were not associated with a singular set of affordances, but instead had the potential to be used in a wide variety of ways. For example, while clay is likely to be associated with the process of sculpting a single object, materials of the every-day – like masking tape – afford diverse interaction. They also valued materials which would invite immediate physical engagement rather than initial thoughts about what to represent through the medium, as might be the case with crayons and paper for example. Linked to this, there was an emphasis on ephemerality so that individuals would not become so attached to the products of the art-making and thereby disengage from the experimental processes of playing with the materials.

In theoretical accounts of early childhood art and arts-based pedagogies, the body is framed as a means through which we can stay with the unfamil-iar and the disruptive, and in doing so, we experience the world differently in 'slow, childlike time' (Denmead & Hickman, 2012, p. 10). This resonates with Deleuze and Guattari's distinction between 'common sense' and 'sense-making'. While in a common sense ontology, we recognize the world according to tem-plates which we accumulate and store internally, in a sense-making ontology, we encounter constant difference and engage with alterity in order to defer the constraints of recognition (Deleuze & Guattari, 1987). Similarly, in the method-ology of 'making strange' (Loke & Robertson, 2008), which builds on the dance practices of Maxine Sheets-Johnstone, the aim is to disrupt our knowledge of the world by disrupting the familiar and habitual movements through which we come to know the world. Through explicit inquiries into movement and pur-posefully making ourselves feel the discomfort of unfamiliar movement, we can open up new spaces in the way we understand and design the body-material-environment assemblage (Loke & Robertson, 2008).

In this section, I suggest that there is a special role for bodily experience in the practices of early childhood art. Arts-based pedagogies frame art as an

experience that arises through the negotiation of bodies and materials and resists familiarity and recognition. It is through the body that we can attain a state of 'slowliness' and immediate physical engagement in which experimentation and play are brought to the fore (Denmead & Hickman, 2012). Important in achieving this state are the properties of the materials that are used in the art-making experience – how open-ended they are, the immediacy of the interactions they invite and their ephemerality.

Sensory stimulation in interactions with digital technologies

If the properties of art-making materials are seen as important for providing the right conditions for the state of 'slowliness', which is in turn seen as integral to art-making, then we need to consider how digital technologies and digital-physical assemblages impact on these conditions. Denmead and Hickman (2012) report scepticism among the adult artists that they interviewed with regards to the use of digital technologies, along with artificial materials such as plastic, in art-making activities. Building on Shusterman (2008), they suggested that digital technologies can overstimulate the senses and lead to a desensitization to the small differences in physical experience that are fundamental to arts practices. The idea that digital technologies are overstimulating is echoed in popular news stories, which suggest that the increasing use of digital technologies in childhood and the tendency of digital environments to offer high levels of visual and auditory stimulation might negatively impact children's attention spans (e.g. 'Kids, Tech and Those Shrinking Attention Spans', *Huffington Post*, 2014).

The artists in Denmead and Hickman's study stated a preference for natural materials, which they saw as more likely to 'draw the body into the liminal space where its senses pleasurably touch and are touched upon by rich materials' (p. 8). This quotation highlights sensory pleasure and richness as facets of the touch itself, rather than as potential consequences of the sensory outputs that might arise as a result of touch in the context of a digital environment. There is a distinction here between touch that is both input and output simultaneously and touch which is used as an input in order to produce an output which is less immediately connected (e.g. a changing visual display). Mangen (2010) describes the latter type of input-output relationship as 'intangibility' and argues that further research is needed to understand the impact that digital technologies and the intangibility that they involve are having on children's experiences. When a child touches paint, they immediately feel the paint and see the effect

of moving their body through the material. On the other hand, when a child touches a screen to produce a paint-like effect in the context of a finger-painting app, there is only an indirect relationship between this touch and the object of manipulation. As a result, Mangen suggests that digital technologies prioritize sight over touch as the arbiter of experience and could create a 'phenomenological detachment between action and perception' (p. 425). This would have important repercussions for early childhood art given the importance of the body and touch in arts-based pedagogies, as outlined in the section above.

While some researchers think about touch as having a reduced role or quality in interactions with digital technologies, others suggest that 'virtual touch' needs to be conceived of differently. In a study observing children's use of iPads in a school for children with severe physical disability, Flewitt et al. (2014) considered how different types of touch were used in the classroom, including virtual and vicarious touch. Building on recent discoveries in neuroscience of mirror neurones, which fire when touch is enacted or when it is observed, Flewitt et al. suggest that there are multiple layers to the nature and experience of touch which must be considered in the context of interactions with digital technologies. When using touch-screen interfaces, touch may not directly manipulate the objects that are on screen, but in seeing the manipulation unfold, however indirect, a kind of vicarious touch sensation may occur. Flewitt et al. refer to this as 'further layering of haptic experience' (p. 108) and suggest that when observing interactions with digital technologies, we have to probe further the 'complex relationship between real, vicarious and virtual touch' (p. 114). Springgay (2005) also highlights alternative manifestations of touch in digital contexts, and Kim (2001) similarly suggests that digital environments open up new opportunities for the construction of intercorporeal practices.

Research comparing children's finger painting on paper and on the iPad suggests that how touch is used as an interactional mode differs depending on the technology. A study by Crescenzi et al. (2014) looking at touch in finger painting with seven preschool children found that when using the iPad, the children aged 2–3 years used a wider variety of touch types and more touch overall as compared to when they were finger painting on paper. The researchers linked this to the physical affordances of the iPad which allows continuous finger painting without the child having to stop in order to replenish the paint. While the use of more touch and of more diverse types of touch could be seen as a potential 'gain' in the digital environment, the researchers were keen to highlight some of the potential losses also. These losses related not so much to touch as a mode of interaction and communication, but instead to touch as a fundamental facet

of felt and lived experience. They suggested, for example, that while the children may have enacted a more diverse range of touch actions, the diversity of the touch experience was reduced when children were finger painting via a screen rather than with paint on paper. They noted the lack of messiness in the digital environment, which could be seen as constraining in an approach to early childhood education which values messy play (see practitioners' comments on this in Chapter 2). At the same time, the researchers observed that for some children, the mess of finger painting with paint on paper was off-putting and shortened their engagement with the materials (Price et al., 2015).

Theoretical and methodological approaches to studying touch

Touch can be observed as an interactional and communicative mode. When this is the case, touch is recorded as something which is visible and plays into the unfolding interaction. For example, Crescenzi et al. (2014) recorded visible parameters of touch, such as the duration and type of the touch that was enacted by the children they were observing. This approach involves a multimodal analysis of video data in which the focus is on action and interaction as it is made visible, as opposed to how it is felt by the participants involved in the interaction. The touch that is enacted can then be linked to the non-human materials that are involved in the interaction through the concept of affordances (Kress & Jewitt, 2003). For example, Crescenzi et al. (2014) were able to conclude that the type of touch that occurs when children finger paint on an iPad will depend on the iPad's properties and the behaviours these afford. This includes the size and weight of the device, its portability as well as the perceived fragility of the object. As Prior (2005) notes, affordances are a complex network of physical properties and learned associations which arise in the moment and are best understood as 'blurred, complex and mutual relations' (p. 26). Nonetheless, a multimodal approach stresses that through observable behaviours, we can develop a stronger understanding of how interactions are shaped by the digital environments in which they occur (Price et al., 2015).

On the other hand, phenomenological research on individuals' interactions with digital technologies have attempted to turn inwards, so that rather than a focus on how interactions play out and are socioculturally mediated, we instead engage with the 'radically material condition' of digital experiences (Mangen, 2010, p. 417). Mangen argues that too much research in HCI has looked from

the outside and focused on how interactions are socially constructed, rather than engaging with the perceptual and sensory facets of experience. In Shusterman's (2008) conceptualization of somaesethetics, This relates to the distinction between the representational and experiential foregrounding of the body. While multimodal approaches focus on the body at a representational level, they do not offer a way to engage with the experiential body. Thus, while Crescenzi et al. (2014) comment on the lack of messiness in interacting with the screen and suggest that this is a difference between finger painting on paper and on the iPad, they are not able to comment on how messiness or the lack of messiness is experienced by children.

While the distinction between a representational and experiential focus on the body might be an easy one to make theoretically, when we begin to frame research that focuses on bodily experiences in interactions with digital technologies, the difficulty in making this type of distinction becomes clear. For example, in the paper of Larssen et al. (2006) entitled 'How it feels, not just how it looks', the title clearly relates to a desire to focus more on the experience of interactions with technology as felt from within rather than as simply observed from outside. In order to do this, Larssen et al. develop the metaphor of 'the body-thing dialogue', which relates to 'how we use our proprioceptive sense and motor skills when incorporating a tool in our bodily space so that it becomes an extension of our bodies' (p. 2). The metaphor of dialogue that Larssen et al. use as their theoretical foundation suggests, however, that this phenomenon is observable and externalized, highlighting that when we try to access the physically felt experience, we often have to start with what can be seen on the outside.

What methodologies have specially been developed for engaging with the felt dimensions of touch rather than touch as it is enacted on the world? From a research perspective, there is no way that touch can be recorded as touch. We can make records of touch which transduce touch into another mode, for example, recording patterns of touch in the form of visual transcripts, but we cannot engage analytically with the touch itself, except in the moment of occurrence. In sensory ethnography, which places an emphasis on embodiment and emplacement, Pink (2008) suggests that visual images can help us to engage and re-engage with what is felt within: they can 'invite us to imagine ourselves into other people's worlds, and in doing so to empathise with their emplacement' (p. 6). Thus, while there is no way to capture touch as touch, visual representations of a situation, in the form of a photograph or video, can evoke highly physicalized memories of the touch experiences that were occurring in the situation. In the context of film studies, Laura Marks has similarly suggested the notion of

haptic visuality, which presents the camera as 'grazing' rather than gazing over spaces and materials (Marks, 2004).

Building on the idea that the visual can help us to remember our own and empathize with others' sensory experiences, first-person, wearable video cameras have been suggested as a breakthrough in phenomenological methodologies. Glăveanu and Lahlou (2012), in their use of first-person cameras to record the craft activity of Easter egg painting in Romania, argue that this tool offers an important insight into the 'phenomenological tunnel' of the participant. Through a follow-up interview with the participant, in which the first-person video is viewed together, there is a chance to discuss together, in a vast amount of detail, the goals and sub-goals that were guiding the participant's action, and the felt experience that accompanied these actions. Wearable cameras that can capture the world from the perspective of a particular individual offer an exciting potential in the context of examining digital technologies in early childhood art. In the observations presented in this chapter, I attempted to combine the use of researcher-generated and first-person visual data, in the form of photographs and video, as a means for accessing the felt experience of one child while finger painting on the iPad.

In conducting the following observations, I wanted to explore how we can effectively think about the sense and mode of touch in relation to digital technologies in early childhood art. In particular, I wished to focus on how different layers of sensory experience, as suggested by Flewitt et al. (2014) – the virtual, the various and the real – play out in a child's interactions with the iPad when it is used for finger painting activities. I was interested in how the affordances of the iPad were made visible through the interaction as it unfolded, and in turn, how these affordances relate to the sensory and bodily dimensions that artists prioritize in their relationships with art-making materials (as discussed by Denmead & Hickman, 2012).

Observing touch in finger painting on the iPad

The observations focus on a single episode of a young child finger painting on the iPad in the home of her grandparents. I recorded this episode of activity as the child's aunt during a Saturday when some of the extended family were together for lunch and an afternoon of play. Along with the child (called Salma from here on in), present in the house and room were Salma's grandparents and Salma's mother. In this relaxed social context, I was interested in what would

unfold when Salma was encouraged to play with the iPad and to use two apps that both encourage a form of finger painting, though in different ways: the Pocoyo colouring app and the magic painting app. When I say 'encouraged to play' I mean that I opened up the apps on the iPad and lay the iPad on the sofa and then observed what happened. Salma was eager to interact with the apps, and her mother, her grandfather and myself all supported her use and engagement through questioning and physical collaboration.

Salma was two years old when these informal observations were made. She lived with her mother and father in a flat a short bus ride from where her grandparents live. She regularly visited her grandparents and is very familiar with the house. I see Salma on a regular basis and she is comfortable when interacting with me. This made it possible for these observations to occur as Salma is otherwise quite shy and reluctant to engage in exploratory activities when she is in the presence of strangers. Surrounded by her family and in a relaxed atmosphere, she was happy to explore the iPad activities and I was able to capture this engagement through video and photography.

To record the interaction, I used the Polaroid Cube Lifestyle Action Camera. This is a micro-camera which exists in a frame of about one cubic inch. The casing around the camera is made of durable rubber and is coloured bright blue with colourful stripes down the side. I protected the camera further by keeping it in a rubber pendant case that could be hung from a clip or from a piece of string. I decided to use this action camera as a means through which to gather both third-person and first-person footage of Salma's experience of interacting with the iPad. In the context of the interaction, Salma was excited about the action camera, which was a new object to her and was small and attractive to hold. She often reached for the camera and held it for much of the time that she was also interacting with the iPad. Salma clearly identified the action camera as a camera, as she would pick it up and hold it up to her face, looking down the lens and saying 'Cheese'! (see Figure 6.1).

Using this type of camera offered a research experience that I have not previously had. In the past, I have used traditional video cameras, either handheld or mounted on a tripod. In using these video cameras, the recording has seemed to be somewhat divorced from the experience and interaction the camera was being used to capture. In this experience, the camera was instead fully embedded in the interaction and the playfulness that characterized it. Salma's engagement with the camera was part of the camera's presence in the situation right from the start – particularly as I unpacked it while Salma was present and she was very enthusiastic about being involved in removing the packaging and pressing all

Figure 6.1 Salma saying 'cheese' to the camera.

the buttons. She was often excited to hold the camera and would grab it out of my hands and hold it in one hand while interacting with the iPad with the other hand. At other times, Salma did not notice the action camera and I would place it on a nearby horizontal surface or on my knee in efforts to capture the interaction from a third-person perspective as it unfolded. So the camera's role moved fluidly between capturing first-person and third-person perspectives.

In addition to the first-person and third-person video footage that was produced through the action camera, I took photographs with a camera phone. I used these after the interaction as a way of evoking memories of the experience which then became the basis for retrospective field notes.

The analysis focuses on six photographs taken by me on a phone camera and four fragments of video captured on the action camera. One of these fragments of video is made by me; two are fragments of video captured while Salma held the action camera and engaged in activities on the iPad simultaneously and the final fragment of video involves me holding the camera to begin with and Salma then reaching for the camera. Initially, the analysis focused on the researcher-generated visual data – the six photographs and the single video fragment. Based on these pieces of data, I wrote notes with the purpose of (1) remembering details of the experience in the way suggested by Pink (2015) and (2) starting to unpick some of the themes that relate to the nature of touch as it is experienced by a child when engaging with the iPad for the purpose of finger painting and colouring activities. The commentaries on the visual data therefore comprise a mixture of transcription, description, remembering and initial impressions about the nature of Salma's sensory experiences and how this played out in the

touch context offered by the iPad and the digital-physical network of the entire interaction. Once I had developed these initial themes, they were further refined and explored through the first-person footage that was collected. I envisaged the first-person data as having the capacity to trouble and extend the conclusions I was starting to draw from the third-person perspective data, and to deepen my insights into the research questions.

Below I report my findings as a series of themes about Salma's sensory experience. For each theme, written descriptions and visual data are presented to offer insight. Each theme is expressed as a statement about the nature of the sensory experience that Salma enjoyed, or about how we need to think about sensory experience in this kind of context. I am by no means suggesting that the themes which are reported here in relation to sensory stimulation and children's use of digital technologies for art-making correspond to all children's interactions. Salma is not representative of all young children and I fully recognize that the ways in which she engaged with the iPad are particular to her and particular to the context in which she was in – a plethora of factors would have shaped the way that she engaged with the iPad. Rather than trying to argue how touch will or is likely to manifest in this type of digital art-making experience, I use these observations as a way of engaging productively with the challenge of how we think about touch and sensory experience in the context of research on digital technologies in early childhood art. Of course, these findings could be examined further with a broader sample, but I hope that even in their limited scope, they will offer insights into sensory experiences in children's digital art-making.

Interaction unfolds with the whole device, not just with the screen

In Figure 6.2, Salma is sitting on the sofa with the iPad in front of her, just within the corner of the shot. Her attention is on the action camera which she is holding up to her face with both hands. She is looking into the lens and is repeatedly saying 'Cheese' as she puts it closer to her nose. Her interest in the camera is evident from this photograph. She was present while I took the camera out of its packaging and tested it for the first time. The bright blue colour and the rubbery texture of the object appealed to her. She bounced the camera case on the ground outside saying 'boing boing', showing that she associated the texture of the camera with a bouncy ball. The size and weight of the object were also appealing since it made the object easy for her to lift and manoeuvre. In addition, I worried less

Figure 6.2 Interaction unfolds with the whole device.

about her playing with the camera because of the rubber casing, which made it durable and relatively safe from breakages. The size of the camera meant that Salma would often hold the camera in one hand while doing something else – including art-making on the iPad.

Through my interpretations of the data, I became aware of the close physical relationship that Salma developed with the action camera, which is of course its own mobile digital technology, just like the iPad. In considering Salma's interaction with the action camera, her physical interactions with the iPad were thrown into relief. In particular, the easy way in which she manipulated the action camera and embedded it within her highly physical play contrasted with her interactions with the iPad, which typically remained horizontal on a surface in front of her. My statement that we need to engage with the affordances of the whole device, and not just the screen, relate to the ways in which Salma's interaction with the iPad was limited as a result of its size and weight. Although the iPad and other tablets are typically celebrated as highly portable devices, the iPad in Salma's interactions was not as mobile as the action camera. In addition to the size and weight of the iPad, this was also attributable to the adults' attitudes that surrounded each device. While the action camera was durable, the iPad was seen as fragile. When Salma picked up the iPad and held it up high – an action that involved considerable exertion (Figure 6.3) – the reaction from the adults in the room was one of concern that the iPad would fall and break. You can see in the image that her mother helps to hold up the iPad, holding the top of the device, which infringes upon the independence

Figure 6.3 Salma holds up the iPad; her mother helps to hold it up.

of Salma's physical interaction and impacts upon her subsequent interactions with the device.

When we think about children's sensory experiences with digital technologies, we tend to think about the touch and other sensory dimensions that arise through interaction with the interface, which is typically the screen. Salma's desire to pick up the iPad from the sofa and her constant physical playfulness with the whole of the action camera (and not just the lens) highlights the importance of engaging with how touch plays out in relation to the whole device. In thinking about the iPad in this interaction, the possibilities for physical engagement that it offers to a two-year-old child are very limited. Although the iPad is advertised as a portable device, and is typically seen as such by adults, a tablet of this size and weight is difficult for a young child to incorporate into physical play. In addition, without a rubber casing, the iPad is seen as fragile by adults that surround the child, and they are likely to guide the interaction more carefully than if a more durable material were used.

The iPad screen diminishes the touch experience

In Figure 6.4, Salma is using one finger on her right hand to 'colour in' the picture on the screen. She uses just one colour, and although she was shown how to change the colour by myself and by her mother, she decided to use just one colour

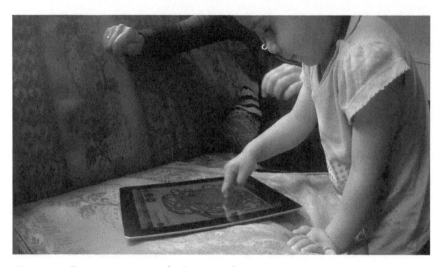

Figure 6.4 Finger painting on the Pocoyo colouring app.

throughout the period of interaction. In the photograph, you can see that Salma is pressing extremely hard with her index finger, which bends at the top knuckle under the pressure. Her mother commented on how hard she was pressing and said playfully 'Salma, you're going to hurt your finger if you press that hard!' Her grandmother asked her mother whether she pressed that hard when she was colouring on paper and her mother said that she did press really hard but only so that the pencil would go through the paper which was an effect she enjoyed.

It is difficult to know why Salma pressed so hard. The pressure she used made no difference to the visual outcome – a light touch would have been just as effective as a heavy touch in creating the marks that Salma was making. In addition, the pressure that Salma used made no difference to the texture that she felt. While on paper, her pressure would break through the paper and create an entirely different felt and visual effect, her pressure in this environment only leads to a feeling of pressure on her fingertip, but does not change any other parameters of the touch. I suggest that because of Salma's inability to change the touch that she is experiencing as a sensory output (even when she changes the touch she uses as a mode of input), the screen can be seen as diminishing her touch experience. By this, I mean that the touch is one-way, with her differences in touch as input failing to correspond to any equivalent differences in touch as output.

Figure 6.4 further highlights the monotony of the physicality of the iPad's screen surface. The smooth surface of the iPad contrasts in this photograph with the woven, rough cushion which sits beneath the iPad. When Salma was younger and unable to walk, she used to sit on the sofa and rub these cushions

with interest, feeling the texture carefully. Would a baby rub an iPad screen with the same interest? When we touch paint, there is a visual effect, but there is also the experience of the interesting textural qualities of the paint, which change depending on the touch. Pressing harder will change the texture of the paint under a finger, but the same is not the case for the iPad. This is what Mangen (2010) describes as the 'intangibility' of the digital and what Kress (2005) and Crescenzi et al. (2014) conceptualize as a loss in children's interactions with digital environments.

The sensory experience of interacting with the device must be seen in the entire network of experiences that are occurring

In Figure 6.5, Salma is interacting with three devices at the same time. While squatting on the sofa, she holds the action camera with her left hand. In her right hand, she is holding the phone and then with her index finger she interacts with the iPad, which is lying on the sofa. Each of these devices offers a distinct sensory experience through their different textures, sizes and weights. They are drawn into a single unfolding interaction in a way that was not uncommon across the entire episode of observation. In particular, Salma often held the action camera in one hand and interacted with the iPad in the other. This means that while we might see the iPad screen as diminishing touch experience, we have to think about Salma's sensory experience in terms of the whole device (as highlighted previously), and also in terms of a network of devices and materials that feed into her engagement in the activity as it happens.

The networked nature of Salma's sensory experience goes beyond the various digital devices that are drawn into the interaction. As Burnett et al. (2014) describe, each experience with a digital environment involves a network of material and immaterial components that are in constant engagement with one another. In Figure 6.5, Salma's touch is not just involved with the three digital devices, but also involves the touch of her feet on the sofa and the texture of it beneath her and through her socks, the feeling in her legs of crouching in this particular position, the positioning of her back against the back of the sofa and so on. Making art engages the whole body even when we place an emphasis on one part of the body through labels like 'finger painting'. Conceptualizing touch in children's digital experiences requires an engagement with the multiplicity of touch that occurs at any one time in an experience.

Figure 6.5 Salma interacts with three digital devices simultaneously.

Beyond touch in this moment, observations of Salma also highlight the fluidity of interaction across time. Over the course of the photographs and screenshots shared in this chapter, Salma moved about the room. The visual data presents moments selected on the basis of interaction with the iPad, but for much of the afternoon, Salma was interacting with other objects. She played with other toys that were in the room including a cuddly toy of Peppa Pig; she ate her lunch at the table (in the same room) and looked out of the window with her mother and pointed out what she could see. Clearly, the sensory experience that arose through direct touch of the iPad was embedded within multiple, diverse and constantly changing interactions with the surrounding environment. This highlights the need to put what Flewitt et al. (2014) refers to as 'virtual touch' into context, and to see it as a relatively small part of the sensory engagement that occurs during an episode of digital art-making.

Digital transformations create distance between input and output

One of the apps that Salma used on the iPad was called 'magic wand painting'. In this app, a user can choose a particular visual effect that they would like the finger painting to create. Music in the background creates an intense and immersive atmosphere. As you can see from the screenshot of the app in action

Figure 6.6 Magic wand painting app.

(Figure 6.6), the effects that are created through the finger painting are transient so that the marks which are left behind with the finger drop down and eventually 'fall off' the screen, or they twinkle and then disappear. This is different to what occurs with finger painting on paper where visual effects remain until they are actively changed.

The diversity and transience of the effects that are created through finger painting are 'magical' in that they are the result of a digital transformation which is not visible to the user. Salma's input was through touch and the primary output was visual. However, even this visual effect had been magically transformed so that it was unpredictable and unknowable. As a result, the distance between the users' input and the output is substantial – not just cross-modal but modified in unpredictable ways.

Digital technologies can evoke sensory experiences from the past

I have already explained how Salma's interactions with the iPad were just one part of a network of experiences that involves other devices and an array of non-digital components, which were in constant flux. This network of sensory experience also extends into the past, and it does so through what Flewitt et al. (2014) describe as virtual touch. Flewitt et al. suggest that physical engagement

with digital devices can evoke sensory experiences that are not immediately present or visible. They can have a sensory richness that is not in their immediate physicality but in their associations with past and possible events. In these associations, touch is remembered or experienced vicariously. In Salma's interaction with the iPad, this can be related to past experiences that Salma remembered and expressed during her interaction.

In Figure 6.7, Salma is sitting on the sofa, leaning over the iPad which is perched on a cushion on the sofa. She is using an app on the iPad which involves colouring in characters from Pocoyo, which is a television programme she enjoys watching. Her engagement with the app involved frequent recognition and labelling of the characters that she recognized. She showed excitement about these characters and looked to her mother for affirmation as they often watch Pocoyo together. Watching Pocoyo is an important sensory experience that Salma regularly engages with. It involves its own physical and material dimensions. Through the virtual touch of engaging this app, this experience was drawn into the interaction and became part of its richness and multiplicity. Similarly, when Salma saw the iPad and the phone, she repeatedly said 'Lola', referring to the programme 'Charlie and Lola', which is another one of her favourite programmes to watch. Salma's layers of experience, which extend beyond this specific episode of interaction, are made visible through these moments of remembering. They highlight the need to consider not just the touch that is occurring in the 'here and now', visible to the researcher, but to see the networks of touch that move beyond the present and correspond to multiple other experiences.

Figure 6.7 Salma engages again with the Pocoyo colouring app.

First-person data

As mentioned earlier, I engaged with the first-person data – that is, the footage captured when Salma was holding the action camera – to challenge and extend the insights that emerged from engaging with the third-person data, both in terms of the sensory interaction that occurred in this particular episode of iPad finger painting and how we can think about sensory interaction during digital art-making more generally.

First-person perspective or object perspective?

So far, I have conceptualizsed footage that was captured while Salma held the action camera as relating to a first-person perspective. However, this conception is based on the idea that Salma would hold the camera to 'see' from her perspective, just as an adult would typically use a handhold camera. Unsurprisingly though, Salma did not engage with the action camera in this way. Although she was aware that the camera was a camera (holding it up to her face and saying 'Cheese'; see Figure 6.1), she held the camera in a variety of ways and did not tend to point the lens outwards so that it mirrored her viewpoint. As Figure 6.8 shows, the data collected while Salma held the action camera captured more of the object's perspective than of Salma's.

When we see from the object's perspective through the action camera, it becomes apparent that Salma's experience of and engagement with touch

Figure 6.8 Footage from the object's perspective.

occurred through much more than just the hands. For a relatively large proportion of the data, the action camera rests against Salma's neck and face. She rubs it slowly over her face feeling the texture, while continuing to interact with the iPad using her free hand. This is not a new finding. Studies of young children's physical experiences have repeatedly shown the importance of the whole body in sensory exploration of the surrounding world. However, the data presented here highlights the importance of thinking about this in the context of digital tablet interfaces, which are typically conceptualized as a relationship between a screen and fingers. Interestingly, when Salma engaged with the iPad screen, she did indeed use only her fingers, while with the action camera she used much more of her body to explore its textures. Could this tell us something about the level of sensory interest that the object offers?

Footage from the object's perspective is characterized by periods of movement and periods of stillness. In periods of movement, there is a high level of flux and the scene that is captured by the camera changes rapidly and constantly. In periods of stillness, a single scene is visible with minimal movement of the action camera. In the periods of stillness, Salma is holding the action camera in her left hand and interacting intensively with the iPad with her right hand. The stillness of the object might therefore tell us something about the level of immersion in the activity, which we know to be important in terms of the art-making experience (Denmead & Hickman, 2012).

What can we learn about sensory stimulation in children's digital art-making?

To summarize, the findings from the observations outlined earlier demonstrate the importance of considering sensory stimulation during digital art-making in relation to the whole body (not just the hands) and the whole device (not just the screen). They also suggest that touch experiences are diminished by the surface of the screen, which offers little sensory feedback in terms of changing textural qualities. Furthermore, through interaction with digital technologies, a child's touch is 'magically' transformed into special visual and auditory effects, which result from a removed digital code that can produce unpredictable transformations. The findings also highlight the need to consider sensory experience in the wider context of a network of interactions, which includes interaction with various devices, with material and immaterial components of the environment and with people and activities simultaneously. Beyond the simultaneous richness of

sensory experience, digital art-making can involve the evocation of past experiences which have their own sensory and physical dimensions. Finally, the findings from the use of the action camera to capture data prompt us to question what the perspectives of the object has to offer in studies of sensory experiences. In the remainder of the chapter I will discuss these findings in relation to previous literature and make suggestions for future research in this area.

Typically, research on touch in digital environments has focused on the hands. For example, the research of Crescenzi et al. (2014) and Price et al. (2015) on pre-schoolers' use of touch in iPad and paper finger painting measured parameters of touch as it was enacted by the fingers. In this study though, the whole body was an important instrument and receptor of touch. In Salma's relationship with the action camera, for example, she used her neck and face to interact with its rubbery texture. On the other hand, her interactions with the iPad occurred through a single finger on her right hand. When considering the nature of touch in digital art-making, we need to consider whether and how the whole body is drawn into the experience. Drawing on Denmead and Hickman's (2012) work on how artists think about the physical materials they work with, how the whole body is used can tell us something about the immediacy of the physical engagement that is inspired by the materials, as well as their capacity to help the artist in making the familiar strange. In rubbing the action camera against her face and neck, Salma appeared to be engaging in a physical experience that was instinctive and immediate. As well as considering the whole body, we need to take into account the entirety of the digital technology under consideration. The iPad is more than just the screen, though this is the active physical-digital interface. The findings show how the physicality of the iPad, including its size and weight as well as its perceived fragility, limited Salma's physical interaction with the device. On the other hand, the action camera as small, lightweight and durable in texture, was truly portable and involved in a wider range of sensory experience. Considering the whole device is part of understanding the slippage of art-making materials, that is, the capacity of the materials to inspire a wide range of imaginative uses and modes of physical exploration (Denmead & Hickman, 2012).

No matter how hard Salma pressed, her touch on the screen was met by the same smooth texture. This contrasts with what would happen in finger painting with paint, where the texture of the paint changes with the nature of the touch which is used to manipulate the paint. Mangen (2010) conceptualizes the former phenomenon as the 'intangibility of the digital', a phrase which suggests that digital environments cannot truly be touched and are fundamentally removed from

the physicality of the user. Kress (2005) identifies this lack of felt texture as one of the losses in the transition from physical to digital environments, and similarly, Crescenzi et al. (2014) suggest that children may lose the messiness of the finger painting experience when it is done on the iPad. While we can think about this aspect of touching the iPad as an example of loss, it is possible to frame it in other ways, and even as a magical transformation. Finger painting on the iPad can involve all sorts of magical transformation to the touch input. I use the word 'magical' to highlight how the effects that are created are not under the control of the user and cannot be predicted. One of the apps Salma used transformed her touch into transient special visual effects, which were controlled through a digital code that was unpredictable (as there were multiple visual effects to choose from and each behaved in its own way) and unknowable (as it occurred 'behind the scenes', beyond reach of the user's input). Therefore, the intangibility of the digital can be seen as part of a series of magical transformations engendered by the iPad. In the language of Flewitt et al. (2014), this is not necessarily a loss of touch but rather an aspect of virtual touch which has its own special properties. If we conceptualize touch in this way, we need to consider how children make sense of virtual touch in relation to 'real' touch, particularly in experiences that involve a constant flux of movement between the two types of touch.

The multiple layers at work in any interaction with a digital environment have been highlighted by Burnett et al. (2014) and their understanding of interactions with digital technologies as a network of material and immaterial components, so that the physical and the digital are constantly intertwined and inextricable in how we experience them. In the study presented here, Salma's direct interactions with the iPad were part of an unfolding network of experiences that included what went beyond the iPad (such as the other people in the room), as well as what was 'within' the iPad (such as her previous experiences of watching particular programmes on the iPad). For Flewitt et al. (2014) and Springgay (2008), the conjuring of past sensory experiences through the current interaction with a digital interface is part of a new type of touch. This in turn represents an aspect of a new corporeality in a digital age. Of course, all art-making materials are potentially redolent with associated meaning and memories of past experience. Paint has its own associations and memories, as does clay or charcoal. Screen-based digital technologies, however, are likely to be particularly replete with memories of watching programmes and engaging with a wide variety of visual stimuli, and therefore of alternative imaginative worlds full of characters and plot lines. This brings a child in closer contact with popular culture references

that can influence how the art-making experience unfolds; this might become a particularly important layer to consider in the context of digital art-making.

Earlier in this chapter, I suggested that there is a tension between a theoretical focus on how sensory engagement occurs and is made visible through interaction and a focus on how sensory stimulation is part of the felt experience. In order to explore this distinction further, I aimed to capture both first- and third-person perspectives in the visual data I gathered through the action camera. What happened, however, is that I captured very little of what we might consider to be the first-person perspective and instead engaged with events as they unfolded from the perspective of the object. The action camera was fully incorporated into the unfolding activity and told its own story about the experience. Watching from the object perspective cannot directly evoke the experience of the researcher in the way that sensory ethnography suggests in relation to researcher-generated video (Pink, 2015). However, the decentring of the researcher is itself an interesting and potentially productive phenomenon. Through the perspective of the object, we can redirect our analysis towards a fuller ecology of the interaction. In posthuman methodologies, focusing on objects can open up our thinking beyond what humans are doing, to see how materialities play into the unfolding interaction, as in Pacini-Ketchabaw's work on the clock (Pacini-Ketchabaw, 2012) and water in early childhood settings (Pacini-Ketchabaw & Clark, 2016). In the experience here, the action camera offered a way to make sense of sensory experience as both a felt condition and an action, fully embedded in the context of the interaction.

Distributed Ownership: How the Digital Can Shake up Notions of the Individual and 'Self-Expression'

Introduction

When a child makes a drawing in an early years (EY) setting, they are typically encouraged to write their name on it, to store the drawing in a safe place and to take it home at the end of the day, or else leave it in the setting for it to be displayed for others to see alongside their name. These practices stem from a belief that artwork is individually owned by whoever spends time and energy in the creation of the artwork. Ownership is conferred through creation and made public through the writing of the child's name onto the artwork. We can link these practices of individual ownership to wider notions about what art-making is for and how it works. In particular, accepting ideas of individual ownership depends on also accepting that the act of creation is an individual pursuit, so that each product is typically linked to a single child. In addition, there is a deeper level on which we confer ownership, so that we see ideas and representations within the artwork as also belonging to the individual creator beyond just the physical product and manifestations of these intangible aspects. This is seen in our belief that it is bad 'to copy' – a belief that is particularly important and prevalent in Western educational settings – since it is seen as a theft of others' creations. When we think about ownership on this level, we are validating notions of self-expression as described by Hawkins (2002), whereby the visual impression that we make through art-making is understood as a piece of ourselves that others have no right to.

Introducing new resources into art-making has the potential to disturb these expected patterns and practices of ownership, and in doing so, to challenge how we think about self-expression in the context of art-making. New semiotic resources,

which are less conventionalized in their use, are likely to be associated with a wider range of practices (Jewitt & Kress, 2003). As a result, practices associated with individual ownership – like writing your name onto an artwork product as a way of clarifying ownership, or storing the drawing in a 'safe place', may not occur to the same extent or unfold in the same way. By disturbing these practices, we disturb the deeper notions on which they rest. Beyond just their newness, digital technologies may have particular affordances that challenge us to rethink ownership. For example, the storage of digital artefacts when digital technologies are shared between multiple children may not reflect other ownership and archival systems that predominate in the EY classroom, which tend to be based on children storing what they create in individual spaces that are inaccessible to others.

In this chapter, I want to consider how ownership, individuality and self-expression manifest when digital art-making is done within an EY classroom using shared digital technologies. I start by examining three bodies of research to elucidate what we know so far about children's sense of ownership in relation to art-making and how digital environments might be shaping this differently. First, I consider research in art education, which looks at what children expect will happen to the artwork they make. Second, I engage with literature in developmental psychology that examines children's sense of ownership more generally and how ownership is conferred and established in relation to creative physical products. Finally, I explore recent research in the fields of HCI, new literacies and social semiotics, which suggests how and why the relationships and sense of ownership we cultivate with digital artefacts tend to be different than purely physical artefacts. To develop these ideas further, I engage with a series of observations, which relate to moments and practices observed in the context of an early years classroom that show us notions of ownership physically manifesting through behaviour in relation to digital art-making. Some of these observations are in line with what we would expect given the previous literature on children's sense of ownership, while others challenge many of our underlying notions about ownership and self-expression in the context of early childhood art.

Children's relationships to their artwork

There is disagreement about the extent to which children feel an emotional attachment to the products of their art-making. On the one hand, studies of children's art-making have prioritized their concern with the process and suggested that children's interest in what they make quickly fades (Kolbe, 2005;

Lowenfield & Brittain, 1970). On the other hand, phenomenological studies of children's interest in how their work is displayed has suggested that a separation between art-making processes and products may not be so pronounced for young children. Research by Boone (2008) and Twigg (2011) found that children were interested and emotionally invested in choices about what would happen to their artwork after they had created it. In both studies, children were keen to be more involved in the display of their artwork, seeing this as a fundamental part of authoring the artwork.

How children think and feel about the physical products of their artwork will depend on the cultural context in which they live and the extent to which their environment places a value on the individual author and the act of self-expression through art-making. Dyson (2010) and Hawkins (2002) have highlighted how in Western cultures we tend to place more importance on the individual's relationship to what they create. If artwork is seen as a representation of something internal to the individual, personal ownership of the artwork is also likely to be emphasized, since the artwork is understood as an externalized part of the maker. Dyson has explored the discourses that surround the activity of 'copying' in the practice of children's early writing and the questions that she asks relate equally to art-making activities. She explores how what we consider to be copying depends on our theoretical orientation towards composition and creation, and can be refigured as collaboration, complementarity and co-construction. This refiguring moves us away from limiting ourselves to an understanding of each artwork as belonging to a (single) artist.

Approaches which favour a less individualistic vision of art-making, such as recent Deleuzian-inspired approaches, are less focused on the relationship between children and their artwork and consequently de-prioritize individual ownership. In accounts of art-making recorded by MacRae (2011) and Knight (2013), for example, the focus moves away from self-expression and the individual towards considering a wider network of influences that shape art-making. They argue that art-making is best conceptualized as 'lines of flight' that unfold in a non-linear way depending on the resources and the environment. In this approach, art products are not understood as representational of individuals or owned by them, but instead as an emerging outcome of ongoing interactions between people, the environment and the materials we use.

Similarly, the Reggio Emilia approach to learning environments stresses the importance of designing environments that prioritize collaboration over individual ownership. According to Fraser (2006) and Strong-Wilson and Ellis (2007), collaboration constitutes one of eight core principles of how space

should be organized in Reggio Emilia environments. On a practical level, this suggests that spaces should be organized to discourage children from feeling that they own individual items in the environment or are even just taking turns with these items; instead, the principle of collaboration places an emphasis on working together and inviting others to contribute in the creative activities in which we engage. This is in distinct contrast with the turn-taking practices that were observed around the IWB as outlined in Chapter 4, whereby the environment encouraged children to take individual turns with the resources, primarily through the presence of a sand-timer that children would use to regulate the time that they and others spent with the resources. Perspectives in Reggio Emilia place more importance on the construction of group histories, which are told through the construction of the environment, and in particular through the accumulation and curation of pedagogic documentation (Gandini, 1998, p. 168), which would include the careful consideration of how artwork is displayed and stored so that it is seen as something that belongs to the entire community rather than just to a single child.

How children understand ownership

Research in developmental psychology suggests that children apply the concept of ownership differently depending on their age and the object they are thinking about. Although I am wary of applying developmental models in our understanding of children's art-making as outlined in the Introduction, findings from this research can be useful in constructing the parameters of our investigation into children's sense of ownership in art-making and how this might be unsettled by the use of different semiotic resources. Research by Nancekivell et al. (2013) suggest that two-year-olds show awareness of ownership rights (who owns what) and will defend their own perceived ownership rights, but not necessarily the ownership rights of a third party. Other studies suggest that three-year-olds are more likely to protest when a third party's ownership is violated, as when a puppet tries to destroy a drawing that someone else has made (Vaish et al., 2011). This body of research also suggests that young children understand that ownership can be obtained by an individual in various ways, including through an object being given to them, through finding it first, or through the investment of time and energy in the creation of the object (Kanngiesser et al., 2010).

While these findings are interesting, the behaviours that these studies show are learned and we cannot think about them as inevitable or immutable patterns

in linear development. Furthermore, while the findings suggest that children are likely to associate ownership with the time and effort involved in creation, they cannot tell us what makes a child believe that the creative time and effort that has gone into a product is worthy of ownership. Vaish et al. (2011) argue that children do not attribute ownership when they have seen an individual simply experimenting with materials rather than making something with those materials, but this prompts us to question how children distinguish between experimentation with materials and acts of creation. Does it matter how long an act of creation takes? Does the creation-ownership link depend on the types of resources that are drawn into the creation? Can multiple people own something at one point or does ownership necessarily transition from one individual to another? To answer these questions in relation to art-making, including digital art-making, I would suggest that we need to conduct in-depth, qualitative observations of children's behaviours in everyday life rather than relying on test conditions where the parameters of how children engage with ownership are predetermined by the research design.

Ownership in digital environments

Research in the field of HCI suggests that archival and accessibility are important facets to consider when focusing on the ownership and attachment that individuals feel in relation to objects. Digital and physical objects are archived and accessed in different ways and this appears to have a stark impact on the extent to which people feel that these objects are part of their everyday life, identity and memory-building. Petrelli and Whittaker (2010) conducted a study to look at how families relate to memories that are embodied in mementoes around the home. They followed 13 families in a memory tour of their home, discussing the physical and digital mementoes that individuals brought to their attention. In the initial tours and discussions, only one of the mementos chosen by the family members was stored digitally. When questioned further about digital mementos, participants were initially reluctant to attribute feelings of emotional attachment and investment to digital objects. As these discussions unfolded, however, family members began to refer to a wider range of digital artefacts than they had initially considered, including photographs, video and digital artefacts created by children, such as word processed stories and poems, digital drawings and PowerPoint presentations. In making sense of their participants' initial exclusion of digital artefacts,

the researchers suggested that digital objects tend to be stored away, are less accessible and therefore less a part of everyday life. They argued that attachment to digital objects would only be fostered if there was more integration of physical and digital storage through the development of physical mementos augmented with digital information.

While researchers in HCI have linked perceptions of digital ownership and attachment to accessibility and archival, researchers from a new literacies perspective argue that differences in a sense of ownership of digital artefacts stem from larger cultural shifts in how we perceive and construct ownership and authorship. Burnett et al. (2014) argue that our orientation towards texts is shifting from one in which we think about texts as belonging to individuals and being authored by a single individual to an understanding of texts that depends on multiple authors and multiple influences on the creative activity as it unfolds. They suggest that the phenomenon of multiple authorship is increasingly common and that even when it appears that a single individual has worked on a text, the pervasive influence of popular culture and distributed imagery mean that authorship is still best thought of as multiple. Within this perspective, art-making would never just belong to one person and would constitute an expression of a pure 'self'. This resonates with the ideas presented in Chapter 3, and in particular with the work of Lankshear and Knobel (2006) which stresses the importance of 'remix' within contemporary creativity, and further research establishing the role of kinderculture in how children engage in art-making (Dyson, 2010; Ivashkevich, 2013; Thompson, 2003, 2007).

Observing ownership of digital art-making in the early years classroom

Based on the discussions outlined, I want to consider how children's sense of ownership can be observed in the context of digital art-making, asking whether children's practices of ownership in this context are similar to those that they are likely to have in relation to art-making they carry out through other media. In exploring children's sense of ownership, I have paid particular attention to the way children engage in practices of archival, retrieval and overwriting in digital art-making, as these concrete practices offer a visible insight into children's feelings of attachment and ownership in relation to artwork.

The observations I offer in this chapter have arisen in the context of observing digital art-making more generally as it occurs in the environment of the early

years classroom. I have drawn vignettes from observations that were carried out first in a reception class with 4–5-year-olds who had access to digital art-making via a laptop during free-flow activity time each day over the course of a week, and second, in a different class of 4–5-year-olds who had access to digital art-making via the IWB, which was available to them during free-flow activity time again over the course of one week. For both sets of observations, the children engaged in digital art-making through the software Tux Paint, which I have outlined in previous chapters.

For the focus of this chapter, I am interested in moments of interaction from either set of observations that can tell us something about children's sense of ownership over the digital artwork they created. These moments manifested in different ways, including through individual expressions of pride and attachment to the artwork created, as well as interactions between individual children that related to processes of archival, retrieval and overwriting. The illustrative examples that I have chosen to share in this chapter not only highlight some of the trends that were observed in relation to ownership, but also demonstrate the diversity with which children in each class approached and understood ownership in digital art-making.

In the first context, where children engaged in art-making via the laptop, observations were recorded through an audio recording device that was placed next to the computer to capture children's interactions around the laptop. In addition, I was present in the classroom throughout the week and captured my observations through written notes both in the moment and in breaks during the day. In the second context, where children engaged in art-making via the IWB, observations were recorded through video recordings that were made through a handheld video recorder that I used whenever I noticed interactions around the IWB. In addition, I made written notes during breaks over the course of the week to capture my thoughts about what I was observing as it occurred. Details of the study design and procedure in the latter set of observations have been outlined in more detail in Chapter 4.

Here, I present three short interactions which relate to wider trends that were observed over the course of each week of observation. The momentary observations are designed to provoke and structure discussion around key issues and debates that relate to children's sense of ownership over their art-making. In the commentary that follows the description of each of the three interactions, I have focused on the relationship between this moment and the wider body of data from which the moment was taken to show how common this sort of interaction was. I have also suggested ways in which

the affordances of the digital resources on offer shaped the particular practice that was observed. Finally in each commentary I raise questions about what we can understand about ownership and attachment on the basis of the observed practice, or how it prompts us to challenge how we think about children's sense of ownership in art-making.

Observation 1: Covering over what's been made

Lini stands on an upturned box to draw on the IWB. She draws a picture of a girl with a smiley face (somewhat visible in the photograph) in a dark red colour. She also stamps repetitively a triangle shape in the same colour around the figure of the girl. While she draws, she sings to herself and sways. She monitors how much of her turn is left through the sand-timer which sits by the teacher's chair next to the IWB. When the end of her go approaches, and there is a queue of children behind her ready to use the board, she chooses the eraser tool and begins to wipe clean her drawing from the board. While doing this, she continues to sing and sway. She carefully covers over each part of her drawing, until what is left is a clean white display ready for the next person to use. She then steps down from the stool and goes to play in another area of the room.

Commentary

The process of finishing a turn by rubbing out what had been drawn was common across many episodes of activity with the IWB, as discussed more extensively in Chapter 4. This process seemed to be a way of preparing the IWB for interaction with the next person. Some children, however, had a stronger sense of the need to cover over what they had created and prepare a blank visual space for the next child using the IWB. In other episodes, children left what they had created on the IWB. The next child to use the board then either began a new file, rubbed out what had been created, or worked on top of it. The diversity that existed in how transitions between children's uses of the IWB were managed suggests that this aspect of digital art-making was not yet established according to set conventions. Instead, the transitions were enacted in a range of ways.

This practice related to the material dimensions of the space in which the digital art-making was occurring. In having to use the same physical space for

their art-making, the children needed to improvise about how to manage the process of handing over the resources. When making art on paper, it is unlikely that the same physical canvas will be used by another child, so there is no need to 'undo' what has been done and create a blank space for the next person to use. Covering over what had been created was a more popular practice than simply starting a new file, though the latter would have been a quicker option. This may have been because children were less sure of the different tools available in Tux Paint or using the eraser facility may have been a fun part of the experience and associated with positive affect.

Processes of finishing a turn in this way (or choosing not to) are of interest in relation to understanding ownership. On the one hand, covering over what you have created before handing over the art-making resources suggests that a child associates what has been made with themselves and not with others. By covering over the artwork, the child has prevented others' contribution to the artwork and in doing so they have prevented other children from owning the artwork in the way that they have experienced. At the same time, however, using the eraser tool to effectively destroy the art that has been created suggests a weak sense of attachment to the product that has been created. Children's interest in what happens to their artwork after its creation has been taken as evidence for their emotional investment in art products as well as the process (Boone, 2008; Twigg, 2011; cf. Lowenfeld & Britten, 1982). If children get rid of what they have created, can this in turn be taken as an indication that they are not emotionally invested in the product?

What was visible in children's interaction did not seem to suggest that covering over was an act of emotional detachment or distancing. Children like Lini smoothly transitioned from the act of creating to the act of destroying, from the practice of painting to the practice of erasing, without shifting the positive affect that was on display through visible behaviours such as singing and dancing. The smoothness of the movement from creating to destroying should make us wonder whether we can even think about covering over as a type of destruction, as opposed to an additional step within the creative process. These observations encourage us to question whether the destruction of what has visually been created previously can be taken as an indicator of emotional detachment or a decreased sense of ownership as compared with when children are eager to keep what they have made. Indeed, the scenario of covering over highlights the possibility that destruction can be a means through which children establish ownership and demonstrate their attachment to the artwork.

Observation 2: Expressing pride over what's been created

Sophie has finished creating on the IWB. Her artwork involves a blue background which she has covered in lots of orange love hearts that are evenly spaced around the screen. Because of the light coming through the skylight, she finds it difficult to see what she has created on the large screen. She comes to look at the artwork on the small laptop screen instead. She crouches down next to the laptop and shows delight at what she sees. She turns smiling towards me; I am holding the handheld video camera and also crouching down. She asks me to take a photograph of what she has made. She points at the screen and says 'take a picture!'. I suggest that we can save what Sophie has made onto the computer and we complete the steps of saving the file together.

Commentary

It was rare to see expressions of pride among children who would so readily involve other people as in this episode. Some of the children demonstrated delight and positive affect about what they had created, and this was made visible through their body movements, facial expressions and oral exclamations, or as in Lini's singing and dancing in the observation described earlier. However, these moments rarely involved others and as described above, children typically covered over what they had created or started a new file before handing over the art-making resources to another child. Sophie's request for me to take a picture of what she had created was enabled through my close proximity to her as she viewed what she had created on the laptop screen and her assessment of what was possible with the camera that I was holding. When I captured other children's art-making, I was often further away from the activity and less involved in the activity as it unfolded.

Although I suggested to Sophie that we could save the artwork she had made as a file on the computer (and she engaged with this process), digital archiving was not a priority in most of the episodes of art-making I observed on the IWB. When files were saved onto the computer, this seemed to be a process that unfolded without prior design (e.g. when a new file was started and there was the option, yes or no, to save the previous file). The children did not visit the archives of what had already been created, so the files that were saved did not appear again within the interactions that occurred around the IWB. In the context of art-making on paper in the early years classroom, children often go to find

a practitioner to celebrate what they have made together and experience an adult vocally appreciating their efforts. This relies on the portability of the artwork. In contrast, when working on the IWB or laptop computer, children are limited in what they can share with others and are aware that it would be inappropriate for them to call over a practitioner to come and see what they have made. As a result, the feelings of pride that they link to art-making on the IWB are less likely to be expressed in a social context. Whereas paper art can be put away into a personal tray, put up on the wall, or taken home to show parents and carers, digital art that is made on collective resources is often not saved, and when it is saved, remains in a digital archive that is not often accessed or shared with a wider community.

The lack of opportunity I saw for children to share pride in what they had made digitally leads us to ask questions about where children's sense of ownership stems from in the context of art-making. Is individual ownership at least partly constructed through others' recognition of your ownership and their validation of the emotional investment and attachment you have made with the artwork? Can you own something (or feel that you own something) if no one else knows that you own it? To make a connection with another, and thereby to establish your ownership in a social context, requires divides across time and/or space to be crossed. When these divides are crossed, by taking a piece you have made to a teacher who is based across the classroom, or by saving something so that your family can look at it when you get home, there is an active construction of a break between process and product – a moment in which the process of making art becomes the physical product of the artwork. If digital art-making does not, as I have suggested, facilitate the crossing of a temporal or spatial divide due to the constraints on portability and archival, perhaps it does not engender a split between process and product in the same way that art-making with other resources might. If this is the case, rather than asking how ownership plays out in the context of digital art-making, perhaps we need to question whether there is anything to be owned in the context of digital art-making since the process may be never-ending and the product never fully realized.

Observation 3: Disagreeing about ownership

Du had created a range of digital artworks using Tux Paint on the laptop over the course of the week of observations. These were similar to each other in the way that they prioritized the careful placement of images and choices of colour. She seemed to approach digital art-making with a focus on the aesthetic design

Figure 7.1 Disagreeing about ownership.

process, bringing together ready-made images that she was attracted to in symmetrical arrangements across the screen (as in Figure 7.1). Du showed signs that she was emotionally invested in what she created. Unlike the vast majority of other children engaged in digital art-making with collective resources, she made a careful effort to save what she had created into the digital archives. She would also retrieve art that she had previously created in order to look at it and admire what she had made, saying 'I love it' while looking at the artwork.

On the other hand, Emma, another child in the class, did not engage in this form of digital art-making. Episodes of digital art-making involving Emma tended to be narrative- or play-based, so that the focus was on the process of the art-making as it unfolded in the moment, and she did not save what she had made into the digital archives.

In the episode described here, Emma has been exploring the digital archives within Tux Paint and looking at what others have created already. She finds one of Du's artworks and opens it while Du is sitting beside her. What follows is an exchange between Emma and Du about whether Emma has the right to change or add to Du's artwork:

Du: I did that one yesterday ... I made that one yesterday, I made that one yesterday

Emma: Did you put these on?

Du: I did that one and that one and that one ... (pointing at each of the
ready-made images that are used in the artwork)

Emma: I'm going to take them off.

Du: No! Don't! No! Don't!

Emma: I just don't want them.

Du: Don't. I don't like them. Don't take them off. Don't like it.

Emma: Just let me do what I'm doing. Just let me do what I'm doing. And
I'm going to put some on ...

Du: Don't!

Emma: I'm going to put different ones and they will look nice.

Du grows increasingly fretful in this exchange and comes to find me to ask me
to intervene. I come to the computer and find that, fortunately, Du's artwork has
not been overwritten. I could access what she had previously created through
the digital archives of Tux Paint. Du is visibly relieved and reassured. Du and
Emma both then go to play in another area of the classroom.

Commentary

As children tended not to access the digital archives, there were relatively few
disagreements that occurred between children about ownership of previously
created artwork and whether children could add or change the artwork that
had been made. Sometimes editing happened without the first creator knowing
about it. For example, an artwork that involved stars stamped across the screen
was added to later on in the week with the addition of images of birds and frogs,
placed on top of the stars. As the first creator of the artwork was not present and
did not try again to access the artwork, these changes did not cause any visible
upset within the time period of the observations. We cannot know how the first
creator would have reacted if they had come across these additions.

These tensions highlight that archiving and retrieval are not established pro-
cesses in digital art-making. They happen haphazardly, where it is not clear what
practices are right or wrong, which are acceptable and which are unacceptable.
Archival in Tux Paint is not organized in the same way that archival surrounding
'the creative table' in the EY classroom would be organized, with the encourage-
ment of children to write their names and store products that they wish to keep
carefully. In Tux Paint, if children save their work (which itself only happened
haphazardly), they did not do this into a personal storage space, but instead into

a shared archive. Tux Paint seems to have been created for use by the same child or family in a domestic context, and as such, there is no emphasis placed on making personalized archival possible.

On a deeper level than the confusion about how to engage in archival and retrieval practices with the software, the interaction between Du and Emma illustrates an unresolvable conflict between two different conceptions of how digital art-making should be enacted. On the one hand, Du is constructing digital art in much the same way that children's paper texts have traditionally been perceived – as products belonging to individuals. On the other hand, Emma's interaction suggests that she sees digital art-making as a collaborative process with the potential of remix and mash-up (see Chapter 3). When we think about these conceptions of art-making in relation to the digital resources available, both to some extent are suggested through the material properties of the software Tux Paint. On the one hand, digital files containing the art have the potential to be saved, retrieved and shared with others at a later date. On the other hand, these files exist unnamed in a communal folder that can easily be explored and tampered with without any realization on the part of other children or the practitioners.

Ownership in art education

Previous literature looking at children's attachment to the products of their artwork suggest that we can 'read' emotional investment and a sense of ownership through the way that children respond to and treat the products of their art-making. Whether they care about how the artwork is stored or displayed has been taken as indicative of whether or not they are attached to the artwork (Boone, 2008; Twigg, 2011). The observations presented in this chapter problematize this notion on the basis that moments of apparent destruction were a frequent way in which children expressed their sense of personal ownership over art-making. Although the children observed were taking no measures to physically maintain what they had made in episodes of digital art-making, they were preventing others from editing or adding to their art-making by covering over what they had made. Although this blurs the conceptual divide between creation and destruction, it simultaneously demonstrates the discourse of self-expression in action (Dyson, 2010; Hawkins, 2002) since the children were reluctant to expose their art-making to further input from others.

Children's developing sense of ownership

Research in developmental psychology suggests that children's concept of ownership depends on the age of the child and the nature of the object over which they might express ownership. The studies introduced earlier in the chapter would suggest that children aged between four and five would have a strong sense of individual ownership and would defend the ownership rights of others as well as of their own. However, these observations of digital art-making from an EY classroom of digital art-making suggest instead that there is a high level of diversity among children's feelings and expressions of ownership in relation to artwork at this age. We can understand this diversity as a response to the unconventionalized nature of the digital art-making resources. Since there was no right or wrong way to enact ownership over artwork in the digital art-making environment, children applied their own rules and procedures, which spanned a wide range of possibilities. For some children, the artwork they made on the laptop or the IWB was very much their own and should not have been touched by others, while for other children, the process of digital art-making did not appear to give rise to a definitive product that could be owned. The fluidity of the relationship between ownership practices and the affordances of the semiotic resources suggests the need to return again to posthuman perspectives on early childhood, which emphasize the ongoing and ever-becoming interactions of the person, environment and materials (Kind, 2013; Knight, 2013; Sellers, 2013).

Digital transformations of ownership

In previous sections, I have suggested that the potential transformations of ownership offered in the context of digital art-making stem from the different and unconventionaliszd cues offered by digital art-making resources. Expressions of ownership are changed and notions of ownership are challenged when something as simple as a storage system shifts. As time progresses and the familiarity of digital art-making resources in the early years classroom grows, there will be a temptation to organize digital art-making according to established, conventionalized methods and procedures that apply in more familiar art-making environments. For example, it may be that as practitioners observe children using Tux Paint, their inclination will be to create personal folders for each child in the class, so that children are encouraged to save work that they wish to keep into a folder that has their name on it. In addition, the practice of taking home

artwork, which for more established methods of art-making is mediated via the personal tray of the child, might play out digitally through a digital 'tray' for each child, in which they can choose which digital artwork they wish to send to parents via email or share via social media at the end of each day. Beyond designing digital resources that mimic how things operate in non-digital environments, there may be a closer coupling of physical and digital components (as suggested by researchers in HCI and outlined earlier in the chapter), so that, for example, children maintain their personal physical tray spaces but these are coupled with personal digital archives of their cumulative work.

Are there compelling reasons for why we might resist the tendency to bring the digital resources that are used for art-making closer in line with and closer into contact with the physical resources that have traditionally underpinned children's art-making? Throughout this book, I have argued that digital resources and practices have the potential to challenge how we think about children's art-making in useful and productive ways. Digital art-making can destabilize how we think about ownership and encourage alternative practices, perhaps practices that are more strongly founded on co-construction, collaboration and multiple authorship. However, the digital can only do this if we allow it to; if we construct it in the image of the non-digital, it will simply reinforce our pre-existing notions of early childhood art, including in relation to ownership and discourses of self-expression. What we need is to be playful in our experimentations with resources for digital art-making. Rather than trying to harness these resources in clear and systematic ways that closely resemble what we would do with non-digital resources, we need to have the flexibility, creativity and confidence to try out new methods and practices. To enable the playful experiences of young children in their art-making, we need to be playful ourselves in how we introduce digital art-making into the classroom. In short, we need to resist the sense of control that is offered to us by the sand-timer and a wall of individual trays, and live for a while with the uncertainty that comes with relatively new, unconventionalized semiotic resources.

Conclusions

Individual ownership practices in early childhood art rest on the notion that the art we make is a 'part of us'. This notion stems from a wider discourse that links art-making with the idea of self-expression (Hawkins, 2002). Involving relatively new resources in art-making – such as in digital art-making – can unsettle these

practices and in doing so can challenge the self-expression discourse. In the obser-
vations presented in this chapter, children's digital art-making had this unsettling
effect through a shift towards more diversity in how ownership was expressed
and the extent to which it was expressed. The observations showed how owner-
ship could be associated with acts of apparent destruction as much as through
the careful storage of a physical product of the art-making. The observations also
demonstrated the difficulty in many instances of digital art-making of distin-
guishing between the process of art-making and an artwork product that could
be owned by an individual. These unsettling shifts resulted not so much from
particular affordances that are distinctive to digital art-making environments, but
rather came about because the digital resources that the children were using were
less conventionalized in how they would be integrated into art-making than other
resources which are typically found in the early years learning environment. This
means that there is an opportunity to challenge notions of individual ownership
and self-expression through digital art-making but only if we allow ourselves to
be playful in experimenting with how digital resources are incorporated into art-
making and do not rush to carry practices and methods across from conventional
art-making resources into relatively new digital environments.

Intentionality in Digital Art-Making

Introduction

In this chapter, I suggest that close observations of digital art-making prompt us to reconsider how meaning is made, and what we mean by meaningfulness in the context of children's art-making. I argue that much of how we think about meaning in early childhood art is framed by the notion of intentionality, whereby we construct children's art as the externalization of what is in the child's mind through the means of representation. In constructing children's art-making in this way, interpretations depend on a sign-signifier relationship as it is traditionally conceived of within semiotics; what we lose is a deep, theoriszd interest in the child's ever-becoming relationship with the materialities of art-making. Digital art-making can help us refocus on this aspect of art-making because, as one practitioner described in Chapter 2, its processes are often wizzy woo and do not follow trajectories of action that we would take to be demonstrative of intentionality.

In this chapter, I consider our preoccupation with intentionality, and closely coupled with this, the emphasis that we tend to place on communication and representation when considering early childhood art. By looking at three examples of children's digital art-making and exploring these in relation to three alternative theories or ways of thinking, I unsettle this focus and suggest other ways of engaging in our explorations of art-making. In particular, I consider an example of children's digital photography in relation to a theory of post-human entanglements; an example of digital collage in relation to theories of improvisation and spontaneous musicking; and an example of 'digital scribbling' in relation to an alternative scribble hypothesis, in which the marks we make are closely coupled with neurological patterns of significance. My aim is that through these considerations, this chapter will elucidate not just how we can theorize digital art-making, but will further the debates and discourses that surround early

childhood art more generally. Rather than simply suggesting that intentionality as a notion is not enough to guide our understandings of early childhood art, the chapter offers some initial explorations of alternative perspectives on early childhood art that can apply regardless of the medium and materials that are used in the art-making interaction.

Intentionality, representation and communication

Literature on children's art-making demonstrates our preoccupation with understanding art-making through the lens of intentionality, representation and communication. Examples of children's artwork are most often thought about as examples of the considered wish to communicate with others. Cox (2005) argues that art-making is 'integrally related to communication' (p. 123) and that children's art-making is best understood as a series of signs. While Cox suggests that these signs can change in their meaning over time, and different meanings will be attributed and communicated by children in different moments, she maintains that our analysis of children's art-making should focus on the deep connection between the material manifestation of artwork and ideas that exist in the child's mind. Cox's work is most often cited as an expansion of our notions of communication, since she suggests that children are not always aspiring towards visual realism (as much of the developmentally focused literature on children's art-making would suggest), and that representation underlies the process of the art-making but is not necessarily evident in the product. However, despite presenting an alternative perspective in this respect, she offers a traditional point of view in her emphasis on children's desire to use art-making in order to convey particular meanings to others. In such a view, empty and floating signifiers, which enter into the world without a singular or apparent attachment to an underlying sign (Barthes, 1977; Derrida, 1980), are unrecognized or discarded as meaningless.

The theoretical emphasis on communication is echoed in the research of Malin (2013). She describes art as a process of 'making meaningful' and theorizes this in the context of a sociocultural perspective in which children engage in a 'human drive to act on and interact with the social and cultural world that one occupies' (p. 15). The perspective here stresses how art-making is in dialogue with the surrounding world, suggesting again that the visual components and activity involved in art-making are best thought of as signs. Despite this theoretical framework, Malin's empirical investigations of children's art-making suggest the potential for children's purposes in art-making to extend beyond

communication and representation. She carried out ethnographic investigations over one year with six-year-olds, observing them as they made art and interviewing them about the projects they engaged in. Using this data, Malin suggested the existence of different categories of intention in children's art-making. These intentions included story-telling, representing self, experimentation, making the imagined real and relational dimensions of art-making. While four of these five categories relate to the intention to communicate something, the category of (intentional) experimentation is more mysterious. Within this category, Malin describes how children conduct processes of trial and error with the materials they are using, trying to achieve particular visual effects with the materials, and create certain colours. In these descriptions of experience, Malin draws our attention to the potential for children to prioritize a hands-on engagement with the materials they are using over the desire to convey a particular meaning to others. Experiments with colour are of course engagements with a cultural world, since perceptions and understandings of colour are deeply embedded in the cultural context. However, experiments with colour go beyond this cultural context; they are an engagement with the physical world itself, and the experiments are unfolding in the (becoming) here and the (becoming) now, without necessary preplanning by the artist. The idea of experimentation that Malin introduces suggests that we may need to expand a theoretical framework so that we contemplate not only children's engagement with the sociocultural context, but also fluctuating entanglements with matter.

The narrowness through which we tend to see children's art-making can be seen in the methods that we typically use to understand more about children's art-making. Commonly, children's artwork is used as visual elicitation to prompt spoken dialogue; this prioritizes the communicative dimension of art-making. For example, Richards' (2009) study focused on how 4–5-year-olds engaged with art-making experiences at school and at home by asking children to take photographs of their experiences of art-making in these environments. She suggested that these photographs had the power to prompt children to be more aware of their everyday practices and were effective in encouraging children to talk more openly about their experiences of making art. Richards suggested that in these retrospective discussions, children would often develop meanings that weren't present or clear in the observations of art-making as it unfolded; in the attribution of these retrospective meanings, children's drawings would become less 'trivial'. Thus, we can see that it is in the act of communication and in creating spoken discourses about artwork that children's art-making often acquires its value according to others.

Research in developmental psychology presents us with more extreme examples of our desire to see children's art-making as communicative. Take, for example, a study by Rose et al. (2012), which involved an investigation into the drawing capabilities of children attending different types of school: mainstream state schools following the English national curriculum, Steiner and Montessori. The study focused on the drawing of 135 children aged 5–9 years. To compare the children's drawings across the three educational systems, each child was asked to create three representational drawings, which would illustrate specific subject matter and three expressive drawings, which would indicate a particular mood. These tasks demonstrate our tendency to see art as a form of communication in which either a thing or a mood is to be represented successfully to others. The narrowness of this lens is even clearer when we consider how these drawings were rated. For the expressive drawings, indicative of a particular mood, the raters based their rating on whether the child had achieved an 'appropriate' expression of themes in relation to the suggested mood of the artwork based on what discernible representations they had included. So, if a child had been told to create a sad drawing, they were rated more highly if the content of their artwork was conventionally associated with sadness (e.g. rain). This suggests that we think children are good at drawing when they are able to understand and exploit cultural conventions around the signs and symbols we tend to use. Within this model, exploration and experimentation with materials has no value. Furthermore, it suggests that mood or affect cannot surface in art-making except through culturally recognizable representations. How might artwork be sad in ways that go beyond this? I would suggest that when we make sad artwork, there is the potential for us to be holding the pencil in a sad way, to be pressing it onto the paper in a way that for us feels like sadness, to make lines that resonate with what we feel within, though there may be no relation to a cultural convention around sadness. In addition, what does it mean that the participants were told what mood to convey through their drawings? Since the affect the child was asked to express did not necessarily correlate with what they were actually feeling, these examples of art-making can be seen simply as exercises in communication through the use of cultural conventions.

The legacy of a developmental approach

The call to move away from purely developmental approaches to children's art-making is by no means new. Both Cox and Malin, whose work I have outlined

earlier, suggest the need to move beyond looking at the features which are absent or present in children's art-making as determinants of age and stage, and instead have proposed engaging with the richness of children's art-making experiences, seen through a lens of communication. However, as Golomb (2003) notes, there may be a desire to move away from stage models of children's art-making but a blind spot in thinking about art-making in non-developmental ways. Both Cox and Malin validate the art-making of younger children by showing that it has the intentionality and meaning of art-making by older children. They portray young children as competent art-makers by constructing them as competent communicators. They suggest that while drawings may not include immediately discernible representations, they can tell us something important about the ideas and thoughts of the child who has created them. In this approach, valuing young children's art-making depends on seeing the communicative intent at work. However, in constructing postdevelopmental theory around children's art-making in this way, we must ask whether we are narrowing our perceptions of what art-making can be and applying a preoccupation with communication across age groups. In doing so, we lose the potential for art-making to be a physical and highly visceral experimentation and exploration of material resources. If we focused on the viscerality of young children's art-making, we would be suggesting that the artwork was 'unintentional' and thereby as 'underdeveloped'. If we truly move away from the constraints of a developmental perspective, however, we can move beyond focusing only on intentional communication and engage with the materialities of art-making without worrying that we are portraying children as incompetent.

While in the past, notions of development have been intertwined with notions of visual realism (Duncum, 1999), now the notion of competence and self-determination is bound together with the concept of intentionality. Schwarz and Luckenbill (2012), for example, suggest that 'as infants become toddlers, they use materials with more intentionality' (p. 28). Work on 'scribbling' suggests a binary opposition between the use of signifiers to evoke particular meanings and the engagement in an activity for the mere pleasure of it (Longobardi et al., 2015). This has led to examinations of children's scribbling with the desire to see how they are in fact using scribbles to represent particular things, such as dynamic properties, affective relationships or even the nature of multimodal stimuli, such as sounds. However, the sharp distinction between signification and pleasure is a troubling one, and the coupling of signification with maturation and development is also perplexing. What we might be seeing as a postdevelopmental approach could in fact be just a different type of developmental

approach, where the ultimate aim is no longer visual realism but intentional communication from one person to another through the means of representation in art-making.

The idea that children use art-making to express something that exists internal to them has been challenged by postmodern theorists (Hawkins, 2002). The notion of self-expression encourages us to conceptualize art-making as something that externalizes inner thoughts and feelings and a sense of self. Hawkins explored children's sketchbooks as a means to reconsider concepts of self and identity, so that these constructs are seen as a product of the art-making experience, rather than as constructs which feed the art-making process. In this approach we make the self through art-making rather than the other way around. Through processes of 'suture', of joining and stitching together visual stimuli, a wider visual language is inhabited and manipulated by children. This perspective, similar to Cox and Malin, highlights the importance of the sociocultural context in which children make art. The sketchbooks studied by Hawkins show the importance of drawings of limousines, gangsters, mosques and so on to children, which in turn demonstrate the centrality of lived experience, which is sutured together through art-making. While Hawkins' questioning of self-expression and the communication of an inner self in art-making is exciting and important, it is important to note that Hawkins's studies of suture and playfulness do not extend beyond clearly representational drawings. The approach suggests that there is more to art-making than the expression of an 'inner essence', but does not extend to consider abstract experimentation and exploration or the relationship that the child has with the materials they use.

McClure (2011) also pushes against 'discourses of optimization' that surround children's art-making, in which children are always seen as working towards something, whether it is realism or 'intentionality'. Furthermore, she questions discourses of inherent creativity, in which children's art-making is mythologized and seen as an outpouring of something inherently creative within them. In questioning these discourses, McClure suggests that we need to focus more on the deeper cognitive underpinnings of children's art-making. She argues that in early childhood education environments, we construct children's art as 'merely expressive, creative or cute, and rarely meaningful, intellectual or worthy of deep theorisation' (p. 129). While McClure's challenges are powerful, I argue that the dichotomies she constructs between 'expressive and creative' and 'intellectual and worthy' are dangerous. I would question the argument that in order to move beyond discourses of optimization and to engage with the richness of children's art-making, we need to apply more of an intellectual overlay to what children do.

As with Malin, Hawkins, Cox and others, McClure puts an emphasis on understanding children as active participants in cultural production through the way they engage and play with the cultural signs that surround them. But if we see all of children's art-making primarily as a form of cultural production, what other dimensions of the activity are we missing?

What are we missing?

Many of the perspectives I have highlighted in the preceding paragraphs stem from a desire to relocate and rethink our approaches to early childhood art. They take us away from narrowly developmental perspectives in which we see children's art-making as progressing according to a linear sequence of stages, always moving towards something which is better and more valuable, with a desirable endpoint of visual realism. While this shift is something I completely agree with, the perspectives above remain wedded to the notion that the most important aspects of children's art-making are those which are intentionally communicative. Thus, these perspectives see art-making exclusively as signing and construct the child first and foremost as a sign-maker and agent of cultural production. It is not my desire to argue that this is not the case – that children are not agents of cultural production – but I would, however, question whether this framework can be applied to all of children's art-making in such a broad-brush way. In particular, I am concerned that this perspective on children's art-making takes us away from the potential of art-making to be a highly physical, material and sensory experience, in which the 'flows and forces of the material' (Ingold, 2013, p. 216) are an active player in the unfolding process. If we see art as a process of becomings rather than as an externalization of pre-existing ideas, thoughts and feelings, then we need to move beyond a discourse of children's art-making which reifies intentionality, communication and representation. Part of my concern that we might be missing something in our analysis of children's art-making stems from my observations of children's digital art-making, which have often highlighted the role that experimental and exploratory dimensions can play in children's art-making experiences.

With at least half of the episodes of digital art-making I have observed, I have struggled to find a clear representational intention at work. I have spent a long time trying to understand what the child's underlying intention or message is, influenced by sociocultural perspectives on children's art-making which theorize the experience as signing. Though I have searched the products and data on the

processes (directive talk, unfolding interactions) for signs of intentional communication, this has consistently appeared to be lacking in a high proportion of children's digital art-making episodes. Of course, this does not mean that intentional communication was not present but I have become increasingly aware that there are other dimensions that need to be brought to the fore and theorized.

Practitioners I have spoken to (as discussed in Chapter 2) talk about children's interactions with digital technologies producing wizzy woo patterns as a result of the relative newness of the technologies. But this is once again positing intentionality as the new endpoint. Instead of adopting this perspective, I have tried to engage with the data in new ways, to see how the wizzy woo may in fact be meaningful in its own right, when new theoretical lenses are applied and used to rework our conceptions of children's art-making. When we do this – when we engage with what we might normally dismiss as 'meaningless' – we can extend our discussions and debates to question some of the assumptions we make about children's art-making. What does it mean to describe some episodes of art-making as intentional and others as not? When we talk about intention and meaning-making, are we really just prioritizing verbal articulation, whether simultaneous or retrospective? Why do we place a value on children's capacity to indicate what something signifies? How can we even begin to interpret children's art-making if we're not constantly looking for 'what this says/represents/means to the child'?

New ways of engaging

To move beyond intentionality, communication and representation, I engage with three theoretical perspectives that might help us to engage with children's art-making differently. By putting these theoretical perspectives into dialogue with examples of children's digital art-making that I have collected across my research, I will explore new ways of thinking about and with children's digital art-making, which I hope will be useful in the context of early childhood art more generally, regardless of the materials that are used.

Posthuman entanglements: Children's photography

Work on children's photography from a posthuman perspective has suggested ways in which we might move beyond our preoccupation with 'looking at' artwork so that we can instead engage with the 'dynamic, bodied ... and the

material practices of photography' (Kind, 2013, p. 431). Kind builds on the work of Tim Ingold who considers the importance of place and materiality in the art-making experience: 'the role of the artist is not to give effect to a preconceived idea ... but to join with and follow the forces and flows of a material that brings the form of the work into being' (Ingold, 2011, p. 216). Applying this perspective to early childhood art, we need to do more than just look at the artwork and recognize what has been represented, attributing meaning to these recognizable elements. Instead, we are encouraged to attempt to engage more openly with the materialities of the art-making process and more immediately, more viscerally with the art product. In the case of children's photography, Kind notes how the children she observed did not look at each others' photography but rather actively responded to them. For example, they would strike poses in resonance with the forms and shapes captured in the photograph, or re-enact what the photograph was showing, or touch the photograph and, in doing so, engage with the different textures it both revealed and kept hidden. In this way, the children in Kind's project were able to enter into what Ingold describes as the 'haptic blindspot' which affects our appreciation of artwork as adults. Deleuzian perspectives on art-making, as suggested and modelled by MacRae (2011) and Knight (2013), similarly suggest the importance of reconnecting with the material and the potentials for meaning to exist in the ever-changing flows between the artist and the materials. Working with adult artists, the research of Denmead and Hickman (2012) also draws our attention to the way in which the properties of each material that the artist engages with constitutes noteworthy 'thing-power' (Bennett, 2004) in the entanglement of art-making.

Figure 8.1 shows a series of photographs that were captured by a child during an episode of child-parent photography in the home using the iPad camera. In this experience, the three-year-old child was first shown how to take photographs using the iPad by her father, and then took the lead in navigating around the house and taking photographs at different points along the journey (this episode of activity was described in more detail in Chapter 5). The photographs in Figure 8.1 show parts of the hallway in the house as the child moves through it towards the front living room, which she will enter next. As the child takes these photographs, her father is present behind her, urging her to stand still before taking the photographs and suggesting objects that he thinks they should capture. The child is engrossed in the activity of taking the photographs and seems to ignore many of her father's directions. Rather than standing still when taking photographs, she is often moving towards the object, and rather than capturing a single photograph of a particular object and then moving on, she focuses on

Figure 8.1 Child photography around the house.

the same part of the hallway but reorientates her body many times, so that she takes photographs of the same objects repeatedly but from various angles, often too close to the object to enable a viewer who was not present at the time to determine what object had been caught on camera.

The child's photographs engage with the 'forces and flows' of the photographic process. Quite literally, the forces and flows of the child's movements are made visible through the photographs, which take us back to the constant motion and multiple orientations that enabled their creation. While the idea of taking a journey around the house and capturing this via photography was a preconceived idea, the photographs themselves do not appear to speak to preconceived ideas about what to represent. The child resisted her father's suggestions about what objects she should capture in the photographs and how she could make these objects easily recognizable to others. In resisting her father's intervention, the child seemed to move beyond the aim of the activity as intending to communicate a description of the environment in her photographic journey.

Kind reminds us that photography is 'dynamic, bodied … and material' (p. 431). This sense of dynamism comes through strongly from the artwork in Figure 8.1; it is visible through the motion blur which is characteristic of most of the images that were taken. In addition, the viewer experiences, while looking at the photographs, a desire to 'get inside' a bodied perspective on the images. The mind starts to imagine the visual perspective that the child had to adopt in order to take the photographs, and the body may even start to re-enact the physical positions that would have been taken by the photographer. The embodied response to viewing the photographs becomes more complex; instead of just

looking at the photographs, we begin to look up, look down and look around, to re-create the ways in which the child would have been engaging with the world around her. This in turn creates a bodily response, almost of motion sickness while looking at the photographs. The viscerality of this response is akin to Kind's observations of children responding to each others' photographs, where they responded in highly physicalized and immediate ways.

The photographs challenge our preoccupation with looking for what is recognizable. Our preoccupation with 'looking at', as described by Ingold, is challenged here where it is almost impossible to isolate objects that are captured in the photographs and to name them. What happens when we are forced to refrain from this way of engaging with the images? Of course, we might typically discard the images as meaningless, but in this instance, in forcing ourselves to engage with the photographs, we are invited to see and feel spaces in between objects – the tips of the shoes, the ridges of the radiator, the feel of the laces, the colours, the textures and the forms. Through our experiences of these photographs, we are invited into a haptic visuality; with the camera 'grazing' rather than 'gazing' the physical environment (Marks, 2004).

Another impact of these photographs is their capacity to make the familiar strange. These photographs were taken in a hallway that I have a long-standing personal connection with. The photographer is my niece and the hallway is in the house where I grew up. However, when I look at the photographs in Figure 8.1, I feel disorientated. I can recognize some aspects of the hallway, perhaps the texture of the radiator or the hues of the carpet, but simultaneously, the images appear to be distorted and do not correspond to my memories of this place. Deleuze and Guattari suggest the importance of engaging with the minute detail of an experience which render visible the never-ending layers of difference that exist from one experience to the next. In this way, these photographs are an experiment in sense-making. While the father was keen to render visible those aspects which formed his common-sense understanding of the hallway – the hallway table perhaps, the cordless telephone charging on the floor, the pictures hanging on the wall and so on – his daughter played with the texture, colour and form in the environment.

Spontaneous musicking/arting: Digital collage

In order to push our understanding of art-making further, it can be helpful to look beyond theories that are intended to relate to the visual world and consider

theories which examine other means for making art. For example, the deeply embedded notions of 'improvisation' and 'spontaneous musicking' in the context of early childhood music-making can help us rethink experimentation and non-intentionality in relation to children's visual art-making. The ideas of improvisation and musicking can help us consider how meaningful patterns arise and can be explored and examined even when there is no clear or verbalized intention in relation to the art-making. Burnard (2000) has considered the process of musical improvisation and considered how it is experienced and constructed differently to composition by children. She argues that improvisation has its own particular lifeworld existentials – its own lived time, social dimensions, place and bodily phenomena. When we focus on this phenomenological account of improvisation, we see how experimentation in art-making more generally can have value and meaning in its own right, without needing to show that it is underpinned by an intention to communicate. The work of Countryman et al. (2015) on children's spontaneous musicking is also helpful since it offers us a framework through which we can see meaningfulness in spontaneity. Countryman et al. draw on the work of Dissanayake and the notions of the aesthetic and 'the proto-aesthetic' for considering how we can make sense of the features that reveal themselves in children's spontaneous musicking. Dissanayake suggests art-making and aesthetic acts are characterized by particular features rather than by explicit intention. These features include patterning, repetition, exaggeration, elaboration and the manipulation of expectations.

Figure 8.2 was created in the context of 4–5-year-old children making art on the interactive whiteboard (IWB) during free-flow activity time. In this art-making experience, ready-made images available through the 'stamp' tool in Tux Paint were dotted around the screen. Some of these images, including the cartoon trucks, the photographic frogs and the photographic penguins were applied to the screen in multiple copies. Other images, such as the cartoon red fire engine truck, cartoon bus, and photographic tank and photographic parachute were applied only once to the screen. The images were applied by a child standing at the big display of the IWB, but he was interacting throughout with a small group of children who clustered themselves around the laptop screen to watch the unfolding visual activity. They responded to the images that were placed on screen with multimodal expressions of emotion, such as laughter and clapping hands. The child who was stamping the images onto the board responded to these expressions of emotion by applying copies of the same image or by changing images. The activity unfolded with immediacy and the action was continuous, without breaks for reflection. There was a focus on nonverbal

Figure 8.2 Example of digital collage.

communication and it was apparent that it was a collaborative process though only one child interacted physically with the IWB.

Burnard suggests that improvisation is characteriszd by a sense of immediacy – 'to be reactive and interactive at each special moment' (p. 233). The same sense of reactivity and moment-by-moment activity is present when we consider Figure 8.2. The collage product captures some of the rapidity of the actions that led to its creation and the responsiveness to the emerging visual effect. Furthermore, in considering the video observation of the art-making as it unfolded, we can see the responsiveness of the main artist to the makeshift audience clustered around the laptop. There were few instances of stopping and starting in this particular episode, though other episodes of art-making on the IWB had shown the children moving back and forth between the IWB and the laptop, and thereby creating a space for reflection and consideration in between moments of action and reaction. In this particular episode, the action was almost entirely continuous. Other aspects of improvisation as highlighted by Burnard also come to the fore. For example, there is a high level of nonverbal communication – giggling, clapping, pointing and shared gaze. Furthermore, the contributions of the audience and the responsiveness of the primary creator to this audience mean that the experience was highly intersubjective, without a strong sense of individual ownership. In this respect also, the experience was

similar to the improvisation episodes observed by Burnard and how they were described by the participants.

Countryman et al. (2015) draws our attention to the way in which artifying can be theorized even if it is spontaneous. They apply the theoretical framework of Dissanayake (2011) in the context of young children's spontaneous vocalizations in the playground environment. Dissanayake (2011) suggests the existence of five devices that indicate whether an experience or action can be considered to be art: patterning, repetition, exaggeration, elaboration and the manipulation of expectations. We can look for these characteristics in the artwork in Figure 8.2, and in doing so, we can see that despite the high level of spontaneity and immediacy which characterizes the art-making experience, these features appear to be important.

- Patterning:
 The characteristic of patterning refers to the presence of structures in the artwrok. In Figure 8.2, we can see a diagonal flow across the image. The trucks travel from the top lefthand corner to the bottom righthand corner; the frogs and penguins seem to be travelling in the opposite direction. The image of the tank breaks up this sense of visual flow and has more salience as a result of this disruption. There is patterning also in the spaces that exist between the different stamp images that have been applied, with a cluster of trucks placed in the bottom right hand corner and more distance between the three trucks on the lefhand side.
- Repetition:
 The cartoon truck image is repeated many times across the artwork. This increases its salience.
- Exaggeration:
 The tank is another prominent feature of the artwork as a result of its colour, size, density and the quality of the image (photographic rather than cartoonish). Its positioning in the middle of the screen cuts up the flow of the truck images and it is positioned on top of the frogs, exercising visual power over the rest of the image. The sense of movement that emanates from the tank is particularly dramatic and it appears almost determined in its indication of movement across the screen.
- Elaboration:
 The different vehicles can be understood as an elaboration on each other. The truck, fire engine and bus are all similar in their presence as vehicles, but they are also stylistically similar because of their cartoonish

construction. The tank continues the content theme, but breaks away from the visual style of the other vehicles. The penguins and frogs, both animals and both photographic, are thematically linked and elaborate on each other.

- Manipulating expectation:
 There is a strong contrast between the animals and the vehicles, as well as between the military images (tank and parachute) and the more mundane vehicles (the bus, fire engine, truck). As mentioned earlier, the positioning, size and density of the tank image is a bold statement that appears in the middle of the screen and breaks up a diagonal sense of flow.

So we can see that the artifying features suggested by Dissanayake are visible in the digital collage of Figure 8.2, despite the spontaneous, improvised manner in which it was created. Are these aspects of the artwork aesthetic or proto-aesthetic? Dissanayake suggests a shift from proto-aesthetic to aesthetic through intentionality, arguing that we can produce these features in an unplanned way (proto-aesthetic) but can also intend to create them (aesthetic). Since the children did not talk about the five features (except perhaps repetition, in their calls for 'again, again'), we can perhaps suggest that they were unintentional. However, it is important to question the distinction between proto-aesthetic and aesthetic and the value that this once again places on the notion of intentionality. Is what we think of as intentionality simply the verbal expression of actions that are being carried out regardless of whether they are explicitly articulated or not? The artist behind Figure 8.2 did not necessarily need to verbalize an intention, in order to effecitvely manipulate the expectations of the audience to whom he was performing and engaging with. The children's expressions of joy and surprise were a fundamental part of the creative process as it unfolded, suggesting that the manipulation of expectation was highly effective.

The alternative scribble hypothesis: 'Digital scribbling'

In an earlier section of this chapter, I highlighted how research is often keen to suggest that children's scribbling is in fact representational, for example, of dynamic properties, affective relationships and the qualities of sound (Longobardi et al., 2015). However, Sheridan (2002) puts forward an alternative way of thinking about children's scribbling, which helps to challenge an

emphasis on communicative intent as an indicator of meaningfulness. Sheridan suggests that scribbles should be seen as 'evidence of a basic underlying, dyadic back-and-forth, oscillatory, organising brain mechanisms' (p. 1). What this means is that scribbles can be understood as an unintentional representation, or perhaps an unintentional resonance, with the fundamental mechanisms at work in our bodies and brains. According to this view, what externally manifests during children's art-making is indicative of a rhythm that is at work in our deepest selves. Thus, scribbles are not meaningless, but nor are they meaningful because of an intention to represent and communicate. Sheridan's perspective on young children's mark-making is almost spiritual in the way in which it connects what children do with neurological, biological and mathematical patterns that are in play in our bodies and in the wider world. In the following analysis, I also link this idea to the conceptualization of schemas, which are patterned actions that play out repeatedly through the everyday activities of young children.

The artwork in Figure 8.3 was created by different children through flowing movements across the screen using different tools available in Tux Paint. Some of the lines and shapes were made using the 'paint' or 'draw' tool, while

Figure 8.3 Example of 'digital scribbles'.

others were created through a dragging motion applied to a 'shape' tool or the 'magic' tool. Three of the images were made on the IWB while another was made on the laptop. There was no indication through the talk that accompanied the creation of this artwork that it was fulfilling a planned representational purpose. The children who made these pieces of artwork were silent during their creation or offered non-linguistic utterances, including singing and humming. From my observations of digital art-making, making what we might think of as 'digital scribbles' is a popular activity. In my observations across contexts, a large proportion of the time spent involved in digital art-making comprised activity created in this manner and leading to products like this.

In making sense of Figure 8.3, Sheridan would suggest we should look for mathematical and neurological resonances in the visual activity, based on an understanding that what we externalize may be an unconscious projection of the inner mechanisms on which our bodies depend. There are similarities between this approach and perspectives in the history of art which highlight the importance of particular mathematical sequences in what we tend to find beautiful (e.g. the presence of the Fibonacci sequence in what we consider to be beautiful in nature and in man-made art). The idea that there are patterns which bind the inner and the outer worlds and natural and man-made artefacts renders our notions of intentionality problematic. In this perspective, rather than signing, art-making is seen as an expression of qualities, patterns and structures that are always present in the world and are felt intuitively.

In taking this approach, we might highlight in Figure 8.3 the marks which look like neuronal spikes, indicative of the way that chemical energy builds within the neurone and is then released when the neurone fires and forges a connection with another. We can also engage with the visual importance of structures which have a clear centre and periphery. For example, in the bottom left-hand drawing, there are clusters of visual activity, which build in density through the application of further colour, and appear to peter out in radials away from the centre. This visual impact brings to mind the images that are calculated through functional magnetic resonance imaging (fMRI), where electrical energy is located in particular parts of the brain with a high density, and then a decreasing level of density as we move away from these parts.

There are two levels at which to consider or apply Sheridan's scribble hypothesis: we can look at the structures and patterns that the children create with the tools that they have, but we can also think about the visual effects that the tools themselves lead to and the structures and patterns on which these design features are based. For example, we can see in the work at the bottom right that

a tool can take straight lines and turn them into spikes. We can see curves and parabolas that are created through the application of a particular effect. There are also tools that create what might seem to be chaos, though Sheridan suggests the need to think differently about chaos – to see the necessity of neurological chaos in order to produce innovation, much like the need for mutation in the context of evolution.

Sheridan's theory rests on the foundational idea that there are recurrent visual patterns at work in children's art-making which relate to underpinning mathematical, biological and neurological structures. This idea of universal structures influencing artwork corresponds in turn to the notion of schemas as developed in the work of Chris Athey, building on the foundational ideas of Piaget. In this view of childhood activity and creativity, there are patterns of motion that recur and are repeated as a means for the child's developing expertise in navigating the world. To mention just a few, these include the enactment and expression of trajectories, rotation and core-and-radial patterns. These passages of motion shape children's activity in the world and can be seen in the child's creative activity. A child engaged in and fascinated by the rotation schema might be entranced by the movement of the washing machine, by the act of spinning and by their paintings of circles and spirals (Athey, 1991). The notion of schemas offers another way to engage with digital scribbling, since we can look for these common patterns and see their repetition and enactment as meaningful in themselves, without the need to attribute intention.

Conclusions

The last decade or so has been characterized by a move away from developmental approaches to children's art-making which posit visual realism as the desirable endpoint. However, my concern is that we may have swapped one endpoint for another. Many of the studies that emphasize the adoption of a post-developmental perspective have in fact offered validation to examples of early childhood art through the attribution of intentionality. Thus, in seeing young children's art-making as signing, it is valued in line with how we value the art-making of older children and adults. In this view, to remake the child as competent and self-determined, children are shown to be agents of cultural production, remixing symbols and signs that make up the sociocultural context in which they live.

While I do not doubt that children can engage in processes of cultural 'suture' and 'remix' (see Chapter 3), I would suggest that by placing an almost exclusive

focus on intentionality, communication and representation, we are missing other dimensions that are at work in early childhood art. When we observe children's digital art-making, we see many examples of art-making that do not seem to fit neatly into a framework of intentional communication. We have the option to discard these episodes of art-making as meaningless, or we can develop richer theoretical perspectives that enable us to see meaning in activity that is not readable as signs. In this chapter, I have attempted to unsettle our preoccupation with intentional communication by suggesting other ways to engage with children's art-making. To do this, I have fostered dialogues between three theoretical perspectives and examples of children's digital art-making.

First, I have considered what posthuman approaches could offer to our understanding of children's photography. The notion of 'entanglements' forcefully reintroduces the physical materials of art-making as an active player in the art-making process. In this framework, the materials used are no longer just the vehicle through which a sign is created and conveyed; instead the materials have 'thing-power' (Bennett, 2004) which comprises a fundamental part of the unfolding interaction. To engage fully with the forces and flows of art-making, we must do more than just look at children's art-making, trying to recognize discernible representations of things in the world. Instead we need to learn (or relearn) how to 'graze' the image, responding to it in immediate and highly physical ways. In the words of Deleuze and Guattari, the shift is one from a common-sense ontology, towards an appropriate recognition for the processes of sense-making, in which children's art-making is a celebration of constant difference and constant newness, and cannot and should not be constrained by the cultural conventions that surround representation. This way of conceptualizing early childhood art has the potential to be deeply empowering for children since it offers the potential for their art-making to be surprising, to not fit what we know already and to be unique to them and unique to the moment. In this view, there is no distinction between competence and incompetence, and as such, there is a real escape from the developmental perspective, without simply swapping one endpoint for another.

Examining theories of musical improvisation and spontaneous musicking opens up possibilities for art to be made in contexts of immediacy, in which intentionality is unclear or not present. Approaches to music education offer us the potential to engage theoretically with what children make when there is no verbalization about signification and when no neat storytelling accompanies the creation of the artwork. Building on Dissanayake and the features of 'artifying', this approach enables us to look for meaningful patterns in artwork

that emerges in a spontaneous way, looking particularly for the characteristics of patterning, repetition, exaggeration, elaboration and manipulating expectations, regardless of whether these are verbally articulated by the child engaged in art-making.

Finally, I took inspiration from Sheridan's alternative scribble hypothesis, which rather than trying to find representational merit in children's scribbling, suggests that these scribbles are resonant with patterns and structures that recur throughout the world in our bodies, the natural world and man-made structures. This perspective suggests that if we apply a mark-making instrument to a blank canvas and create a line with spontaneity, building something intuitively, it will not be random or meaningless in its creation, but a response to and a connection with the wider world.

These alternative approaches are not just exercises in theory. They offer us practical ways of engaging with children's art-making and artwork. In particular, they take us away from questions of 'what is it?' and 'what are you trying to say?' and offer us new ways to conceptualize children's art-making experiences. The posthuman perspective suggests the importance of responding to art-making in ways that extend beyond verbalization. It also suggests the need to spend time in the 'mess' of activity itself and to value the relationship between the artist and the materials. The work on improvisation and spontaneity, and the notion of 'artifying' put forward by Dissanayake, offers a way to comment on and respond to children's art-making. It offers a starting point for a language of the aesthetic that practitioners and children can both engage with. Finally, Sheridan's alternative scribble hypothesis might offer us a means for developing what children have created, particularly abstract art, to highlight patterns and structures that are present in children's art-making and also present in the world around us. Looking at the patterns in a child's piece of art-making is akin, in this perspective, to looking at the patterns in the veins of a leaf. It makes no more sense to ask whether a child's piece of artwork is 'competent' than it does to ask whether the leaf's beauty is competent.

While I agree with McClure's (2011) argument that the early childhood art curriculum is often 'over-determined but under-theorised', I would disagree that what is called for is an engagement with the deeper cognitive underpinnings of children's art-making, since this places an almost exclusive emphasis on intentionality, communication and representation. While I am not denying that children are agents of cultural production, I would suggest that our theorization of children's art-making can be even richer than looking only for the use and suture of cultural signs. My hope is that this chapter has offered the means through

which we can begin to theorize children's digital art-making on other levels, in ways that go beyond looking for evidence of intentional communication. This will be helpful to us as we make sense of children's digital art-making and enable playful experiences with digital art-making but is applicable in early childhood art regardless of the media that are used.

9

Conclusions: Enabling Playful Experiences

Introduction

In the first chapter of this book, I suggested that as digital technologies become an increasingly prevalent feature in the experiences of young children, there is an urgent need to explore how they feed into everyday interactions and practices. I suggested that the interactions and practices of early childhood art would be a particularly fertile context in which to ask this question. Over the course of this book, I have focused on young children's digital art-making from various perspectives and with a diverse range of concepts and dimensions of art-making in mind. I have considered issues of visual culture, collaborative creativity, closeness, sensory interactions, ownership and intentionality in relation to digital art-making, drawing on previous research in these areas and observations of children engaged in digital art-making. Through exploring these issues, I have developed insights into what it means to be playful in digital art-making and how playfulness can be enhanced in early childhood art education. In this final chapter, I suggest how we can think about and observe playfulness in children's interactions with digital technologies. Building on this, I then make some suggestions on how educational practice can develop both around children's interactions with digital technologies and their engagement with early childhood art. One of the most important outcomes of a focus on digital art-making is the potential to question and challenge some of our existing notions about early childhood art, and I hope to offer some productive challenges in this chapter that prompt us to rethink how we make sense of and support children's art-making. Finally, I will offer some suggestions about future directions for research in the field of early childhood, focusing on digital technologies and art-making.

Playfulness and the flexibility of affordances

A theoretical starting point throughout this book has been that digital technologies have affordances that feed into interactions in impactful ways. Through these affordances, digital technologies have 'thing-power' (Bennett, 2004) which shapes the unfolding activity. From a posthuman perspective, the thing-power is conceptualized as a type of agency so that technologies are seen as agentive elements in the entanglements of interactions. In the case of digital art-making, this perspective suggests that what digital technologies do and do not do is important for how art-making occurs and even what we conceptualize it to be. In some of the chapters in this book, disentangling the affordances of particular digital technologies has been an aim. For example, in Chapter 5 where the focus was on iPad photography in the home and the experiences of closeness between a child and a parent engaged in this activity, I attempted to show how different properties of the technology were important in shaping the extent to which closeness was fostered and how it manifested. I suggested that there were particular affordances of the technology that enabled moments of meeting and others that created rhizo mo(ve)ments between the child and the parent. For example, I argued that the portability of the iPad technology meant that the child and the parent together turned their attention to activities that were occurring in a fleeting way in the external environment and attempted to capture these moments of activity in their iPad photography. Also, the portability of the iPad created opportunities for the child and the parent to use the device together in settings around the home that are associated with informality and higher levels of affection (e.g. sofas and beds), and this shaped the levels and types of closeness that were observed between the duo.

At the same time as attempting to disentangle pertinent affordances and how they shape the activity of art-making in different ways, the research presented in this book has highlighted the extent to which affordances of a technology always exist as part of a network. Although it might be analytically helpful to take apart this network of affordances and attempt to isolate particular properties and how they shape action (e.g. portability, the presence of ready-made images, how archival and retrieval of digital images can occur), each interaction is in reality made up of the constant interplay between these different material affordances, as well as the wider social associations and environments in which the activity is unfolding. For example, in Chapter 2, I focused on the prevalence of ready-made images in the context of digital art-making and argued that these images are an important part of the digital art-making experience. However, at the same

time, my observations of how young children use these images and engage with them demonstrated that their presence could not be thought of separately from what the digital software enabled the children to physically do with the images. In the case of Tux Paint, children have access to a large bank of images, which are both cartoon-like and photographic, but they also have the tools available to manipulate the size, orientation and position of these images in a wide range of ways. The result of this manipulation is that children often appear empowered in relation to the images that they are using, subverting what the image appears to show and playfully engaging with the content of the image through these practices of visual manipulation. This counters concerns that have been raised about the impact of kinderculture or 'visual busyness' (Tarr, 2004) on children's creativity, and demonstrates the importance of considering not just what is present in a digital art-making environment but always what children are able to do with what is available.

As well as the different material affordances that a digital technology comprises, and the way that these different affordances interact with one another, we cannot ignore the wider social and material environment in which digital art-making occurs. As many of the chapters in this book have shown, there is a constant dialogue between what a digital technology can offer and what is suggested by the wider context about how the technology could or should be used. In Chapter 4, I focused on the potentials and missed opportunities for collaborative creativity when 4–5-year-olds were engaged in digital art-making on the interactive whiteboard (IWB) during free-flow play time in their classroom. I showed how there was often a tension between what the IWB had been intended for from a design perspective, and particularly the wish to engender higher levels of social interaction and collaboration, and how the technology was situated in the social context of the classroom. The need for children to 'share nicely' had greatly impacted on how the IWB was being used, so that the children regulated their turn-taking with the digital resources through the presence of a sand-timer that sat next to the IWB and dictated when an individual's turn began and ended. Although there were some instances of negotiation and shared art-making, there were many examples of interaction which demonstrated that children thought it was essentially wrong to interfere with one another's turn with the IWB. As a result, the majority of interactions that unfolded around the IWB did not enable collaborative creativity to unfold. A particularly helpful notion in understanding this situation is Burnett's (2014) concept of 'classroom-ness' which highlights the interplay between the existing rules and etiquette of a classroom and new resources that are introduced into the

space of the classroom. While the new resources may have a somewhat trans-formative effect on what goes on in the classroom, this will be tempered by the effect of the classroom on how the resources are used and embedded.

When Gibson first put forward the idea of affordances in field of the psychol-ogy of perception in the 1960s, he suggested that the affordances of an object or element in the environment were our immediate perceptions regarding the usefulness of that object. For example, when walking, rather than seeing a rock, we see the action that is associated with successfully navigating past or over that rock. Similarly when we see a chair, rather than perceiving the object of the chair, we perceive a shape that is conducive to sitting down. Through its take-up as an idea in design contexts, the notion of affordances has been applied more flexibly, and they have themselves been seen as potentially encompassing more flexibility. By this I mean that we now tend to think about affordances as some-thing that do not just immediately exist, but something with which we can play and take some control in relation to. In the context of writing on Reggio Emilia educational environments, there has been a suggestion that facilitating children's experimentation and playfulness depends on helping children to see the many affordances associated with objects in the environment, rather than allowing them to become limited in their viewpoint so that they see only one thing that can be done with an object (Fraser, 2006; Strong-Wilson & Ellis, 2007). This would mean that rather than simply seeing a chair as 'to sit on', we would open our minds to other potential activities we could engage in with the chair and pay attention to the details and infinite potential difference in interacting with that chair. Strong-Wilson & Ellis (2007) offers the example of glue and how children can encounter glue as something which simply allows sticking, or can experi-ment with pouring, rubbing or wiping the glue and exploring its different sen-sory properties when it comes in contact with other materials.

This focus on facilitating children to see and engage with a wider range of affordances resonates with the Deleuzian concept of sense-making, which is positioned in opposition to a common-sense approach to the world in which differences are ignored in order to make way for striated, rule-bound interac-tions. In a sense-making ontology, we are aware of the constant difference that we encounter in the world through our senses, and we seek out and value this difference through our way of being. In art-making, this approach is particularly important, as Denmead and Hickman (2012) note how the 'slippage' of materi-als – the extent to which materials have the potential to be used in a wide variety of ways – is a fundamental part of the experimentation and play which ena-bles innovation and creativity. By allowing ourselves to be aware of the various

ways that we could interact with the physical world around us, we can embark on 'lines of flight' that takes us from striated to smooth space, where rules and boundaries are usurped in favour of difference.

So, although it may be helpful to attempt to disentangle the affordances that are associated with different digital technologies, there is simultaneously a value in holding onto the potential of all objects and materials to afford a wide variety of actions. In this book, I have moved back and forth between attempting to pick apart what is special or different about digital technologies in comparison to other materials that are used in children's art-making, while at the same time staying with the diversity of children's interactions with digital technologies, which highlight the constant multiplicity of digital affordances. For example, in relation to children's ownership practices (Chapter 7), I have argued that there are some features of the digital art-making environments that young children use which disturb typical ownership practices associated with traditional art-making environments (writing your name onto the artwork, storing it in a personal 'safe' space and not overwriting the work of others). At the same time, the way that these features will be taken up varies from situation to situation. Some children will embrace the disturbance prompted by the new material properties of the resources, while others will push against the disturbance and apply the traditional practices even though the environment may not on the surface seem to afford these practices. Enabling playfulness in the context of digital art-making depends on maintaining a flexible approach to affordances, so that they do not blinker the way that we envisage children interacting with the physical-digital assemblages of which they are a part.

Recommendations for practice

Throughout this book, I have kept in mind the needs of practitioners when it comes to supporting young children in their art-making with digital technologies. In Chapter 2, I reported on the concerns that practitioners had in relation to digital art-making, and I have tried to address these concerns through the particular case studies considered in the subsequent chapters. As a result of engaging actively with these concerns, I have developed some loose recommendations for practice regarding how digital technologies can be better integrated into early childhood art, particularly in the context of educational settings. I think about these as 'loose' recommendations because they are not rigid guidelines or step-by-step measures that need to be taken, but rather productive ways

in which practitioners can explore the opportunities afforded by digital tech-nologies and enhance the playfulness with which children encounter and engage with digital art-making.

Practitioners in Chapter 2 voiced a concern that digital technologies provided an experience that was less rich in terms of sensory stimulation. As a result, they questioned whether digital art-making could be seen as 'early years-ish' given that it did not offer potentials for messiness and high levels of sensory interac-tion, particularly through the mode of touch and the experience of diversity in felt textures. My own observations of sensory interactions with digital tech-nologies during art-making on the iPad (Chapter 6) related strongly to these concerns and I suggested in this chapter that the screen of the iPad did indeed diminish touch experiences. This was seen in the way that the young child varied the pressure of their touch interaction with no change in the touch input that they were experiencing. However, the observations also highlighted the extent to which this kind of touch interaction with the screen is embedded in a much wider physical-digital assemblage of activity, which involves a variety of sensory interactions and unfolds simultaneously or in quick succession. A young child's interaction with a touch screen or with a mouse pad or mouse does not occur in a sensory vacuum, but occurs in an environment that comprises different but networked sensory experiences. With this in mind, there is an opportunity in practice to ensure that the digital technologies which children use are embed- ded in rich sensory contexts that feed into digital art-making even when the screen appears to be providing a less satisfying touch experience. This could mean ensuring that digital art-making can unfold in outdoor environments or in the sensory richness of the home corner, rather than being isolated to a corner of the educational setting which is set aside for this kind of interaction. Digital interactions will be enriched by being placed in the context of rich physical interactions. This principle can act as a guide in the physical layout of early years educational environments.

Another concern of practitioners voiced in Chapter 2 was that digital technol-ogies are associated with lower levels of social interaction and dialogue between children and that they are more likely to be used by children alone. The chapters in this book that focused on social interaction – particularly Chapter 4 which looked at collaborative creativity and Chapter 5 which looked at closeness – showed the extent to which digital art-making could feed into social interactions and vice versa. At the same time, Chapter 4 demonstrated how the etiquette of the classroom and the demand for children to share resources in constrained ways impacted negatively on the potentials for collaboration in digital art-making.

In order to counter this, practitioners need to feel more confident in their own interactions with young children around digital art-making and in exploring how social interactions could unfold differently around digital resources in the classroom. In Chapter 2, the practitioners interviewed suggested that they tended to spend less time interacting with children as they engaged with the digital technologies in the classroom, and this resonated throughout the class-room observations described in this book, where not a single child-practitioner interaction was observed around the classroom laptop or IWB. It is certainly important for practitioners to consider the amount of time they spend with chil-dren engaged in using digital technologies, particularly the time which is not simply 'reactive supervision' (Plowman et al., 2010) when there is a digital glitch, but time in which they are aware of and open to the diversity of social practices and challenges that can arise. For example, insights into the different owner-ship practices that children engage in during digital art-making can prompt deeper reflections on how ownership practices are enacted in the classroom and why tensions sometimes arise. Rather than seeing these situations as something which needs to be solved immediately (e.g. through the introduction of a sand-timer), there is the potential for these situations to be purposefully explored as a classroom matter as part of a site-orientated pedagogy (McClure, 2011).

I have suggested that practitioners can be inspired by the social interactions they observe among young children engaged in digital art-making and use these as a springboard for the development of pedagogic explorations, provocations and interventions. Rather than seeing what young children do with digital tech-nologies as something which needs to be solved and/or regulated, we need to prepare to be challenged by young children's digital art-making practices. Rather than having in mind a 'right' way for them to engage in digital art-making, if we are open to their experiences, we will observe new ways to engage with digital art-making that we had not previously thought of. I observed this in Chapter 5 with the moments of dissonance and distance between the child and the par-ent when their notions of what photography was and what it should involve appeared to be divergent. While this could be read as a negative impact of digital art-making on social closeness, the different outlook of the child when it came to digital photography could also be read as a productive challenge to adult assump-tions about the practice. The child's approach to photography was exciting in the extent to which it involved motion and captured an embodied experience of the house they were in, which unsettled and defamiliarized the environment. The recommendation here is to simply be ready to learn from children about how we can do digital art-making. In the case of children's photography, it would

mean refraining from telling children to frame the photographs or to stand still before taking the photograph, and instead being relaxed enough to see what happens when children have the freedom to adopt a medium for their own ends and purposes.

I am not arguing that practitioners should be uninvolved in young children's digital art-making and should take a step back to a point where they are no longer visible agents. This would relate to an 'unfolding' interpretation of early childhood art (Gardner, 1980) which I do not possess. What I am arguing for, in line with McClure (2011), is a site-orientated pedagogy in early childhood art that responds to children's own 'funds of knowledge' (González et al., 2013). In the early years, this starts with observing children with an open mind. Observation in the early years is often too concerned with the measurement of what a single child can or cannot do, but I would suggest that the power of observations is in how they can inspire a teacher to explore new opportunities with all the children in their classroom. Rather than measuring children's digital art-making against the capacity of children to physically manipulate tools in a particular way, or to present coherent representations that live up to the standards of visual realism that are imposed, we can see observations of children's digital art-making as a starting point for exploring new ways to do digital interactions and new ways to engage in art-making. I will summarize how digital art-making can push our boundaries of thinking about early childhood art in the subsequent section.

While practitioners can adopt a mindset which evokes and encourages playfulness in themselves and in children in relation to digital art-making, it is important that practice is supported by digital design that is also driven by observations of how children actually use digital technologies as part of their early childhood art. For example, with the issue of touch, there is an obvious need for the rapid development of a greater range of interfaces that do not diminish sensory experiences but provide stimulating tactile encounters that link input and output. This might manifest as vibrotactile surfaces or highly textured interfaces, and recent work in HCI is starting to respond to this need. In addition to enriching the touch experiences that occur when a young child engages directly with a digital technology, there is a need for designers to examine the entirety and complexity of the physical-digital assemblage that constitutes the activity of digital art-making. They can do this by considering the whole of the digital device and the sensory experiences it provides, rather than just focusing on the input-output of the device. In Chapter 6, my observations showed how our assumptions about what a device can afford do not always relate to what a young child experiences. While the iPad is known for its lightweight portability, the

observations of a two-year-old child interacting with the iPad demonstrated the difficulty she experienced in holding or moving around with the iPad because of its weight. In contrast, the small rubber action camera was an object that she could play with in different ways, sometimes interacting with its digital functionality and sometimes not.

Rethinking early childhood art

The excitement I have felt in exploring the role of digital technologies in early childhood art has arisen at least partly because digital art-making has the power to challenge our existing conceptions and assumptions about early childhood art. Observing digital art-making and remaining open to the new ways in which children can engage in digital art-making encourages us to question some of the wider practices that are embedded in early childhood art. For example, in Chapter 3 I considered how the role of ready-made imagery in digital art-making can disturb discourses of self-expression in the context of early childhood art, as a result of the possibilities of digital art-making to involve high levels of appropriation and remix. Similarly, the observations of diversity in how ownership was thought about and enacted in Chapter 7 demonstrated a tension between ownership practices that are more generally applied to early childhood art and how these were reinterpreted or removed altogether by children as they engaged in digital art-making.

In a discourse of self-expression, children's art is seen as an outward expression and representation of something which is deeply internal to the individual. Hawkins (2002), Dyson (2010) and others have argued that rather than reading early childhood art in relation to a search for a pre-existing 'inner voice', we should be prepared to understand children's art-making as an act of cultural production, through which they actively make themselves and the kinderculture that surrounds them. In addition, research focusing on children's relationships with the materials that they use in their art-making has highlighted how the activity of art-making can unfold through a series of 'lines of flight' which do not coalesce into a single predetermined goal that is aligned to a child's 'self', but rather occur in the complexity of the child-materials-environment interaction (Knight, 2013; MacRae, 2011). Children's use of ready-made images in digital art-making and their looser sense of whether they own the products they make in a digital space can be used to support these alternative way of looking at early childhood art, which move away from the discourse of self-expression.

In addition, when we observe young children's digital art-making our preoccupation with visual realism as an endpoint is challenged. Postmodern thinkers on art education have highlighted how much of the practice that surrounds early childhood art tends to celebrate visual realism and see this as what children are striving towards. Thus, we are more likely to praise children's art-making when it contains discernible representations than when it involves abstract art or pattern-making. Digital art-making challenges this focus on visual realism since so much of what children create in digital environments does not correspond to the standards of visual realism. We are then confronted with a dilemma of whether to simply discard this art-making as meaningless, or whether to challenge ourselves to see alternative types of meaning at work. Digital art-making also questions the very definition of visual realism. Since ready-made images, often photographic in nature, tend to be prevalent in digital art-making environments, we are prompted to question whether a child's use of these images is necessarily an example of visual realism, or whether their use of the images can correspond to multiple pathways, only some of which are interested in the practice of representation (see Chapter 2).

Digital art-making challenges a focus on visual realism not only through the nature of the products that the children create, but also through how we tend to observe digital art-making and what this can teach us about different ways to observe early childhood art in general. For example, multimodal interaction analysis, with a focus on embodied interaction as it unfolds, has been particularly important in carrying out the observations on digital art-making presented in this book. Through a focus on bodily modes such as gaze, facial expression, body movement and body posture, I have been able to see patterns at work in art-making that would not have been visible had the focus rested solely on the visual activity of the art-making. Children's methods of abstract experimentation, for example, can become more apparent when we focus on what the child's body is doing, as opposed to an exclusive focus on the art as it is made. Turning this emphasis to the entirety of the child-art interaction can be a way to engage productively with early childhood art in general so that we do not prioritize the creation of discernible, ideally 'realistic', representations.

Although I am arguing that observations of digital art-making have an important role to play in the postmodern goal of moving away from an exclusive focus on visual realism as an endpoint in art education, I would also argue that digital art-making can challenge some of the perspectives that are being used to replace the focus on visual realism. In the previous chapter, I questioned whether postmodern approaches in this field may be replacing

one endpoint (visual realism) with another (intentional communication). The concept of signing (Cox, 2005; Malin, 2013) and the focus on children as agents of cultural production (Hawkins, 2002; McClure, 2011) means that children's art-making is typically read through a lens of intentionality. The mark-making of the youngest children is validated through reading these marks as intentional signs. This is problematic because it does not really move us away from a developmental perspective, but instead replaces the developmental goal of visual realism with the alternative developmental goal of signing. While I do not doubt the potential of very young children to make and communicate meaning, I am keen to move away from a traditional semiotic perspective in which every output is read as a referent of an idea that exists in our minds. Instead, I suggest we move towards a social semiotic approach, inspired by posthumanism, in which the materialities of the activity are seen as agentive players in how art-making unfolds, and what is externalized is not always in direct relation to an internal idea.

I went on in Chapter 8 to suggest some alternative ways of engaging with children's visual art-making, inspired by three different perspectives that have been applied to early childhood art and take us beyond a traditional semiotic approach. These alternative approaches depend on placing more of an emphasis on the 'forces and flows' of the materials that are incorporated into the art-making experience. This resonates with research on adult art-making, which has highlighted the importance of materiality in the art-making experience (Denmead & Hickman, 2012). Inspired by approaches to early childhood music and children's improvisation and spontaneous vocalizations, we can see early childhood art as something which is meaningful and worthy of study even when there is not a single coherent representation at work or when the child's intentionality is not prioritized as a means for making sense of the experience. Finally, the alternative scribble hypothesis put forward by Sheridan (2002) shows us how we can read children's art-making not through the lens of what they had intended to represent through their marks, but instead as part of a much wider set of patterns at work, which do not belong to individual voices but are part of biological and mathematical patterns of significance that bind humans and the natural world.

Future research

Future research in this area would benefit from a closer focus on child agendas (Dyson, 2010). That is, our focus should remain on what children are actually

doing with digital technologies in the context of early childhood art, rather than trying to measure what they do against pre-existing assumptions and conceptions of the activity. When we observe the diversity with which children draw digital technologies into their art-making experiences, we move away from dichotomous debates that exist on a theoretical level about digital technologies. How we think about digital technologies in early childhood is riddled with these sorts of dichotomous debates in which technologies are seen as either a good or bad influence on childhood. When we actually observe children's interactions with digital technologies on the other hand, we are forced to move away from a simple distinction between positive and negative. We also move away from positioning digital technologies as having a distinctive influence on children's practices that can be disentangled from other aspects of their experience of the world. As I suggested in Chapter 3, we can see that children are often inspired to use digital resources in ways that we had not predicted or imagined. This is an excellent starting point for considering playfulness with digital technologies. While there may be a concern that adult discourses surrounding digital design lack an emphasis on play and playfulness (Edwards, 2013), when we observe what children do with these digital technologies, we can see playfulness as it occurs and opportunities for enabling playful experiences in the future. In the case of ready-made images, for example, how children manipulate ready-made images in digital art-making prompts us to think about how we can invite children into a critical and empowering conversations with the digital images that surround them as part of their everyday lives.

Focusing on digital art-making encourages us to question and challenge some of our modes of thinking about early childhood art more generally. This is a productive line of questioning that needs to be taken further in future research. In particular, more needs to be done in post-developmental lines of inquiry in order to move away from set endpoints, whether this is visual realism or intentionality, and to still have a language that we can use to make sense of early childhood art and respond to its richness. Currently, early childhood art education is based on the starting point that visual art is a representation of ideas, but to engage with the full richness of children's interactions and activity, we need to develop observations that focus on the entirety and complexity of each child-environment-material interaction. This means being in tune with each of these components, understanding them as agentive, while simultaneously placing an emphasis on the interactions between these components and how these give rise to the lines of flight which comprise the art-making experience.

References

Abeele, V. V., Zaman, B., & De Grooff, D. (2012). User eXperience laddering with preschoolers: Unveiling attributes and benefits of cuddly toy interfaces. *Personal and Ubiquitous Computing*, 16(4), 451–65.

Ahn, J., & Filipenko, M. (2007). Narrative, imaginary play, art, and self: Intersecting worlds. *Early Childhood Education Journal*, 34(4), 279–89.

Anning, A. (1999) Learning to draw and drawing to learn. *Journal of Art & Design Education*, 18(2), 163–72.

Anning, A. (2002) Conversations around young children's drawing: The impact of the beliefs of significant others at home and school. *International Journal of Art and Design Education*, 21(3), 197–208.

Anning, A. (2003) Pathways to the graphicacy club: The crossroad of home and pre-school. *Journal of Early Childhood Literacy*, 3(1), 5–35.

Arnheim, R. (1954/1974) *Art and visual perception*. Berkeley: University of California Press.

Athey, C. (1991). *Extending thought in young children: A parent-teacher partnership*. London: Sage.

Aubrey, C., & Dahl, S. (2008). A review of the evidence on the use of ICT in the Early Years Foundation Stage. Retrieved on 11 April 2016 from: http://dera.ioe.ac.uk/1631/

Ava Fatah gen. Schieck, & Moutinho, A. M. (2012). ArCHI: Engaging with museum objects spatially through whole body movement. In *MindTrek 2012, Proceedings of the 16th International Academic MindTrek Conference*, 39–45.

Barthes, R. (1977). *Image, music, text*. London: HarperCollins.

Bennett, J. (2004). The force of things steps toward an ecology of matter. *Political Theory*, 32(3), 347–72.

Bezemer, J., & Mavers, D. (2011). Multimodal transcription as academic practice: A social semiotic perspective. *International Journal of Social Research Methodology*, 14(3), 191–206.

Beudert, L. (2008). Spectacle pedagogy: Art, politics, and visual culture: A review essay. *International Journal of Education & the Arts*, 9 (Review 2). Retrieved 11 April 2016 from http://www.ijea.org/v9r2/

Bianchi-Berthouze, N., Kim, W. W., & Patel, D. (2007). Does body movement engage you more in digital game play? And why? In J. Luo (Ed.) *Affective computing and intelligent interaction* (pp. 102–113). Berlin: Springer.

Bjorkvall, A., & Engblom, C. (2010). Young children's exploration of semiotic resources during unofficial computer activities in the classroom. *Journal of Early Childhood Literacy*, 10(3), 271–93.

Boone, D. J. (2008). Young children's experience of visual displays of their artwork. *Australian Art Education*, 31(2), 22–45, 31(22), 22–45.

Bradley, M. M., & Lang, P. J. (2000). Measuring emotion: Behavior, feeling, and physiology. In R. D. Lane & L. Nadel (Eds.) *Cognitive neuroscience of emotion* (pp. 242–52). New York: Oxford University Press.

Braun, V., & Clarke, V. (2006). Using thematic analysis in psychology. *Qualitative Research in Psychology*, 3(2), 77–101.

Bruce, B. C. (1997). Literacy Technologies: What stance should we take? *Journal of Literacy Research* 29(2), 289–309.

Buchholz, B., Shively, K., Peppler, K., & Wohlwend, K. (2014). Hands on, hands off: Gendered access in crafting and electronics practices. *Mind, Culture, and Activity*, 21(4), 278–97.

Burnard, P. (2000). Examining experiential differences between improvisation and composition in children's music-making. *British Journal of Music Education*, 17(03), 227–45.

Burnett, C. (2014). Investigating pupils' interactions around digital texts: a spatial perspective on the "classroom-ness" of digital literacy practices in schools. *Educational Review*, 66(2), 192–209.

Burnett, C., & Myers, J. (2006). Observing children writing on screen: exploring the process of multimodal composition. *Language and Literacy*, 8(2). Retrieved 11 April 2016 from: http://ejournals.library.ualberta.ca/index.php/langandlit/article/view/17806

Burnett, C., Merchant, G., Pahl, K., & Rowsell, J. (2014). The (im) materiality of literacy: The significance of subjectivity to new literacies research. *Discourse: Studies in the Cultural Politics of Education*, 35(1), 90–103.

Carter Ching, C., Wang, X. C., Shih, M. L., & Kedem, Y. (2006). Digital photography and journals in a kindergarten-first-grade classroom: Toward meaningful technology integration in early childhood education. *Early Education and Development*, 17(3), 347–71.

Chandler, D. (2007). *Semiotics: The basics* (2nd Ed). Abingdon: Routledge.

Chen, Y. J. (2011). Young children's collaborative strategies when drawing on the computer with friends and acquaintances. Dissertation presented to the faculty of the graduate school of the University of Texas, Austin, in partial fulfillment of the requirements for the degree of Doctor of Philosophy, University of Texas, Austin, Texas, USA.

Chen, J. Q., & Chang, C. (2006). Using computers in early childhood classrooms Teachers' attitudes, skills and practices. *Journal of Early Childhood Research*, 4(2), 169–88.

Clark, V. (2012). Becoming-nomadic through experimental art making with children. *Contemporary Issues in Early Childhood*, 13(2), 132–140.

Coates, E. (2002). 'I forgot the sky!' Children's stories contained within their drawings. *International Journal of Early Years Education*, 10(1), 21–35.

Countryman, J., Gabriel, M., & Thompson, K. (2015). Children's spontaneous vocalisations during play: aesthetic dimensions. *Music Education Research*. Retrieved 11 April 2016 from: http://www.tandfonline.com/doi/pdf/10.1080/14613808.2015.1019440

Couse, L. J., & Chen, D. W. (2010). A tablet computer for young children? Exploring its viability for early childhood education. *Journal of Research on Technology in Education*, 43(1), 75.

Cox, S. (2005). Intention and meaning in young children's drawing. *International Journal of Art and Design Education*, 24(2), 115–25.

Craft, A., & Wegerif, R. (2006). Thinking skills and creativity. *Thinking Skills and Creativity*, 1(1), 1–2.

Crescenzi, L., Jewitt, C., & Price, S. (2014). The role of touch in preschool children's learning using iPad versus paper interaction. *The Australian Journal of Language and Literacy*, 37(2), 86–95.

Csikszentmihalyi, M. (1988). The flow experience and its significance for human psychology in M. Csikszentmihalyi & I. S. Csikszentmihalyi (Eds.) *Optimal Experience: Psychological Studies of Flow in Consciousness* (pp. 15–35). New York: Cambridge University Press.

Csikszentmihalyi, M. (1999). If we are so rich, why aren't we happy?.*American psychologist*, 54(10), 821–27.

De Block, L., & Buckingham, D. (2007). *Global children, global media: Migration, media and childhood*. New York: Palgrave Macmillan.

Deleuze, G. and Guattari, F. (1987). *A Thousand plateaus: Capitalism and schizophrenia*. Minneapolis: University of Minnesota Press.

Denmead, T., & Hickman, R. (2012). Viscerality and slowliness: An anatomy of artists' pedagogies of material and time. *International Journal of Education & the Arts*, 13(9). Retrieved 11 April 2016 from: http://www.ijea.org/v13n9/v13n9.pdf

Derrida, J. (1976). *Of grammatology* (trans. G. C. Spivak). Baltimore, MD: John Hopkins University Press.

Derrida, J. (1980). *Writing and difference*. Chicago, IL: University of Chicago Press.

Dillenbourg, P., & Evans, M. (2011). Interactive tabletops in education. *International Journal of Computer-Supported Collaborative Learning*, 6(4), 491–514.

Dissanayake, E. (2000). *Art and intimacy: How the arts began*. Washington: University of Washington Press.

Dissanayake, E. (2011). Doing without the ideology of art. *New Literary History*, 42(1), 71–79.

Donker, A., & Reitsma, P. (2007). Drag-and-drop errors in young children's use of the mouse. *Interacting with Computers*, 19(2), 257–66.

Dourish, P. (2001). Seeking a foundation for context-aware computing. *Human-Computer Interaction*, 16(2–4), 229–41.

Duncum, P. (1999). A multiple pathways/multiple endpoints model of graphic development. *Visual Arts Research*, 25(2), 38–47.

Duncum, P. (2002). Visual culture art education: Why, what and how. *International Journal of Art & Design Education*, 21(1), 14–23.

Duncum, P. (2010). Seven principles for visual culture education. *Art Education*, 63(1), 6–10.

Dyson, A. H. (1986). Transitions and tensions: Interrelationships between the drawing, talking, and dictating of young children. *Research in the Teaching of English*, 20(4), 379–409.

Dyson, A. H. (2003). "Welcome to the jam": Popular culture, school literacy, and the making of childhoods. *Harvard Educational Review*, 73(3), 328–61.

Dyson, A. H. (2010). Writing childhoods under construction: Re-visioning 'copying'in early childhood. *Journal of Early Childhood Literacy*, 10(1), 7–31.

Edwards, S. (2005) Identifying the factors that influence computer use in the early childhood classroom. *Australasian Journal of Educational Technology*, 21(2), 192–210.

Edwards, S. (2013). Digital play in the early years: A contextual response to the problem of integrating technologies and play-based pedagogies in the early childhood curriculum. *European Early Childhood Education Research Journal*, 21(2), 199–212.

Eisner, E. W. (2004). What can education learn from the arts about the practice of education. *International Journal of Education & the Arts*, 5(4), 1–12.

Early Years Foundation Stage (2014). Retrieved 11 April 2016 from: http://www.foundationyears.org.uk/eyfs-statutory-framework/

Flewitt, R. (2011). Bringing ethnography to a multimodal investigation of early literacy in a digital age. *Qualitative Research*, 11(3), 293–310.

Flewitt, R., Kucirkova, N., & Messer, D. (2014). Touching the virtual, touching the real: iPads and enabling literacy for students experiencing disability. *Australian Journal of Language & Literacy*, 37(2), 107–116.

Formby, S. (2014). Practitioner perspectives: Children's use of technology in the early years. National Literacy Trust. Retrieved 11 April 2016 from: http://www.literacytrust.org.uk/assets/0002/1135/Early_years_practitioner_report.pdf

Fox, N. J., & Alldred, P. (2015). New materialist social inquiry: Designs, methods and the research-assemblage. *International Journal of Social Research Methodology*, 18(4), 399–414.

Fraser, S. (2006). *Authentic childhood: Experiencing Reggio Emilia in the classroom.* Albany, NY: Nelson Thomson Learning.

Frisch, N. S. (2006). Drawing in preschools: A didactic experience. *International Journal of Art and Design Education*, 25, 74–85.

Gandini, L. (1998). Educational and caring spaces. In C. Edwards, L. Gandini & G. Forman (Eds.), *The hundred languages of children: The Reggio Emilia approach – advanced reflections* (2nd ed., pp. 161–78). Westport, CT: Ablex

Gardner, H. (1980). *Artful scribbles: The significance of children's drawings.* New York: Basic Books.

Garoian, C. R., & Gaudelius, Y. M. (2008). *Spectacle pedagogy: Art, politics, and visual culture.* New York: State University of New York Press.

Glăveanu, V. P. (2010). Paradigms in the study of creativity: Introducing the perspective of cultural psychology. *New Ideas in Psychology*, 28(1), 79–93.

Glăveanu, V. P. (2011). Creativity as cultural participation. *Journal for the Theory of Social Behaviour*, 41(1), 48–67.

Glăveanu, V. P. (2015). The status of the social in creativity studies and the pitfalls of dichotomic thinking. *Creativity. Theories–Research-Applications*, 2(1), 102–119.

Glăveanu, V. P., & Lahlou, S. (2012). Through the creator's eyes: Using the subjective camera to study craft creativity. *Creativity Research Journal*, 24(2–3), 152–62.

Goffman, E. (1961). *Encounters: Two studies in the sociology of interaction.* Oxford: Bobbs-Merrill.

Goffman, E. (1972 [1964]). 'The neglected situation', in P. P. Giglioli (Ed.) *Language and social context* (pp. 61–6). Baltimore: Penguin (orig. pub. *American Anthropologist* 66: 133–6).

Golomb, C. (2003). Art and the young: The many faces of representation. *Visual Arts Research*, 29(57), 120–143. Retrieved 11 April 2016 from: http://www.jstor.org/stable/20716086

Golomb, C., & Farmer, D. (1983). Children's graphic planning strategies and early principles of spatial organization in drawing. *Studies in Art Education*, 24(2), 86–100.

González, N., Moll, L. C., & Amanti, C. (Eds.). (2013). *Funds of knowledge: Theorizing practices in households, communities, and classrooms.* London: Routledge.

Goodwin, C. (2000) Action and embodiment within situated human interaction. *Journal of Pragmatics*, 32(10), 1489–522.

Goodwin, C. (2007). Participation, stance and affect in the organization of activities. *Discourse & Society*, 18(1), 53–73.

Goodwin, M. H. (2006). Participation, affect, and trajectory in family directive/response sequences. *Text & Talk-An Interdisciplinary Journal of Language, Discourse Communication Studies*, 26(4–5), 515–43.

Hämäläinen, R., & Vähäsantanen, K. (2011). Theoretical and pedagogical perspectives on orchestrating creativity and collaborative learning. *Educational Research Review*, 6(3), 169–84.

Harlow, A., Cowie, B., & Heazlewood, M. (2010). Keeping in touch with learning: the use of an interactive whiteboard in the junior school. *Technology, Pedagogy and Education*, 19(2), 237–43.

Harris, D. B. (1963) *Children's drawings as measures of intellectual maturity.* New York: Harcourt, Brace & World.

Hawkins, B. (2002). Children's drawing, self expression, identity and the imagination. *International Journal of Art & Design Education*, 21(3), 209–219.

Heidegger, M. (1962/1927). *Being and time* (trans. J. Macquarrie & E. Robinson). New York: Harper.

Heydon, R. M. (2012). Multimodal communication and identities options in an intergenerational art class. *Journal of Early Childhood Research*, 10(1), 51–69.

Higgins, S., Beauchamp, G., & Miller, D. (2007). Reviewing the literature on interactive whiteboards. *Learning, Media and Technology*, 32(3), 213–25.

Hodge, R., & Kress, G. (1988). *Social semiotics*. Ithaca, NY: Cornell University Press.

Hosea, H. (2006). 'The brush's footmarks': Parents and infants paint together in a small community art therapy group. *International Journal of Art Therapy*, 11(2), 69–78.

Hurworth, R. (2012). Techniques to assist with interviewing. In J. Arthur, M. Waring, R. Coe & L. V. Hedges (Eds.) *Research Methods and methodologies in Education* (pp. 177–86). London: Sage.

Ingold, T. (2011). *Being alive: Essays on movement, knowledge and description*. New York: Routledge.

Ingold, T. (2013). *Making: Anthropology, archaeology, art and architecture*. New York: Routledge.

Ivashkevich, O. (2013). Appropriation, parody, gender play, and self-representation in preadolescents' digital video production. *International Journal of Education & the Arts*, 14(2). Retrieved 11 April 2016 from http://www.ijea.org/v14n2/v14n2.pdf

Ivashkevich, O., & shoppell, S. (2012). Appropriation, parody, gender play, and self-representation in preadolescents' digital video production. *International Journal of Education & the Arts*, 14(2). Retrieved 11 April 2016 from http://www.ijea.org/v14n2/

Jakobson, R. (1960). *Linguistics and poetics*. Cambridge, MA: MIT Press.

Jakobson, R. (1973). Selected Writings (Volume 2). Retrieved 11 April 2016 from http://www.ebooksread.com/authors-eng/roman-jakobson/selected-writings-volume-2-oka.shtml

Jarvis, M., & Lewis, T. (2002). Art, design & technology – a plea to reclaim the senses. *International Journal of Art & Design Education*, 21(2), 124–31.

Jewitt, C., & Kress, G. (2003). Introduction. In C. Jewitt & G. Kress (eds.) *Multimodal Literacy*. New York: Peter Lang Publishing.

Johnson, R., Bianchi-Berthouze, N., Rogers, Y., & van der Linden, J. (2013, September). Embracing calibration in body sensing: Using self-tweaking to enhance ownership and performance. In *Proceedings of the 2013 ACM international joint conference on Pervasive and ubiquitous computing* (pp. 811–20). ACM.

Kanngiesser, P., Gjersoe, N., & Hood, B. M. (2010). The effect of creative labor on property-ownership transfer by preschool children and adults. *Psychological Science*, 21(9), 1236–41.

Kim, J. (2001). Phenomenology of digital-being. *Human Studies*, 24(1–2), 87–111.

Kind, S. (2013). Lively entanglements: The doings, movements and enactments of photography. *Global Studies of Childhood*, 3(4), 427–41.

King, N., & Horrocks, C. (2010). *Interviews in qualitative research*. London: Sage.

Knight, L. M. (2013). Not as it seems: Using Deleuzian concepts of the imaginary to rethink children's drawings. *Global Studies of Childhood*, 3(3), 254–64.

Knobel, M., & Lankshear, C. (2008). Remix: The art and craft of endless hybridization. *Journal of Adolescent & Adult Literacy*, 52(1), 22–33.

Kolbe, U. (2005). *It's not a bird yet: The drama of drawing*. Byron Bay, NSW: Peppinot Press.

Koppitz, E. M. (1968). *Psychological evaluation of children's human figure drawings*. London: Grune & Stratton.

Kress, G. (1997). *Before writing: Rethinking the paths to literacy*. London: Routledge.

Kress, G. (2005). Gains and losses: New forms of texts, knowledge, and learning. *Computers and Composition*, 22(1), 5–22.

Kress, G. (2010). *Multimodality: A social semiotic approach to contemporary communication*. London: Routledge.

Kress, G., & van Leeuwen, T. (2002). Colour as a semiotic mode: notes for a grammar of colour. *Visual Communication*, 1(3), 343–68.

Kucirkova, N., Messer, D., Sheehy, K., & Flewitt, R. (2013). Sharing personalised stories on iPads: A close look at one parent – child interaction. *Literacy*, 47(3), 115–22.

Kucirkova, N., Messer, D., & Sheehy, K. (2014). The effects of personalisation on young children's spontaneous speech during shared book reading. *Journal of Pragmatics*, 71, 45–55.

Labbo, L. D. (1996). A semiotic analysis of young children's symbol making in a classroom computer centre. *Reading Research Quarterly* 31(4), 356–85.

Lamb, B. (2007). Dr. Mashup or, why educators should learn to Stop worrying and love the remix. *Educause Review*, 42(4), 13–14.

Lambert, G. (2005). 'Expression', in C. J. Stivale (Ed.), *Gilles Deleuze: Key concepts* (pp. 31–42), Chesham: Acumen Publishing.

Lankshear, C., & Knobel, M. (2006). *New literacies: Everyday practices and classroom learning*. Maidenhead: Open University Press.

Larssen, A. T., Robertson, T., & Edwards, J. (2006, November). How it feels, not just how it looks: When bodies interact with technology. In *Proceedings of the 18th Australia conference on Computer-Human Interaction: Design: Activities, Artefacts and Environments* (pp. 329–32). ACM.

Levi-Strauss, C. (1950/1987). *Introduction to the work of Marcel Mauss* (trans. Felicity Baker). London: Routledge & Kegan Paul.

Lillis, T. (2008). Ethnography as method, methodology, and 'deep theorizing': Closing the gap between text and context in academic writing research. *Written Communication*, 25(3), 353–88.

Lindahl, M. G., & Folkesson, A. M. (2012). ICT in preschool: Friend or foe? The significance of norms in a changing practice. *International Journal of Early Years Education*, 20(4), 422–36.

Loke, L., & Robertson, T. (2008, December). Inventing and devising movement in the design of movement-based interactive systems. In *Proceedings of the 20th Australasian Conference on Computer-Human Interaction: Designing for Habitus and Habitat* (pp. 81–88). ACM.

Løkken, G., & Moser, T. (2012). Space and materiality in early childhood pedagogy-introductory notes. *Education Inquiry*, 3(3), 303–315.

Longobardi, C., Quaglia, R., & Iotti, N. O. (2015). Reconsidering the scribbling stage of drawing: A new perspective on toddlers' representational processes. *Frontiers*

in Psychology, 6. Retrieved 11 April 2016 from http://www.ncbi.nlm.nih.gov/pmc/articles/PMC4543818/

Lowenfeld, V. (1947). *Creative and mental growth*. New York: MacMillan.

Lowenfeld, V. T., and Britten, W. (1982). *Creative and mental growth*. New York: Collier Macmillan.

Lynch, J., & Redpath, T. (2014). 'Smart'technologies in early years literacy education: A meta-narrative of paradigmatic tensions in iPad use in an Australian preparatory classroom. *Journal of Early Childhood Literacy*, 14(2), 147–74.

Machover, K. (1949). *Personality projection in the drawings of the human figure*. Springfeld, IL: Thomas.

MacRae, C. (2011). Making Payton's Rocket: Heterotopia and lines of flight. *International Journal of Art & Design Education*, 30(1), 102–112.

Malchiodi, C. A. (Ed.). (2011). *Handbook of art therapy*. Guilford Press.

Malin, H. (2013). Making meaningful: Intention in children's art making. *International Journal of Art & Design Education*, 32(1), 6–17.

Mangen, A. (2010). Point and click: Theoretical and phenomenological reflections on the digitization of early childhood education. *Contemporary Issues in Early Childhood*, 11(4), 415–31.

Marks, L. U. (2004). Haptic visuality: Touching with the eyes. *Framework, the Finnish Art Review*, (2), 79–82.

Marsh, J. (2004). The techno-literacy practices of young children. *Journal of Early Childhood Research*, 2(1), 51–66.

Marsh, J., Brooks, G., Hughes, J., Ritchie, L., Roberts, S. and Wright, K. (2005). *Digital beginnings: Young children's use of popular culture, media and new technologies*. Sheffield: University of Sheffield, Literacy Research Centre.

Mavers, D. (2007). Semiotic resourcefulness: A young child's email exchange as design. *Journal of Early Childhood Literacy* 7(2), 155–76.

McClure, M. (2011). Child as totem: Redressing the myth of inherent creativity in early childhood. *Studies in Art Education*, 52(2), 127–41.

McLennan, D. M. P. (2010). Process or product? The argument for aesthetic exploration in the early years. *Early Childhood Education Journal*, 38(2), 81–5.

McPake, J., Plowman, L., & Stephen, C. (2013). Pre-school children creating and communicating with digital technologies in the home. *British Journal of Educational Technology*, 44(3), 421–31.

McTavish, M. (2009). 'I get my facts from the internet': A case study of the teaching and learning of information literacy in in-school and out-of-school contexts. *Journal of Early Childhood Literacy*, 9(1), 3–28.

Mercer, N., Warwick, P., Kershner, R., & Staarman, J. K. (2010). Can the interactive whiteboard help to provide 'dialogic space'for children's collaborative activity? *Language and Education*, 24(5), 367–84.

Nancekivell, S. E., Vondervoort, J. W., & Friedman, O. (2013). Young children's understanding of ownership. *Child Development Perspectives*, 7(4), 243–47.

Norman, D. (1988). *The design of everyday things*. New York: Basic Books.

Ofcom (2014) Children and parents: Media use and attitudes. Retrieved 11 April 2016 from: http://stakeholders.ofcom.org.uk/binaries/research/media-literacy/media-use-attitudes-14/Childrens_2014_Report.pdf

Oliver, M. (2005). The problem with affordance. *E-Learning and Digital Media*, 2(4), 402–413.

Pacini-Ketchabaw, V. (2012). Acting with the clock: Clocking practices in early childhood. *Contemporary Issues in Early Childhood*, 13(2), 154–60.

Pacini-Ketchabaw, V., & Clark, V. (2016). Following watery relations in early childhood pedagogies. *Journal of Early Childhood Research*, 14(1), 98–111.

Patton, M. Q. (2002). Two decades of developments in qualitative inquiry: A personal, experiential perspective. *Qualitative Social Work*, 1(3), 261–83.

Palaiologou, I. (2016). Children under five and digital technologies: Implications for early years pedagogy. *European Early Childhood Education Research Journal*, 24(1), 5–24.

Petrelli, D., & Whittaker, S. (2010). Family memories in the home: Contrasting physical and digital mementos. *Personal and Ubiquitous Computing*, 14(2), 153–69.

Pink, S. (2008). An urban tour: The sensory sociality of ethnographic place-making. *Ethnography*, 9(2), 175–96.

Pink, S., Mackley, K. L., & Moroşanu, R. (2015). Researching in atmospheres: Video and the 'feel'of the mundane. *Visual Communication*, 14(3), 351–69.

Plowman, L., & Stephen, C. (2005). Children, play, and computers in pre-school education. *British Journal of Educational Technology*, 36(2), 145–57.

Plowman, L., Stephen, C., & McPake, J. (2010). Supporting young children's learning with technology at home and in preschool. *Research Papers in Education*, 25(1), 93–113.

Price, S., Jewitt, C., & Crescenzi, L. (2015). The role of iPads in pre-school children's mark making development. *Computers & Education*, 87, 131–41.

Price, S., Sakr, M., & Jewitt, C. (2015). Exploring whole-body interaction and design for museums. *Interacting with Computers*, accessed 19 July 2016 from http://iwc.oxfordjournals.org/content/early/2015/09/25/iwc.iwv032.short.

Prior, P. (2005). Moving multimodality beyond the binaries: A response to Gunther Kress' 'Gains and Losses'. *Computers and Composition*, 22(1), 23–30.

Proulx, L. (2003). *Strengthening emotional ties through parent-child-dyad art therapy: Interventions with infants and preschoolers*. London: Jessica Kingsley Publishers.

Richards, R. D. (2009). Young visual ethnographers: Children's use of digital photography to record, share and extend their art experiences. *International Art in Early Childhood Research Journal*, 1(1), 1–16.

Ringrose, J. (2011). Beyond discourse? Using Deleuze and Guattari's schizoanalysis to explore affective assemblages, heterosexually striated space, and lines of flight online and at school. *Educational Philosophy and Theory*, 43(6), 598–618.

Roberts-Holmes, G. (2012). 'It's the bread and butter of our practice': Experiencing the early years foundation stage. *International Journal of Early Years Education*, 20(1), 30–42.

Rogers, Y., & Lindley, S. (2004). Collaborating around vertical and horizontal large interactive displays: which way is best? *Interacting with Computers*, 16(6), 1133–52.

Rojas-Drummond, S. M., Albarrán, C. D., & Littleton, K. S. (2008). Collaboration, creativity and the co-construction of oral and written texts. *Thinking skills and Creativity*, 3(3), 177–91.

Rose, S. E., Jolley, R. P., & Burkitt, E. (2006). A review of children's, teachers' and parents' influences on children's drawing experience. *International Journal of Art & Design Education*, 25(3), 341–9.

Rose, S. E., Jolley, R. P., & Charman, A. (2012). An investigation of the expressive and representational drawing development in National Curriculum, Steiner, and Montessori schools. *Psychology of Aesthetics, Creativity, and the Arts*, 6(1), 83.

Russell, D. M., Drews, C., & Sue, A. (2002). Social aspects of using large public interactive displays for collaboration. In *UbiComp 2002: Ubiquitous Computing* (pp. 229–36). Berlin: Springer.

Sakr, M., Jewitt, C., & Price, S. (2014). The semiotic work of the hands in scientific enquiry. *Classroom Discourse*, 5(1), 51–70.

Sakr, M., Jewitt, C., & Price, S. (2016). Mobile experiences of historical place: A Multimodal analysis of emotional engagement. *Journal of the Learning Sciences*, 25(1), 51–92.

Sakr, M., Connelly, V., & Wild, M. (2015). The semiotic work of teachers' writing in displays of young children's drawings. In A. Archer & E. Breuer (Eds.) *Multimodality in writing: The state of the art in theory, methodology and pedagogy*. Bingley: Emerald (pp. 278–98).

Schiller, J., and Tillett, B. (2004). Using digital images with young children: Challenges of integration. *Early child development and care*, 174(4), 401–414.

Schwarz, T., & Luckenbill, J. (2012). Let's get messy! Exploring sensory and art activities with infants and toddlers. *YC Young Children*, 67(4), 26–32.

Sellers, M. (2013). *Young children becoming curriculum: Deleuze, Te Whāriki and curricular understandings*. London: Routledge.

Serazio, M. (2010). Shooting for fame: Spectacular youth, web 2.0 dystopia, and the celebrity anarchy of generation mash-up. *Communication, Culture & Critique*, 3(3), 416–34.

Snibbe, S. S., & Raffle, H. S. (2009, April). Social immersive media: Pursuing best practices for multi-user interactive camera/projector exhibits. In *Proceedings of the SIGCHI Conference on Human Factors in Computing Systems* (pp. 1447–56). ACM.

Shami, N. S., Hancock, J. T., Peter, C., Muller, M., & Mandryk, R. (2008, April). Measuring affect in HCI: Going beyond the individual. In *CHI'08 Extended Abstracts on Human Factors in Computing Systems* (pp. 3901–4). ACM.

Sheridan, S. R. (2002). The neurological significance of children's drawing: The scribble hypothesis. Paper presented at the Toward a Science of Consicousness Conference (Skovde, Sweden, August 2001). Retrieved 11 April 2016 from http://eric.ed.gov/?id=ED477425

Shouse, E. (2005). Feeling, emotion, affect. *M/C Journal*, 8(6). Retrieved 11 April 2016 from: http://www.journal.media-culture.org.au/0512/03-shouse.php

Shusterman, R. (2008). *Body consciousness: A philosophy of mindfulness and somaesthetics.* Cambridge: Cambridge University Press.

Soundy, C. S., & Drucker, M. F. (2010). Picture partners: A co-creative journey into visual literacy. *Early Childhood Education Journal*, 37(6), 447–60.

Springgay, S. (2005). Thinking through bodies: Bodied encounters and the process of meaning making in an e-mail generated art project. *Studies in Art Education*, 47(1), 34–50.

Springgay, S. (2008). *Body knowledge and curriculum: Pedagogies of touch in youth and visual culture.* New York: Peter Lang.

Steinberg, S. R. (2014). Contextualizing corporate kids: Kinderculture as cultural pedagogy. *Communication & Social Change*, 2(1), 31–57

Stephen, C. (2010). Pedagogy: The silent partner in early years learning. *Early Years*, 30(1), 15–28.

Stephen, C., McPake, J., Plowman, L., & Berch-Heyman, S. (2008). Learning from the children: Exploring preschool children's encounters with ICT at home. *Journal of Early Childhood Research*, 6(2), 99–117.

Stern, D. N., Sander, L. W., Nahum, J. P., Harrison, A. M., Lyons-Ruth, K., Morgan, A. C., … & Tronick, E. Z. (1998). Non-interpretive mechanisms in psychoanalytic therapy: The 'something more' than interpretation. *International Journal of Psychoanalysis*, 79(5), 903–21.

Stern, D. N. (2000). *Interpersonal world of the infant: A view from psychoanalysis and development psychology.* London: Basic books.

Stern, D. N. (2004). *The present moment in psychotherapy and everyday life (Norton series on interpersonal neurobiology).* London: W. W. Norton.

Strong-Wilson, T., & Ellis, J. (2007). Children and place: Reggio Emilia's environment as third teacher. *Theory into Practice*, 46(1), 40–7.

Surin, K. (2005). 'Force', in C. J. Stivale (Ed.) *Gilles Deleuze: Key concepts* (pp. 19–31), Chesham: Acumen Publishing.

Szyba, C. M. (1999). Why do some teachers resist offering appropriate, open-ended art activities for young children? *Young Children*, 54, 16–20.

Tarr, P. (2004). Consider the walls. *Young Children*, 59(3), 88–92.

The Telegraph (2014) How digital technology and TV can inhibit children socially. Retrieved 11 April 2016 from: http://www.telegraph.co.uk/news/science/science-news/11054305/How-digital-technology-and-TV-can-inhibit-children-socially.html

Thompson, C. M. (2003). Kinderculture in the art classroom: Early childhood art and the mediation of culture. *Studies in Art Education*, 44(2), 135–46.

Thompson, C. M. (2007). The culture of childhood and the visual arts. In L. Bresler (Ed.) *International handbook of research in arts education*. Netherlands: Springer (pp. 899–916)

Time (2014). Why access to screens is lowering kids' social skills. Retrieved 11 April 2016 from: http://time.com/3153910/why-access-to-screens-is-lowering-kids-social-skills/

Turkle, S. (2011). *Alone together*. New York: Basic Books.

Turkle, S. (2015). *Reclaiming conversation: The power of talk in a digital age*. New York: Penguin Press.

Twigg, D. (2011). Look out below (and above)! Challenging adult understandings of displaying young children's artwork. *Contemporary Issues in Early Childhood*, 12(3), 262–73.

Vaish, A., Missana, M., & Tomasello, M. (2011). Three year old children intervene in third party moral transgressions. *British Journal of Developmental Psychology*, 29(1) (2011), 124–30.

Van Leeuwen, T. (2005). *Introducing social semiotics*. Abingdon: Routledge.

Van Maanen, J. (1988). *Tales of the field: On writing ethnography*. Chicago: University of Chicago Press.

Vannini, P. (2007). Social semiotics and fieldwork method and analytics. *Qualitative Inquiry*, 13(1), 113–40.

Vass, E., Littleton, K., Miell, D., & Jones, A. (2008). The discourse of collaborative creative writing: Peer collaboration as a context for mutual inspiration. *Thinking Skills and Creativity*, 3(3), 192–202.

Wegerif, R. (2007). *Dialogic education and technology: Expanding the space of learning*. New York: Springer.

Wegerif, R., & Dawes, L. (2004). *Thinking and learning with ICT: Raising achievement in primary classrooms*. London: RoutledgeFalmer.

Williams, A., Kabisch, E., & Dourish, P. (2005). From interaction to participation: Configuring space through embodied interaction. In *Proceedings of UbiComp 2005: Ubiquitous Computing* (287–304). ACM.

Wilson, B., & Wilson, M. (1977). An iconoclastic view of the imagery sources in the drawings of young people. *Art Education*, 30(1), 5–12.

Winner, E., & Gardner, H. (1981). The art in children's drawings. *Review of Research in Visual Arts Education*, 14, 18–31.

Winnicott, D. W. (1971). *Playing and reality*. London: Routledge.

Wohlwend, K. E. (2009). Damsels in discourse: Girls consuming and producing identity texts through Disney princess play. *Reading Research Quarterly*, 44(1), 57–83.

Wright, S. (2012). *Children, meaning-making and the arts*. NSW: Pearson Australia.

Wu, L. Y. (2009). Children's graphical representations and emergent writing: Evidence from children's drawings. *Early Child Development and Care*, 179(1), 69–79.

Wyeth, P., & Purchase, H. C. (2002, April). Tangible programming elements for young children. In *CHI'02 extended abstracts on Human factors in computing systems* (pp. 774–75). ACM.

Index